From
Ordinary to
Extraordinary

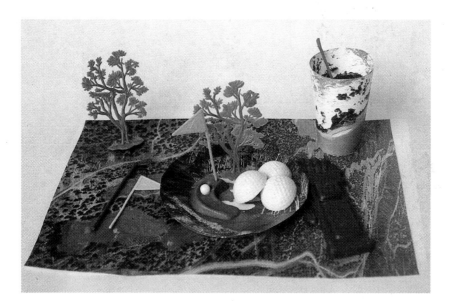

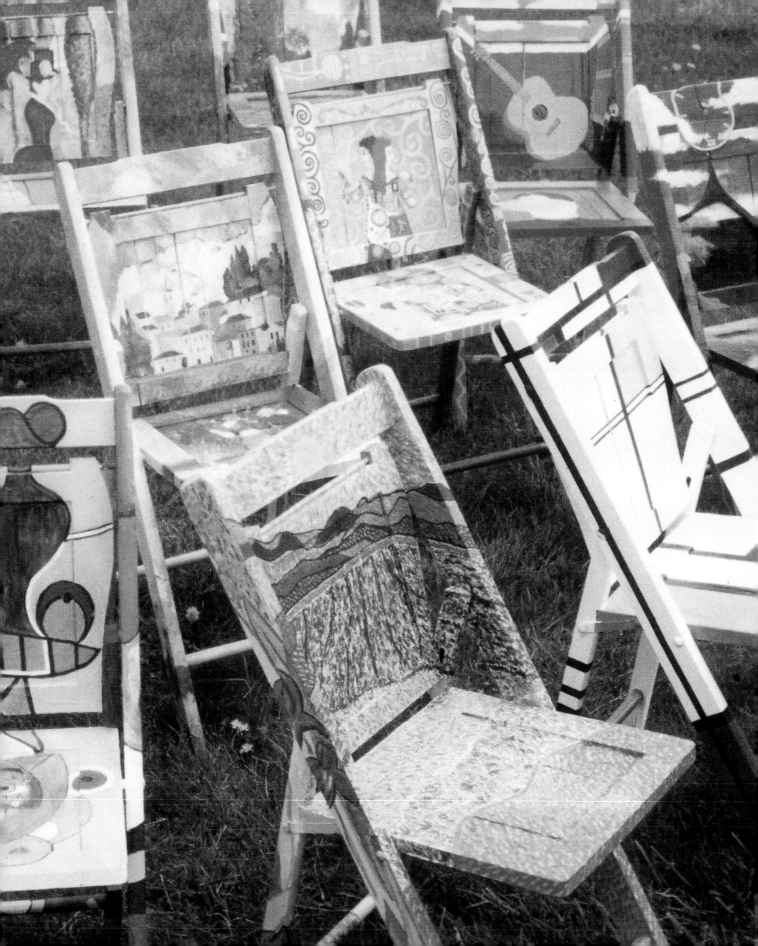

From Ordinary to Extraordinary

Art and Design Problem Solving

KEN VIETH

Davis Publications, Inc.

Worcester, Massachusetts

Acknowledgments and special thanks to:

- All the hard-working students from Montgomery High School, Skillman, New Jersey

- Kent Anderson and Eldon Katter for years of acceptance and encouragement and for publishing my work in *SchoolArts* magazine

- Peggy Burke for reading and editing my submissions to *SchoolArts* magazine

- Scott McVay and the support of the Geraldine R. Dodge Foundation

- Christa McAuliffe Fellowship, New Jersey, 1997, for supporting and acknowledging my work in visual problem solving

- Dan Bush for creating educational videos about this work

- Helen Ronan and Carol Harley, editors at Davis Publications, Worcester, MA

- Outreach Advisory Committee for International Studies, Princeton University

- Nigel and Elaine Frost: Architecture Workshops, Cambridge, England, UK

- My wife Joann and my daughters Kyla and Erin

- My family and friends!

From Ordinary to Extraordinary
Copyright © 1999
Davis Publications, Inc.
Worcester, Massachusetts U.S.A.

Half-title page: Alison Holmes, grade 12. *Golf*. Mixed media, 9" x 15" x 7" (22.9 x 38.1 x 17.8 cm).
Title page: Various artists. Acrylic paint over white latex paint on wooden chairs.

Publisher: Wyatt Wade
Editorial Director: Helen Ronan
Production Editor: Carol Harley
Manufacturing Coordinator: Jenna Sturgis
Editorial Assistance: Colleen Strang
Copyeditors: Karla Beatty, Sheila Boyle
Design: Cyndy Patrick
Photography: Ken Vieth

Library of Congress Catalog Card Number: 98-83127
ISBN-10: 0-87192-387-4
ISBN-13: 978-0-87192-387-5
10 9 8 7 6
Printed in the United States of America

Contents

Preface

Art is an extraordinary subject, one that deserves the kind of passion and commitment that transforms technique to concept, media to expression, ordinary to extraordinary. This book recounts an artist/teacher's journey applying and reflecting on ideas and techniques for teaching art on the secondary level. It is a journey that involves students who look to art for personal fulfillment and educators who long to succeed as artists and teachers.

The ideas, methods, and projects presented in this book develop and enhance thinking processes integral to visual problem solving. The art activities described here are designed to spark students' imaginations, promote their skill development, and encourage them to take risks as they engage in the creative process. It is my desire to share this teaching model primarily because using this model, I have witnessed astounding growth in thinking, skill levels, and artistic expression.

—Ken Vieth

Introduction

As we look toward the American workplace of the twenty-first century, we can anticipate some qualities that future employers will want. Most will look for people who are willing to collaborate and work in teams. They will want the individuals and teams they hire to be problem solvers and to show flexibility in dealing with others. They will want employees who are able to address complex social issues, devise creative solutions, and imagine new worlds and new possibilities.

The opportunity to prepare students for the future is exciting. As art teachers, we can contribute significantly to this preparation by stressing the importance of visual problem solving, encouraging students' creative thinking, and involving students in cooperative projects. The primary purpose of this book is to articulate the process of visual problem solving and, in so doing, celebrate the journey of student and teacher as together they learn to see problems visually and devise creative solutions to these problems.

This book is not meant to be used as a curriculum for secondary level art teachers. Rather, it is intended to provide ideas that will expand the borders of our creative thinking as art teachers. The intent is to motivate, to open doors, and to make new connections through projects that foster depth and breadth in our work with students.

On its most basic level, art is visual expression. Too often in secondary education we focus exclusively on the teaching of technique and media and, in so doing, miss the most important aspect of visual expression: the capacity to be expressive. The approaches to visual expression provided in this book will help the artist/teacher address the question: "How can we help our students to make visual connections?" As we motivate our students to make visual connections we are also helping them to express themselves and their relationships to their families, cultures, society, and world.

The processes explained in this book are intended to increase students' higher-level thinking skills, technical proficiency, and ability to apply these skills to personal expression. To accomplish this, the artist/teacher must stay connected to the art world, understand that this connection is vital to classroom success, give careful thought to the structure of class assignments, and encourage student decision making and risk taking. This book provides examples of diverse visual problems successfully solved in two and three dimensions—projects that fired my enthusiasm as a teacher and elicited a desire for greater self expression from my students. It is my hope that the approach outlined in this book will encourage and engage the artistic expression of both students and the artist/teacher and, in doing so, move the experience of art in the classroom from ordinary to extraordinary.

CHAPTER I: Insights on the Journey of the Artist/Teacher

The opening chapter describes the role of the artist/teacher and presents a dynamic philosophy concerning art and teaching.

CHAPTER II: Translating the Ordinary to Extraordinary

The visual problems in the second chapter are designed to unlock the creative potential of students by changing the way they view everyday objects. As they see everyday objects in a new context, students make new visual connections and begin thinking in a critical and innovative manner.

In all of these visual problems, students will engage in forms of higher-level thinking that fosters creativity. Each assignment is thoughtfully structured and developed to motivate students and elicit creative responses from them. Because lessons encourage independent decision making and risk taking, diverse solutions result.

CHAPTER III: Moving from Skill to Expression

As art educators, we must increase students' skill levels before challenging them to be more expressive. The third chapter of this book focuses on projects that increase those skill levels while nurturing and directing what is personal and expressive in students. For most projects, the work begins with observational drawing. The drawings are then followed with more creative or expressive interpretations. Student decisions concerning size, media used, or even subject matter contribute significantly to their results.

The connections made in the cooperative Family Tree project are part of the experiential process. For a full description see chapter 4, page 83.

CHAPTER IV: Moving from Personal Expression to Significant Meaning

Helping students connect artistic technique and personal expression is a challenge and an important part of teaching the visual arts. To do this the artist/teacher must help students see themselves as artists deeply involved in the process of creating.

Such a transformation begins with introspection, reflection, and self-revelation as students work through projects such as a Hockney-style photographic self-portrait, a symbolic sculpture, or a creative mask in which students explore the landscape of the mind. Projects in chapter 4 encourage students to go outside of themselves, reflect on their social relationships, and discover how they fit into the larger world. Students may also uncover connections between themselves and their heritage, their personal values, and the outside world.

CHAPTER V: Connecting with Others in Cooperation

Student motivation and thinking skills are considerably enhanced when students work collaboratively to produce a visually unified result. The majority of the three-dimensional artworks described in this chapter were created by thirty to fifty students working collaboratively. In "Famous Artist Chairs," two students coordinate their efforts to reflect a famous artist's style. This type of project helps students make connections between such concepts as the individual in relation to his or her culture, freedom, ecological balance, and architecture. Asking students to work together toward a common goal has the additional benefit of encouraging values such as citizenship, responsibility, and commitment to community.

CHAPTER VI: Advocacy for the Arts

This book shares work that celebrates the creative thinking of the individual, the inventive and creative use of materials, and the impact of creativity on the school environment. It also addresses the importance of creating a close relationship between students and teacher. Student exhibitions—ongoing shows or permanent works exhibited in the school—will enhance the impact of art throughout the school, connect students' work to the larger community, and insure the integrity of the overall art program.

Insights on the Journey of the Artist/Teacher

Excellence in an art program depends on many components. The most important of these focus on the teacher as artist/teacher who develops creative projects, builds communication skills, increases student empowerment, encourages individual risk taking, and develops students' capacity for personal reflection. The problem is how to make these components, so often viewed in isolation, work together. The guidelines that follow provide a good place to start. In the chapters that follow they are implemented and integrated as part of specific projects.

GUIDELINES FOR THE ARTIST/TEACHER

1 Be an artist as well as a teacher.

2 Develop creative problem-solving assignments.

3 Develop and refine communication skills.

4 Increase student empowerment.

5 Be a risk taker.

6 Be resourceful.

7 Include reflective writing.

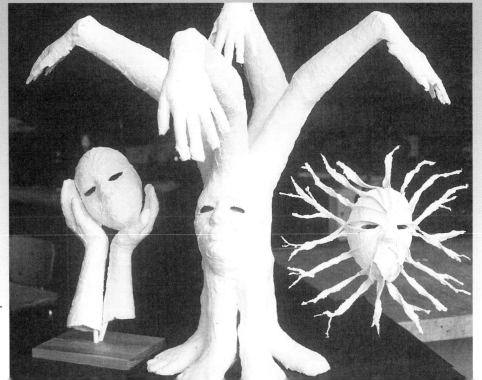

In truly engaging visual problems, students will produce more than what is expected.

Allison Motto, grade 12. Plaster gauze self-portraits. (Each mask is life-size.)

Art Educators: Artists as well as Teachers

As we examine the importance of the artist/ teacher in the classroom, it helps to separate the two roles and look at significant qualities of each. Let's begin with the artist since it is likely that it was an interest in art and expression that first inspired us to pursue teaching art as a career.

"When the artist is alive in any person he[/she] becomes an inventive, searching, daring and self-expressing creature," writes author Robert Henri in *The Art Spirit.* Artists satisfy their desire to create by confidently responding to, representing, and reordering reality—all to create something new. Their response is fueled by increased visual awareness, creative energy, and a willingness to take risks—in short, a freedom that produces unique visual results. As Henri states, "We are not here to do what has already been done." Artists are travelers on the road to self-discovery. Their commitment to the task of self discovery moves them to share their vision with others and produce work. At times the path is joyous; the feeling of joy is a product of both the personal process and the results produced. Other times it is lonely and isolating. Hopefully, the process is always dynamic.

As artist/teachers, we have the opportunity to share our knowledge, skills, and enthusiasm for art. We need to be visionary leaders for our students, modeling standards, sharing insights, and engaging them in ways that will impact their thinking beyond the classroom. When students observe us in our role as "teacher," they will notice and respond to our level of dedica-

tion, our optimistic attitude, and our involvement in the creative teaching process. As teachers, we are in a position to see, acknowledge, and encourage individuality and originality in our students' work.

Ken Vieth, *Portrait of a Student.* **Watercolor and fine-line marker, 15" x 29" (38.2 x 74 cm.)**

Devi used newspaper as a textural element.

Devi Sengupta, grade 11. Paper collage, watercolor, 3" x 3" (7.6 x 7.6 cm).

As teachers of art, we need to be actively involved in producing art. This will allow us to maintain perspective and our self-esteem as artists—always remembering that we were artists before we were teachers. One way to stay productive as an artist is to do the challenging assignments we give our students. Students thus see the teacher in the learning mode—willing to take risks, make decisions, and find expressive solutions to problems. Seeing the teacher as both artist and a mentor, students develop respect, trust, and increased confidence. For us, as working artists, adopting this style of teaching contributes to our own development and growth. It energizes the vital qualities of both facets of our identity: teacher and artist.

The most significant benefit of this mode of teaching is the synergy that results from performing the two roles in tandem. As teachers, we think about how we communicate and carefully choose our words, personally participate in the creative thought process, share our vision, engage students in the process of expression, and add passion to the task of producing visual images. We inspire both ourselves and the students we teach. Finally, we can and often do learn from the students we teach. Students frequently challenge our thinking in unexpected ways and if we keep our minds open, we can become better artists by responding thoughtfully to the questions they pose.

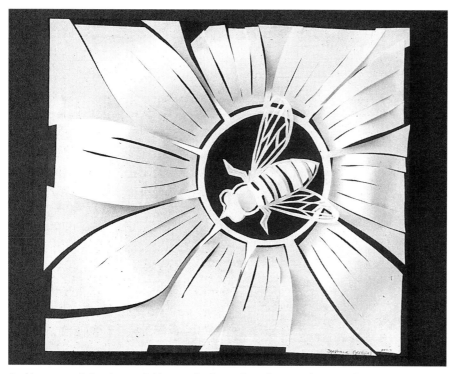

A white paper relief project can bridge a student's experience from two-dimensional to three-dimensional work.

Stephanie Gorziel, grade 11. Cut paper, 12" x 13" x 1 1/4" (30.5 x 33 x 3.2 cm).

Develop Creative Problem-Solving Assignments

Visual problem solving is a process that engages students on many levels. The process evokes questions that in turn elicit still more questions. As they strive to find answers, students exercise creativity. The aim always is to enhance critical thinking skills, improve technical skills, and encourage individual expression. Teachers can design assignments that will motivate students to reach new levels of understanding, expand imaginative thought, and increase their willingness to take risks.

INSIGHT INTO THE TEACHER'S PROCESS

Identify direction.

The needs and interests of both teacher and students will help the artist/teacher identify the direction of future work. The process might begin with a desire to explore a particular theme or concept, to respond to a current historical event, or to identify and develop a particular skill. In any event, what ensues is an open dialogue between students and teacher as they share ideas for the direction of future work. The teacher should remain open to any possibilities he or she sees to foster student growth. Allow the thinking and planning time needed to develop the concept and structure of visual problems.

Gather resources.

The teacher gathers information about the concept to be explored and then shares this and related work by other artists. This provides students with the artistic grounding they need to explore a visual concept. For example, the artist/teacher might increase students' knowledge of Impressionism by showing artists' works such as Claude Monet's explorations of the way light visually changes form. Most valuable to students is content that links information about the visual concept to the problem they will explore.

Present the challenge.

Structure the visual problem so that students understand the concept to be explored, participate in the decision-making process, and have sufficient time to develop personal solutions. By sharing open-ended possibilities with students, the teacher clarifies the direction their learning will take. Admittedly, the teacher does have preconceived

Stages and Characteristics of Visual Problem-Solving Assignments

1 Identify a visual theme, concept, or skill that when developed will encourage new and personal solutions.

2 Research the idea, acquire relevant information, and share visual information, such as examples of other artists' work.

3 Present a visual problem, one that will increase individual skill levels and expression. This open-ended process produces diverse results because it empowers students by encouraging them to make decisions and take risks.

4 Support the process with information, motivate students, and act as a problem-solving facilitator for technical difficulties students may experience.

5 Include reflection on the learning process by asking students to complete verbal and written critiques.

ideas about the outcome of the visual work and may attempt to move students in that particular direction. Any changes in the structure of the project that increase its depth and enhance student learning should be enacted. As the teacher presents the problem-solving assignment it is important to recognize that the very nature of problem solving means that students will produce varied solutions, some of which take the project in unforeseen directions.

Provide support.

Throughout this process, the teacher offers support by providing information about the use of media, visual composition, and other technical problems. Open discussions, as they apply to student projects, focus on the use of media, aesthetic concerns, and craftsmanship. Students become engaged in various aspects of critical thinking as they make choices (media, color, etc.) to solve particular problems.

As they work to solve the problem, students experience the freedom to make decisions backed up by the support of a knowledgeable adult: the teacher. Their final results often surprise students as they discover they have increased their skills, learned new information and techniques, and produced quality visual images.

Direct student reflection.

In the final stage of visual problem assignments, students stop and reflect. The teacher may, for example, ask: "What have we just learned?" "What is the value of the learning that has taken place?" A few open-ended questions at the end of each project can give both students and teacher valuable insights and a sense of the true worth of the project. Examples of such questions, which students can answer either verbally or in written critique form, are provided in the Evaluate sections of each project description. For additional information about reflective writing, refer to page 15.

The Creative Process

As we structure assignments, it is important to consider the creative process. Research indicates a progression in the thought processes that allow us, as humans, to create. The creative process begins with identifying and defining the problem. The individual is caught up in a problem that defies solution, despite prolonged study. Suddenly, without conscious volition, the mind is focused, and a moment of insight occurs. This leads to a period of concentrated thought (or work) during which the insight is fixed into some tangible form.

The nineteenth-century German physicist, Hermann Helmholtz, was one of the first to try to describe the creative process. Helmholtz divided the process into three distinct stages. The first stage, Saturation, describes the point in research where you have some information. The second stage, Incubation, refers to the time during which ideas are mulled over. The final stage, Illumination, focuses on the sudden solution. Helmholtz refers to this sudden solution as the "Ah-Ha." In 1908 the French mathematician Jules Henri Poincaré added a fourth stage that he called Verification. Verification is the act of putting the solution into concrete form and checking its error-level and usefulness. In the early 1960s, American psychologist Jacob Getzels added another preliminary stage to the process: Formulation of the Problem. This stage consists of identifying an existing problem or of asking new and searching questions of an already identified problem. Notice that although each of these five stages vary in length of time it takes to complete, only the third stage brings insight.

Some current research does not assume that creativity is always linked to the sudden realization of a solution. In reality, the creative individual works hard for years and then, produces a solution. Remember Einstein's frequently quoted statement, "Genius is one percent inspiration and ninety-nine percent perspiration."

Develop and Refine Communication Skills

To excel as teachers we must learn to communicate verbally, but for the artist this can be a daunting task. As artists, we have chosen to communicate visually, using artistic media. We are versed in the language of art, but not necessarily in verbal articulation.

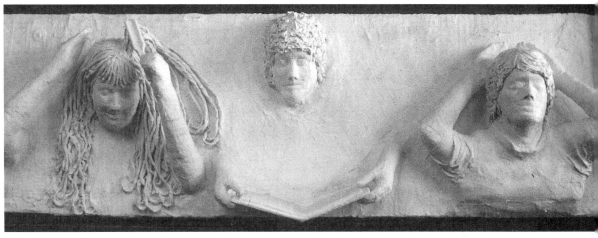

Students used this sculpture to communicate varied aspects of their school day.
Detail of sculpture. Students, grades 10, 11, 12. Plaster gauze, 2' x 15' (61 x 457 cm).

Eventually we must make the transition from art student to art teacher. Increased knowledge, awareness, and a willingness to share with others will help us make that transition. Effective teaching begins with a desire to share what we know. In the process of teaching, one develops the ability to ask key questions and stimulate open-ended answers. We also learn to communicate the respect we feel for our students and the subject we teach. To do this requires that we be sensitive to individuals in our class and to their cultural differences. Teacher acceptance of diversity must be evident and clearly understood by all. The importance of a relaxed attitude and sense of humor cannot be overestimated.

As we strive to build our communication skills, we should make a special effort to develop our listening skills. Students will recognize our efforts and conclude that because we want to talk with them, we value them as individuals. Communication skills such as these take years to develop. First we understand the concepts behind effective communicating. Then, with time and practice, these skills manifest in our behavior and lead to a positive classroom environment.

Because it is vital that artist/teachers communicate well, we need to build on the communication skills we already have. I highly recommend the following practices:
• Choose your words carefully when framing assignments. Be creative and well organized, as you present problem-solving assignments in clear and understandable formats.
• Consider how students will perceive your words. Pay attention to their faces to check that they understand what you say.
• Listen carefully as students raise questions or concerns. Speak directly to the point; respond to students with respect and acceptance.
• Offer concrete support for varied ideas. Respond with enthusiasm, avoiding hollow or meaningless praise.
• Be expressive. Use words that open doors to new possibilities for thinking and artistic expression.

Increase Student Empowerment

Student empowerment is an important aspect of visual problem solving assignments because it forces students take responsibility for their learning and what they produce. One way to empower students is to have them make significant decisions (such as subject matter, size of the work, media, or the amount of time needed) about each assignment.

As teachers, we need to be flexible concerning student input, always cognizant that the areas in which students might make significant decisions may vary from one assignment to another. If a student makes a suggestion that opens possibilities without diminishing the quality of learning, consider changing the assignment accordingly.

As students feel a greater sense of control, the effort and self-discipline they apply to their work increases. In this setting, the teacher does not need to impose a set of expected solutions, but can rely instead on students' increased sense of ownership to influence positively their solutions to visual problems.

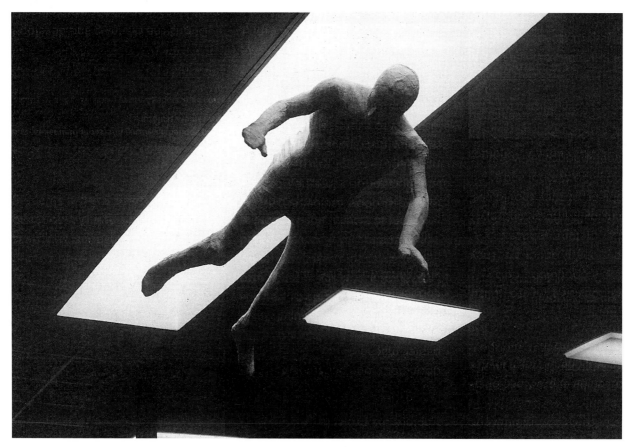

Students decided on the concept of movement and selected the location before developing the sculpture. Students, grades 10, 11, 12. Plaster gauze, life-size.

Be a Risk Taker!

Often, the more entrenched we become in the educational system, the more we run the risk of seeing our subject in narrow or rigid ways. The demands of the traditional educational structure can cause us to lose sight of fresh approaches to our subject. Unless we are part of a large system, as art teachers we usually work in isolation. Many times we lack access to professional feedback and critique. We and our supervisor and principal may believe that our work is producing good results, but even the most experienced teacher can fall into a slump and lose perspective. Such slumps lead to a sense of complacency, frustration, and a loss of enthusiasm that eventually affects students' attitudes.

There are ways to avoid a professional slump. We need to stand back and reassess why we went into art education, recall our initial enthusiasm, and realize we can change. We need to risk varying the curriculum and begin reinventing what and how we teach. This is no easy task, but it is necessary if we are to remain vital as artists and teachers. The process starts with the willingness to try to do things we have never done before. We can begin by changing our teaching style, finding an innovative way of presenting a concept, exploring a thematic approach to our material, working with another professional, or developing an idea in as many directions as possible.

As both teachers and students, we need to free our thinking and make ourselves open to new possibilities. We will soon realize the benefits of such openness as we experience a new sense of freedom and enthusiasm. *Remember: Fully engaged minds are not bored, nor are they constrained by educational structures.*

ENCOURAGE STUDENTS TO TAKE RISKS.

Following the practices listed below will help.

• Provide students with time to reflect, brainstorm, and ask questions as each new concept is presented.
• Encourage students to change their perspective and eliminate preconceived ideas. Have students take the concept and look at it from different angles. Mentally turn it upside down and see what changes.
• Remind students not to accept their first idea without exploring other options.

When they reach a potential "stopping place" in their project, suggest they continue developing and evolving their work.
• Reassure students and validate varied and diverse solutions.

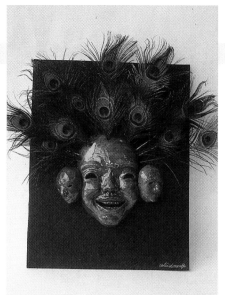

Alerica's symbolic self-portrait represented parts of her personality. See page 75 for a complete description of the project.

Alerica Lattanzio, grade 10. Glazed ceramic fired mask with peacock feathers, life-size.

WHAT CAN CREATE A BRIDGE BETWEEN CULTURES?

WHO CAN BE A DIPLOMAT?

WHAT IS DIPLOMACY?

Ask provocative questions to stimulate thinking and open doors to visual possibilities. Project details are on page 102.

When change is required, the artist/teacher must boldly pursue it, rather than let the subtle pressures of conformity prevent risk taking. We should never outgrow our sense of curiosity—curiosity motivates us to learn new skills and expect the unexpected. Staying fresh and alive as an artist and as a teacher can produce profound results.

Be Resourceful

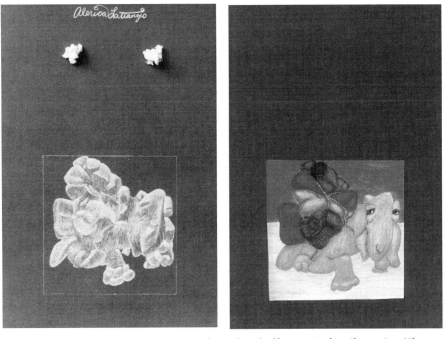

Simple popcorn can become an engaging subject for study and self-expression (see Chapter 2, p. 25) Alerica Lattanzio, grade 11. White charcoal pencil and colored pencil, 6" x 6" (15.2 x 15.2 cm).

Another quality that goes hand in hand with risk taking is resourcefulness. When we have a great idea we need to devise a way to make it happen. It is important to not give up or find excuses as to why a certain idea can't be actualized, whether the idea concerns acquiring new materials, establishing places to exhibit student work, finding available funding through grants, or completing a visual project.

The perpetual inadequacy of budgets adds to the importance of teacher resourcefulness. We need to nurture our native resourcefulness and remain open as we consider materials that support creative thinking and our art programs.

This can also be applied to locating and applying for grants. We need to be resourceful researchers and maintain a clear understanding of the purpose of the grant. Make the effort; if you never write a grant proposal you miss the chance of ever receiving a grant.

Include Reflective Writing

Evaluating student work requires that we develop fair and consistent standards. Quality verbal feedback and rubrics are important. Nongraded reflective writing assigned as the project progresses or when it is completed, can also provide the teacher with considerable insight into what students have learned.

Encourage students to articulate their thinking process and reflect on what they have learned. To do this, ask students to answer three to four well-constructed, open-ended questions about the process as it relates to specific projects. Have students determine the length of their answers. Often students exhibit amazing depth in their thinking and learning. Experiencing insights is an important part of most creative problem-solving projects.

The chapters that follow offer concrete and varied approaches to visual problem solving and are intended to spark thinking, enhance understanding of the process, and guide teachers as we devise creative challenges for our students. In all instances the intent is to open doors so that as artists/teachers we can more effectively encourage growth and creativity in both our students and ourselves.

Heather's portrait of F. Nietzsche uses reflective writing as part of the composition. This writing becomes a textural element as she reflects on Nietzsche's philosophy and her response.

Heather Freeman, grade 12. Pen and ink, 16" x 16" (40.6 x 40.6 cm).

This symmetrical design engages the viewer in the use of negative space. Beads surround the slide form. The experience included reflective writing as a component—for details see page 30.

Alerica Lattanzio, grade 10. Mixed media, 2" x 2" (5 x 5 cm).

Translating the Ordinary to Extraordinary

How do we inspire our students, encourage their creativity, and, at the same time, increase their skill levels? One way is to teach students to transform ordinary objects into extraordinary works of art.

With the focus on developing thinking skills, students progress from a basic knowledge of the subject to an awareness of the many ways a given visual problem might be solved. Students apply this knowledge as they brainstorm possible solutions. Students then decide which idea presents the most potential. This process encourages students to engage in innovative thinking and to take risks by making independent decisions. Students analyze all aspects of their idea before and during the production stage. At times they will require feedback from the teacher or other students and perhaps need to rework their project. In the end, they are ready to evaluate their solutions to the visual problem using rubrics, verbal feedback, and group critique.

The projects presented in this chapter provide students with a visual problem that will help them view and then transform everyday objects into artistic expressions. Emphasis on creativity and higher-order thinking skills such as analysis, synthesis, and evaluation motivates students and builds recall and comprehension skills as well.

Each project has the following two objectives: first, to motivate students to explore new possibilities and take the risks necessary to transform an object in an innovative manner; and second, to empower students to engage in creative and critical thinking by incorporating decision making as an integral part of the process.

Students choose the media they will use for the three-dimensional projects. Two-dimensional projects are included to increase students' skill levels in the use of either watercolor or colored pencil. Craftsmanship and creativity can be assessed through a rubric provided on page 34. Time frames given are based on 42-minute class periods.

Jennifer Chen, grade 10. Watercolor, felt-tip marker, 24" x 18" (61 x 46 cm).

 # Coffee Mugs

INSPIRATION

The first project began with simple coffee mugs. How could art students be inspired to transform them into something unique? I was inspired to do this project because I sensed the potential of inexpensive white ceramic mugs to increase student creativity.

PROBLEM

Students will innovatively transform an ordinary mug into something extraordinary. They will discover potential for transformation by seeing the mug in a new context.

TIME FRAME

Two concentrated weeks. (Students had to work at home in order to complete this project in two weeks. An additional three days would have been more workable.)

MATERIALS

• newsprint
• acrylic paint
• five-minute epoxy
• plaster-coated gauze

(Students provided additional materials such as colored feathers or various spray paints as needed to develop their idea.)

STARTUP

Wrap each mug in blank newsprint paper to disguise its identity. Place the wrapped package in

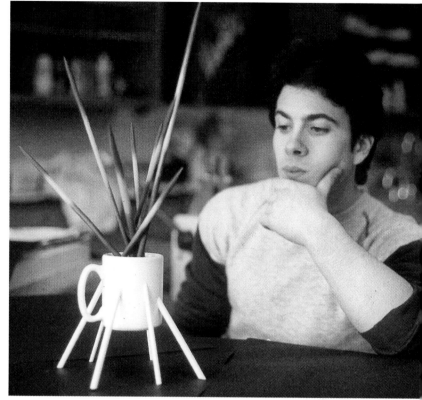

Damon saw the object as something that transforms. The concept was that as beams of light pass through the form they create a prismatic effect.

Damon Dilluvio, grade 12. Mixed media (wood dowels, acrylic paint), 15" x 6" x 5" (38.1 x 15.2 x 12.7 cm).

front of each student, but tell students not to touch it. At this point you do not want students to feel the weight, identify the handle, or start guessing the contents of the package. Suggest that students focus on the interesting folds of paper and the overall visual form of the object in its wrapped state. Remind students that they might find the enclosed object rather boring once revealed.

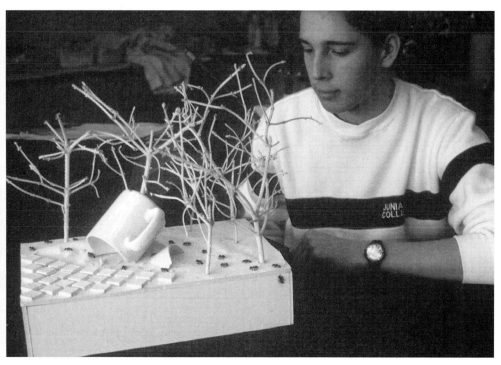

A monumental cup impedes the march of ants in this fantasy garden.
Jeff Tunkell, grade 10. Mixed media, 12" x 10" x 10" (30.5 x 25.4 x 25.4 cm).

PROCESS

Critical thinking begins when the mugs are unwrapped. Have students brainstorm ideas and decide what materials they need to bring these ideas to fruition. Ask: "Has anyone ever seen a work of art that used everyday objects?" One example is Pablo Picasso's *Bull's Head* made out of a set of handlebars and a bike seat. Other examples include the work of artists Jim Dine and Robert Rauschenberg, both of whom use everyday objects in their work. The goal is for students to be imaginative in their own work and find expressive solutions to the problem. The teacher's role in this process is to motivate—validating student ideas, fielding questions on the use of media, and supporting student expression. Stress the importance of well-crafted images and presentation. For example, remind students to make sure that bonding materials do not show on surfaces.

CHOICES

• media
• size
• development of subject

EVALUATION

Have students consider their creative process. Ask: "What was the most difficult aspect of integrating the mug into your work of art?" "How many ideas did you generate before beginning your final piece?" "How well did you bring together the various materials you used?" See also the rubric on page 34, which provides a useful tool for evaluating craftsmanship and creativity.

RESULTS/OBSERVATIONS

I am a firm believer in the concept that if you can surprise yourself you will surprise others. For this reason, I encouraged my students' creativity and applauded the surprises their ideas generated both in terms of their thinking processes and the work itself.

CONCLUSION

Throughout the project there was evidence of strong student learning and shared enthusiasm. Results were diverse and innovative. For me, this project was a first step toward broadening my way of thinking and teaching creative problem solving.

Soda Cans

INSPIRATION

Does the concept and practice of recycling have any influence on student creativity? The motivation for this project came from my desire to recycle a large quantity of aluminum soda cans that were being discarded by the school store. In a desire to connect art and science, I narrowed the focus of the visual research to a single subject with vast variety—insects.

PROBLEM

The students will use one or more aluminum soda cans to create a "never-before-seen-by-human-eyes, fantastically creative insect." Explain that craftsmanship is a concern, both aesthetically and structurally. The insect must be strong enough to be dropped without breaking.

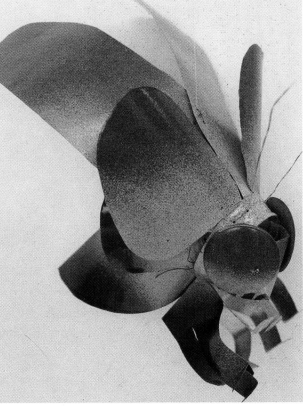

J. J.'s solution to the problem was to first establish a strong visual form before applying spray paint as a unifying element.

J. J. Balestrieri, grade 10. Soda can and spray paint, 5" x 6" x 5" (12.7 x 15.2 x 12.7 cm).

TIME FRAME

Two weeks.

MATERIALS

- scissors
- compass
- five-minute epoxy
- fine wire
- nylon fishing line

STARTUP

Collect empty aluminum soda cans from the school store or have students bring cans from home. Explain that as artists we see and find inspiration in nature, with its variety of complex forms. Display visual images of insect forms gathered from the school science department or library, or Internet search. Share with students basic information about insects (insects have six legs, three body parts, two sets of wings).

PROCESS

Have students develop a preliminary sketch of their idea. Distribute the cans as needed. Encourage students to destroy, mangle, cut, and mutilate the cans. Caution them to

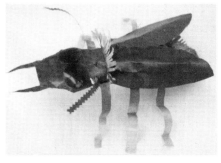

Evan folded, bent, and twisted various cans to create a strong form which captures the structure of the insect. He spray painted each surface before assembling the sculpture.

Evan Dilluvio, grade 10. Soda cans and spray paint, 5" x 10" x 5" (12.7 x 25.4 x 12.7 cm).

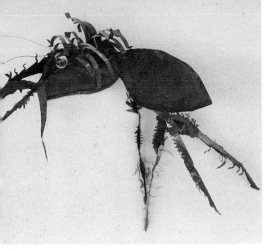

Heather responded by creating a diverse textural form which captures an aggressive quality.

Heather Freeman, grade 9. Soda can and spray paint, 9" x 11" x 3" (22.9 x 28 x 7.6 cm).

handle sharp-edged pieces with care. Suggest that students think about overall form, color, and size as their work progresses. Remind them that the aim is to draw the viewer into the sculpture's unique complexity. Use fine wire along with five-minute epoxy to connect the cans. To do this, poke a compass point through each can, tie the individual cans together, and then glue. Students can use other materials if desired as long as the major portion of the three-dimensional structure is aluminum.

CHOICES

- form
- changing the shape or color of the can
- adding other materials
- overall size

EVALUATION

Have students review their creative process. Ask: "Did you maintain the basic form of the insect including wings, body parts, and legs?" "What did you learn about the form of insects?" "Did you change the color or leave the soda cans their original color?" "Why?" "How well is your insect constructed?" Can it be dropped without breaking?" See also the rubric on page 34.

RESULTS/OBSERVATIONS

As they observed insects, students were impressed by their variety, color, and shapes. This variety gave students a sense of freedom and encouraged choice and expression. Students produced diverse sculptures, bold and varied in size. The project prompted students to see the potential of using recycled materials for other art projects.

CONCLUSION

This three-dimensional visual problem thoroughly engaged students. We displayed their finished sculptures in a large glass showcase, using nylon fishing line so that sculptures would appear to be suspended in space. It proved an eye-catching, conversation-starting display.

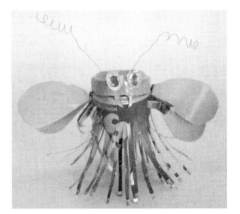

Christine shared a sense of whimsy in this outer space image. She also retained the honesty of the materials by not completely covering the soda can.

Christine Kallens, grade 10. Soda can and spray paint, 6" x 10" x 3" (15.2 x 25.4 x 7.6 cm).

Doorknobs

INSPIRATION

A quantity of new brass doorknobs donated by a local company led me to think about and develop this project. Students were asked: "How can a doorknob become a work of art or be integrated into a work of art?" The project can be approached on a variety of levels, one of which invites students to work with metaphors.

PROBLEM

Students will devise a way to utilize and integrate a doorknob into a three-dimensional work of art. They should either metamorphose the object, changing it into an entirely different object, or they should use the doorknob as a symbol and develop a metaphorical artwork.

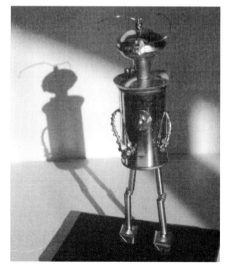

Todd utilized new and recycled metal to create his version of the tin man. The fact that all his materials were shiny added to the sculpture's unity.

Todd Larosa, grade 10. Mixed media, 9" x 4" x 3" (22.9 x 10.2 x 7.62 cm).

TIME FRAME

Each student is given two weeks at home to think, plan, gather materials, and begin. Plan for two hours of class time to finalize the image and complete the project.

MATERIALS

• doorknobs, one per student
• papier-mâché
• sheet metal
• brass rods
• copper foil sheets
• glue guns, wood glue, and five-minute epoxy

STARTUP

Explain that doors can be seen as metaphors for openings, new beginnings, or divisions of space. Ask students how doorknobs might be used artistically to express such metaphors. Display one of the doorknobs and inform students they will use it to create a work of art. Encourage students to explore many directions in order to produce varied results. Ask questions such as: "How can you make a doorknob look like something it's not?" "Does the shape of the doorknob remind you of anything else?" "How could this evolve into a child's toy?" "What materials could you add or subtract in order to create a wearable piece of jewelry from this doorknob?" Posing varied questions will direct students' thinking and engage their imaginations.

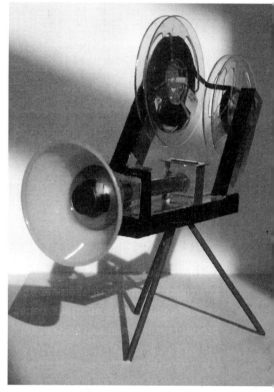

Jason applied his strong interest in filmmaking to create this camera sculpture.

Jason Saro, grade 12. Mixed media, 12" x 5" x 12" (30.5 x 12.7 x 30.5 cm).

During the planning and development stage, doorknobs were placed in an empty glass showcase near the artroom, with a large sign that asked the question: "Given two weeks, what could you do to make a doorknob into a work of art?" The aim was to engage non-art students in the thinking process. Some students stopped in the artroom, took advantage of the offer, and tried the assignment.

PROCESS

Distribute one doorknob per person. Have students brainstorm many ideas before making a final decision as to what they will create. Students should keep their decisions to themselves and begin work by developing preliminary sketches of their ideas. Suggest that they plan their materials and ask questions on the use of media. To facilitate problem solving, circulate among students as they sketch, offering individual guidance. Encourage exploration of media and tools such as soldering guns and different types of glues. Inform or remind students of Picasso's observation: "For every act of creation first comes an act of destruction." Students should freely manipulate the original form.

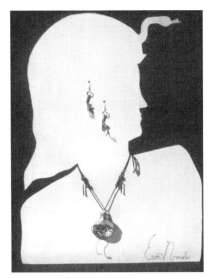

Erin chose to cut the doorknob and use its pieces to make wearable jewelry. She enhanced the presentation of necklace and earrings by mounting them on foam core board.

Erin Normile, grade 9. Mixed media, 18" long (45.7 cm) necklace.

CHOICES

- subject
- overall size
- media: papier-mâché, metal sheets or rods

EVALUATION

Have students present their work and reflect on their process, personal decision making, and level of satisfaction with what they created. Ask: "How did you come up with your idea?" "What was the most challenging aspect of this project?" "Would you make any additional changes now that you are finished?" "How satisfied are you with what you produced?" See also the rubric on page 34.

RESULTS/OBSERVATIONS

By keeping their ideas confidential during the planning and material-gathering stages, students added an element of surprise to their final creation. Some explored sawing, bending, and twisting the metal and other materials. Others learned to use tools and materials with which they were previously unfamiliar. Their diverse solutions included birds, insects, and other animals. A few utilitarian objects were created such as a baby rattle and a desk lamp.

CONCLUSION

In the end, some students' work reflected intellectual responses while others employed humor in their solutions to the problem.

Erica incorporated linear and solid material, and a variety of media, to create this potted flower.

Erica R. Emerson, grade 12. Mixed media, 15" x 12" x 6" (38.1 x 30.5 x 15.2 cm).

Using an object as ordinary as a doorknob as a jumping-off point worked well because students felt free to alter its form and purpose. Students shared with each other insights about their process of creating. In addition, they surprised each other with their creations.

Hopefully, this project will help both students and the artist/teacher to see the artistic potential of using everyday objects in a new and creative context. Whether or not you can secure a quantity of doorknobs is not important; what is important is to be open to the possibilities of what you do have. If a local manufacturer offers you a quantity of leftover extruded plastic parts, accept them graciously, and then begin to ponder their creative potential.

No. 2 Pencils

INSPIRATION

Any object that is seen or used on a regular basis begins to go unnoticed. What we stop seeing is the form, color, or the object's visual properties. For years, students in public schools have used No. 2 pencils. The pencils are handled daily throughout the United States. They are indeed an ordinary, everyday object. I became curious about what art students might develop by building a two-dimensional image using pencil shapes and colors.

PROBLEM

Students will study pencils, transform them, and learn to see No. 2 pencils in a new way. They will maintain the color of the traditional pencil: yellow, with black lettering and a pink eraser.

MATERIALS

• No. 2 pencils for reference, one per student
• 12" x 18" white drawing paper
• watercolors or colored pencils
• black markers, fine-tipped (optional)

STARTUP

Distribute No. 2 pencils and paper. Have students look carefully at the pencils, then brainstorm a subject category to work within. Categories might include people, cars, insects, sports, or violins. Have them plan a drawing of the subject.

PROCESS

Ask students to develop a contour line drawing, and then fill the interior space of the drawing with pencil images. Encourage them to stretch, condense, curve, or otherwise transform the pencil shapes. Students also might make use of pattern, value, and size.

CHOICES

• subject category
• media: watercolors or colored pencils
• treatment of pencil images within the drawing

Herbert's fierce mythological creature utilizes fantasy to view the subject in a new way.

Herbert Li, grade 10. Colored pencil, 12" x 18" (30.5 x 45.7 cm).

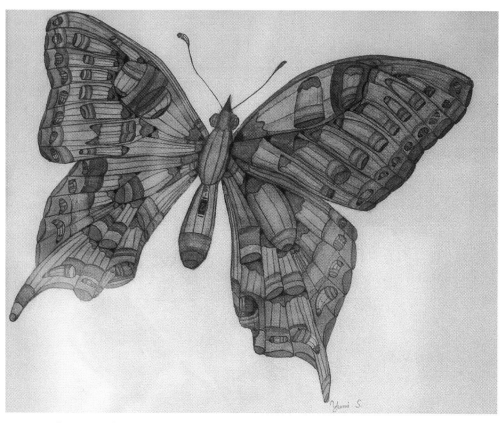

Yumi chose watercolor to blend and repeat numerous pencil images to create her subject.
Yumi Shibatani, grade 12. Watercolor, 12" x 18" (30.5 x 45.7 cm).

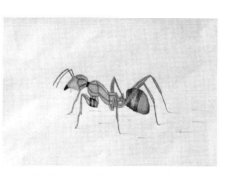

Successful distortion of the pencil creates this walking ant.

Dan Fiori, grade 10. Colored pencil, 12" x 18" (30.5 x 45.7 cm).

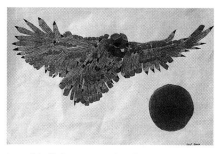

An owl in flight was completed using multiple images of the pencil. The sun is represented by the end of the eraser.

Julie Huang, grade 12. Colored pencil, 12" x 18" (30.5 x 45.7 cm).

EVALUATION

Ask students to think about the transformation process and reflect on what they learned as a result of engaging in the process. Ask: "How did you decide on your subject?" "How many pencil images did you use to develop that subject?" "Do you see the potential for using other everyday tools or objects for expressive purposes?" See also the rubric on page 34.

RESULTS/OBSERVATIONS

Students found this relatively simple project challenging and produced diverse and creative solutions. Students' completed work showed both variety (no two solutions were the same) and skill. The results showed that students had used higher-level thinking skills, increased their visual awareness, and enhanced their creative capabilities.

CONCLUSION

As teachers, we need to encourage our students to become more visually aware. We can help our students develop their visual memory and thus enable them to use images to enhance their creativity. As Woodrow Wilson stated, "Creativity is seeing something everyone else sees but with a fresh pair of eyes." His thought certainly applies here.

Popcorn: Seen as Abstract, Viewed with Imagination

INSPIRATION

As children, we have all looked at clouds and seen imagery in their forms. We know that different people perceive vastly different images in clouds. The inspiration for looking at popcorn creatively came as I viewed the work of a fellow artist. The artist's work made me see popcorn as an abstract object. The artist used white chalk on black paper to illustrate an exploded kernel of popcorn. At first a series of objects such as flowers, clouds, and budding leaves suggested themselves to me as possible inspirations for the drawing. Suddenly, its true identity became apparent. Intrigued with my varied interpretations, I began to wonder and plan how my students might be able to work with similar common objects in abstract terms.

PROBLEM

Students will first develop an observational image of popcorn and then creatively view this image. Students will then develop a second, new image out of what they see emerging from their first drawing. For this part of the process, suggest that students look at their drawings as they might look at clouds. Ask them: "What images do you see in your drawing?"

Remind students that their viewers will need to see a clear connection between their first drawing and the image developed from that drawing.

TIME FRAME

Two and one-half weeks.

MATERIALS

- 10" x 15" dark gray illustration board
- popcorn (popped)
- white glue to adhere the popcorn
- white charcoal pencils
- 9" x 12" white drawing paper
- colored pencils
- tracing paper

STARTUP

Pop the popcorn prior to class to avoid the lingering smell of fresh popcorn. (You want students to focus on drawing rather than eating.) Cover a large tray with black paper and spread out approximately forty kernels of popped corn for student selection. This will also help students refocus their view of popcorn and see the kernels as objects to be observed rather than eaten.

By adding stems to the two day lilies that emerged from her first image, Stephanie solved the problem. Stephanie Johnson, grade 12. White charcoal pencil and colored pencil, 6" x 6" (15.2 x 15.2 cm).

PROCESS

Part I

Students begin the study with a drawn image of popcorn. Distribute the dark gray illustration board and have students choose two to three pieces of popped popcorn for observational drawing. Then have them glue the popcorn to one end of the illustration board using white glue. At the opposite end, have them establish a 6" square for their drawing. This will leave a 2" border. Remind students of the importance of keeping the white charcoal pencil sharp. Demonstrate for students hatching and cross-hatching techniques.

Students accustomed to shading with graphite pencils will soon realize they are engaging in the opposite process when they use white charcoal pencils. The artist uses graphite pencils to develop dark values or shadow areas. Working with white pencils increases or emphasizes the brightest areas, leaving the darker gray board showing for the shadow areas. As students progress they will notice that their drawings do not resemble their preconceived ideas about what popcorn should look like. Thus, students begin to see an abstract quality in their work and the work of other students.

Pin students' work onto a large display board. This will give students an opportunity to see their classmates' work and reassure them

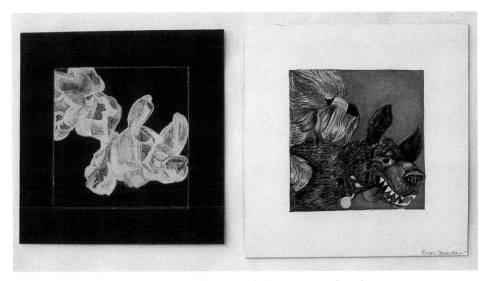

Regan solved the problem with movement and energy. As her image emerges from the popcorn, we see two dogs chasing one another.
Regan MacKay, grade 11. White charcoal pencil and colored pencil, 6" x 6" (15.2 x 15.2 cm).

they are not alone in their perceptions. At this point have students discuss what they think their popcorn really looks like. In the same way that images emerge from clouds, images will start to emerge from their white drawings. Discussion among students will become animated and enthusiastic. Seize this creative energy, and quickly introduce the second part of the project.

Part II

Instruct students to view their first drawing from all sides, even upside down, in order to see what images might emerge. Have students select what they feel is the strongest image and do a color interpretation of it. The size, a 6" square, stays the same for visual consistency. Have them complete Part II on white drawing paper using colored pencils. Students begin by using

tracing paper to trace the major compositional lines from their first white drawing and transfer that information to the white drawing paper. After the information is transferred, students can begin their interpretation.

There are two important aspects of this part of the project. The first is that the two drawings are to be viewed together. In this way, the image students see in their work the viewer will also see. In other words, the relationship between the white drawing and the color drawing has to be clear. The second is that color has to be mixed and made part of the overall 6" square. Students have the freedom to alter or add to the developed color image. For example, stems could be added to flowers, or bodies to heads. Cartoons are also acceptable.

CHOICES

- collaborating with other students to decide which image they will develop in their second drawing
- use of expressive color (part II)
- altering or adding to the developed color image

EVALUATION

Students share their successes in this project through verbal critique. Ask: "In the first image, did the media present difficulties?" "For those who struggled with the second image, what helped to resolve your conflict?" "What was the most challenging aspect of your work?" "What other subjects could be handled in the same way?" See also the rubric on page 34.

RESULTS/OBSERVATIONS

Lively discussions evolved as students looked at their own image and the images others created. In a collaborative spirit, students exchanged ideas and made suggestions about each other's work. Making the transition from white on black to mixed color enhanced students' technical skills and their ability to execute ideas. Students' second drawing was exhibited, along with the popcorn and their initial study, for public viewing. This display of each student's process of study had a very positive impact on the viewer response.

CONCLUSION

When we, as artist/teachers, progress from observation to expression and creativity, we inspire our students to do the same. Something as small and insignificant as popcorn can be the catalyst for such an experience. Students saw varied images in the popcorn, such as skiers, flowers, cartoon characters, and mythological characters. What was helpful and even amusing were instances of students offering their opinions concerning what they saw in another student's first drawing. The cooperative spirit and playfulness the project elicited made it fun. As a result of this experience, the way students view popcorn, like clouds, will never be quite the same.

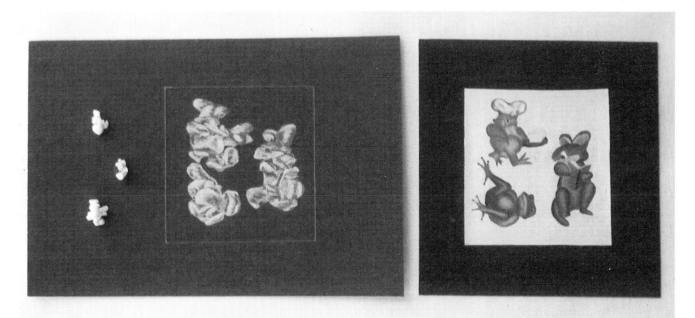

Kristin looked to cartooning to resolve her individual problem. The three storybook characters are seen from three different directions.
Kristin Olson, grade 11. White charcoal pencil and colored pencil, 6" x 6" (15.2 x 15.2 cm).

Artroom Tools and Keys

INSPIRATION

Part of our responsibility as teachers is organizing our art materials. As I was doing this routine activity, I was struck by how often we take color for granted and how color can change the way we see the world. Students can illustrate the power and life that color adds to ordinary objects.

PROBLEM

Students will transform an art tool or set of keys into something visually striking through enlargement and the use of mixed color.

TIME FRAME

Two weeks.

MATERIALS

• 18" x 24" white drawing paper
• watercolor paints
• fine-line black markers
• 15" x 20" illustration board
• colored pencils

STARTUP

Have beginning-level (Art I) students select an artroom tool in which color is not a significant aspect, such as paper clips, pushpins, safety pins, scissors, a paper punch, or a compass. Advanced-level students will explore creative color using their own house or car keys. Both levels will begin by producing enlarged contour line drawings of the subject.

PROCESS

Art Tools

Ask Art I students to draw in contour line an enlargement of one of the objects they selected. They can decide on the placement and size of the object, with their only restriction being that the subject be drawn completely within the confines of the paper. Have them draw the object three times in pencil on an 18" x 24" sheet of white drawing paper. Next, have students mix watercolor and begin painting within each shape. At least one of the objects has to be painted using the whole range of color in the spectrum. The use of color in the two other objects is optional. Suggest that students use warm colors, cool colors, or complementary colors to develop their forms.

At this point, to add to the complexity of the compositions, have students draw their chosen subject three more times. Have them paint these three additional drawings in a gray value scale. The idea is to repeat the subject and give the impression that the objects developed in gray recede to a lower level. This can be partially achieved by having the color objects appear to be overlapping the gray value ones. Have students consider how intensely they will apply the watercolor medium both in color and gray values. The

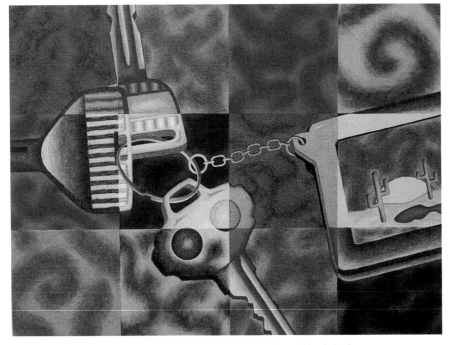

An advanced-level student created a strong image by expressive use of blended colors.
Jeremy Kirsh, grade 11. Colored pencil, 15" x 20" (38.1 x 51 cm).

contrast of the color and the gray will add to the overall unity of each piece. A fine-line black marker defines the edges of the final work.

Keys

Have advanced-level students use a simple set of car keys or house keys as their subject. They, too, will use these everyday objects as a jumping-off point for developing a strong composition with creative use of mixed color. Students begin with an enlargement of the subject drawn in contour line on illustration board. Over the enlargement, have students draw a grid of 2" squares, thus dividing the subject. This division will encourage a more experimental use of color mixing and blending. Tell students to choose either colored pencils or watercolor as their medium. Encourage students to examine and be aware of the colors they place next to each other in the grid. Encourage mixing and blending between the squares.

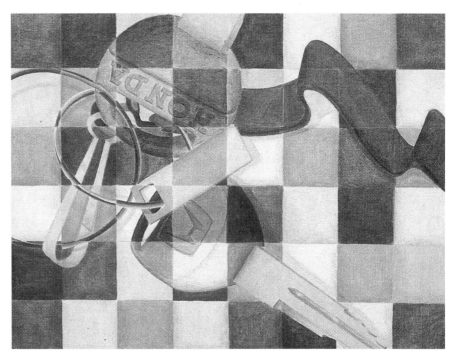

Chris created visual rhythm by repeating colors.
Chris Campbell, grade 11. Colored pencil, 15" x 20" (38.1 x 51 cm).

Michelle created strong rhythm in this composition through the repetition of oval openings seen in the scissor handles.

Michelle DiDonato, grade 10. Watercolor, felt-tip marker, 18" x 24" (45.72 x 61 cm).

CHOICES

- subject and composition
- media: colored pencils or watercolors

EVALUATION

Encourage students to discuss their creative process. Ask: "Can you see the objects in the gray value study as visually receding, while the color attracts attention and moves forward?" "What have you learned about color and mixing color?" "How can you apply what you have learned to other artistic expressions?" See also the rubric on page 34.

RESULTS/OBSERVATIONS

The variety of solutions that students devised were directly related to their selection of subject, overall composition, and application of the medium. On the Art I level, the contrast between the color and the gray values helped the students understand how color can give life to even the dullest subjects. It also increased their understanding of how value study can add depth and dimension. On the advanced level, students were given permission to explore fully color and color mixing. Their use of color and design added to the expressiveness of their work.

CONCLUSION

This project presents small everyday objects in a new and original context. On both levels, students use simple objects (artroom tools or keys) to develop clear, bold images. The project encourages students to appreciate the important role color plays in our perception of the world.

35mm Slides

INSPIRATION

As artist/teachers, we are always open to developing new projects from materials considered unusable. There are reasons for this phenomenon. Art materials are costly, teachers work on restricted budgets, and humans can be wasteful. Creative people also see in all materials (new or used) the potential for producing works of art.

The idea for this project came as a result of my encountering some old, unusable 35mm slides. When student work is photographed for use in a publication or portfolio, one or two slides from each roll of film are usually developed as solid black. I had stored these slides in my desk. One day I happened to take one out and draw on it with a silver metallic pen. I then realized the potential of using discarded 35mm slides to develop a visual problem.

PROBLEM

Students will create miniature works of art from discarded slides. Students will be empowered to take risks and focus on their process through the simultaneous development of several slide-originated artworks. The finished image will be made into wearable jewelry by adding a pin back.

TIME FRAME

Two weeks.

This low level relief, using copper to represent the sun, shows unity in its expression, yet maintains the integrity of the slide.

Lynn Winningham, grade 10. Mixed media, 2" x 2" (5.1 x 5.1 cm).

MATERIALS

• slides, three or four per student
• variety of drawing and painting materials (colored pencils, pen and ink, markers, colored chalk, acrylic paint, watercolors)
• five-minute epoxy
• pin backs
• illustration board, 5" square

STARTUP

If necessary, ask students to bring discarded slides from home. The slides may have either cardboard or plastic mounts. Distribute three slides and an envelope (for storage between classes) to each student. Encourage students to think about being very experimental with media. The small scale of the work lends itself to experimentation—large investments of time or materials are not an issue.

PROCESS

Explain that students should maintain the basic integrity of the slide; at the same time, they should feel free to change all aspects of the slide's structure. In other words, parts of the slide can be destroyed or added to, provided the viewer can identify the work as having originated from a slide. Materials can be added to and even extended beyond the slide.

Ask students to present their works-in-progress, choose one to be finished, and present that one later for evaluation. The final work can be presented by attaching a pin back with epoxy. The pin is then mounted onto a piece of illustration board for display.

The subject seems to peer through the opening, engaging the viewer. Regan's interest in animals inspired her to solve the problem.

Regan MacKay, grade 11. Colored pencil, 2" x 2" (5.1 x 5.1 cm).

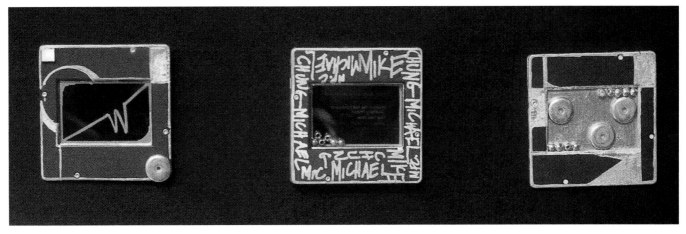

Visual consistency is the result of creating high-tech images in black, white, and silver pens. Michael P. Chung, grade 12. Mixed media, 2" x 2" (5.1 x 5.1 cm) each.

CHOICES

- media
- which of several ideas to complete
- whether to use the slide film, mount, or both

EVALUATION

Have students consider their creative process through reflective writing. Ask: "What was it like to work on more than one idea at a time?" "How did you make a decision about which slide to finish?" "What media did you use and why?" "What were the visual consistencies in the work you produced?" The rubric on page 34 provides additional guidelines for evaluation.

RESULTS/OBSERVATIONS

Students' reflective writing revealed their successes and difficulties. Many students noticed that working on multiple images allowed for greater creativity, experimentation, and risk taking. Some students found a totally open choice of media to be a challenge. Some resolved this difficulty by using one medium and applying that medium to their entire series of slides. In this way, they could focus on exploring ideas other than media choice. Students' work was displayed on 5" square colored illustration board. In the end, many students choose to develop two slide pins to the final presentation stage.

CONCLUSION

This project focused on working small and developing a series of ideas that resulted in successful and creative solutions. Students produced diverse results and experimented with a wide range of techniques and materials. Students' small yet striking images were placed on a large foam core panel in a glass showcase.

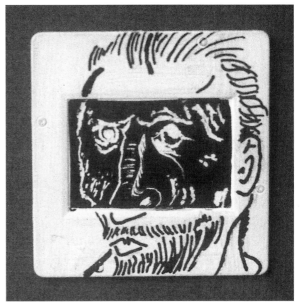

This image evolved as Dan looked at both the white and black areas of the slide. His linear portrait of Vincent van Gogh exhibits balance.

Dan Scott. grade 10. Mixed media 2" x 2" (5.1 x 5.1 cm).

Creative Food

INSPIRATION

What began as a simple homework assignment evolved into a thought-provoking visual problem that gave students considerable freedom of expression. Students were asked to think about the concept of "breakfast" and draw it as a still life. As they handed in their work, I noticed that two or three students had decided to take some artistic license and create new kinds of images. Their work elicited a positive response from both me and their classmates. One student had created a Surrealist plate of brightly colored insects, and another an image of floating Volkswagen cars that looked like a bowl of toasted oat cereal. It was the responses of these students to the original homework assignment that inspired the Creative Food project.

PROBLEM

Students will see the subject of food as a concept to be explored imaginatively, and then invent a new way of representing food artistically. Their images can be either two- or three-dimensional. Each image is to include a plate, tableware, something to drink, and perhaps a napkin.

TIME FRAME

Two weeks.

MATERIALS

• a variety of drawing and painting materials and sculptural materials
• 15" x 20" illustration board
• 12" x 18" white drawing paper

STARTUP

Introduce students to the Surrealist art style that juxtaposes normally unrelated objects in a realistic manner. Inform students they have permission to alter the characteristics of the subject matter they select. Show as an example René Magritte's *The Castle of the Pyrenees* (1959) in which he turns varied subject matter into stone. Follow this by suggesting possible themes, such as an architectural lunch, a musical dinner, a gardener's break, an artistic snack, or a sports meal.

PROCESS

Ask students: "What makes food appealing?" "What are some creative ways to view food?" "How can you create a strong composition with visual interest?" Encourage students to explore many ideas before making a final decision. Then ask: "How can you create an image about food that is imaginative?" Have students choose a compositional point of view—such as looking down or at an angle, as though one were sitting at a table—that will make the subject easy to identify. The viewer should be able to "read" the image immediately as a table setting. Students choosing to work in three dimensions should use the size of a typical table setting as a way to assure visual readability.

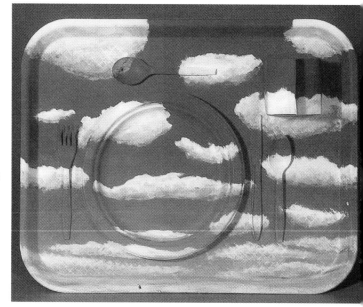

Dan chose to reflect on Surrealism in response to the problem.

Dan Fiori, grade 12.
Magritte School Lunch.
**Mixed media,
4" x 18" x 15" (10.2 x 45.7 x 38.1 cm).**

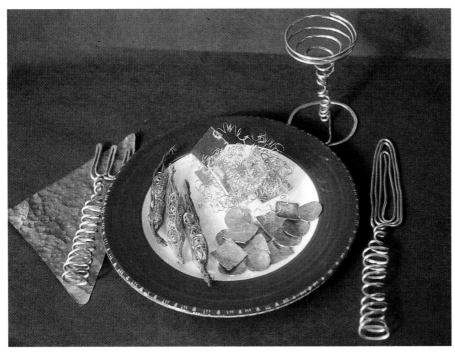

Sarah utilized a ceramic plate, wire, copper, brass, and mirrors to create this sculptural meal. She cut, pounded, and manipulated the metal to form the main ingredients.

Sarah Sheber, grade 10. Mixed media, 6" x 18" x 15" (15.2 x 45.7 x 38.1 cm).

RESULTS/OBSERVATIONS

The responses of teachers and students to their exhibited work validated students and their imaginative creations. Students' work showed high skill levels and attention to detail.

CONCLUSION

Since we all can relate to food as a subject, asking students to look at food in a new way inspires their creativity. Having students use the table setting as a viewpoint gives the assignment just enough structure, while saving it from being too restrictive. The image remained visually readable and always included the elements of a plate and tableware. This visual structure helps to draw the viewer into the creative subject matter. As they searched for imaginative ways to explore the subject, students experienced freedom and were incredibly expressive.

VISUAL RESOURCES

- Works by Italian artist Giuseppe Arcimboldo: *Summer*, a 1575 Renaissance portrait of a man made up of fruit and vegetables; also *Portrait of Rudolf II as Vertumnus.*
- The work of Surrealists such as Salvador Dali and René Magritte

CHOICES

- media
- overall size
- subject development
- point of view
- working in two or three dimensions

EVALUATION

Have students reflect verbally on the creative process. Ask: "How did you first decide what your image was going to be?" "What makes your creative food appealing?" "What was the most difficult aspect of your project?" "How did you overcome that difficulty?" Have students pick another student's work and discuss why it is artistically successful. See also the rubric on page 34.

Chris, motivated by his passion for architecture, skillfully integrated a table setting and food into an architectural building form.

Chris Campbell, grade 12. Colored pencil, 15" x 20" (38.1 x 51 cm).

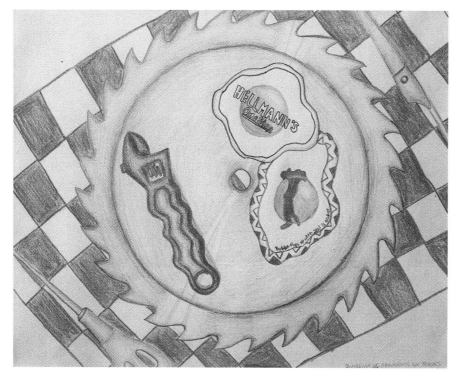

Seeing food in a creative way, Michelle developed her image using a circular saw blade for the plate, metal jar lids as eggs, and a wrench for bacon. An awl and broken scissor finish the table setting.

Michelle Baker, grade 10. Colored pencil, 12" x 18" (30.5 x 45.7 cm).

Creativity:

1 Novice and restricted approach to developing the idea with no evidence of risk taking.

2 Improved thinking and expression in development of creative idea, but with limited risk taking.

3 Competent development in expression of creative idea with increased attempt at risk taking.

4 Excellent approach to original thinking and expression, with evidence of risk taking.

5 Refined and sophisticated approach to original and unique expression with a high degree of risk taking.

Effort:

Additional points can be added for time on the task (evident by observing students' use of daily class time) and for creative effort (defined as the degree to which an idea was developed).

Craftsmanship:

1 Novice understanding and application of artistic qualities: line, color, texture, and balance in the use of materials.

2 Improved understanding and application of artistic qualities: line, color, texture, and balance in the use of materials. Little attention to detail.

3 Competent understanding and application of artistic qualities: line, color, texture, and balance in the use of materials. Adequate attention to detail.

4 Excellent understanding and application of artistic qualities: line, color, texture, and balance in the use of materials. Good attention to detail.

5 Refined and sophisticated understanding and application of artistic qualities: line, color, texture, and balance in the use of materials. Extreme attention to detail.

Thoughts on Transformation

THOUGHTS ON TRANSFORMATION

This chapter presents just a few ideas for viewing ordinary objects in new ways. The primary goal of these visual problem-solving projects is to inspire thinking in both teacher and students. Students are encouraged to be risk takers and decision makers in regard to their work. Risk taking benefits both teacher and students and adds to the curriculum the refreshing element of surprise.

Projects lasted an average of two weeks (ten class periods, each forty-two minutes in length)—a time frame that gave students enough time to think, make decisions, and plan. When necessary, students completed their work at home. Because the time frame was tight, studio time was well spent. For all projects, the teacher answered students' questions about the use of media and made suggestions as to how they might solve compositional or technical problems.

After they had posed and resolved each problem, students reflected on their process through a written or verbal critique. Open-ended questions helped students understand their own thinking and learning processes. This nongraded aspect of projects provided feedback to the teacher as well as insight to students.

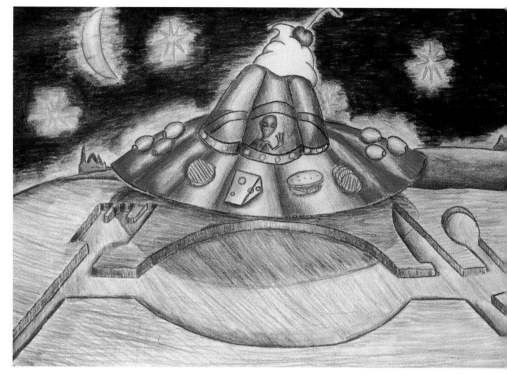

A spaceship lands in a flattened cornfield place setting.
Gavin Lawrence, grade 11. *Jupiter Jello.* Colored pencil, 12" x 18" (30.5 x 45.7 cm).

Students' work was immediately exhibited in either a large glass showcase outside the artroom or in the library, thus assuring that their work was shared with the larger school community. Witnessing students' imaginative powers at work resulted in an increased appreciation for the art program.

We live in a throwaway society, and one final way of looking at these projects is as an opportunity to encourage future citizens to appreciate nature's intrinsic beauty and be more aware of the materials they use in their daily lives. As artist/teachers we recognize and appreciate the visual qualities of the objects we encounter daily. By taking responsibility for improving the visual quality of our everyday environment, we can encourage our students to think about art and how it relates to daily living.

As the projects in this chapter focused on encouraging creativity, those in chapter 3 address increasing students' skill levels and self-expression.

3 Moving from Skill to Expression

Each student brings a unique set of skills to the classroom. Although as artist/teachers, we try to build on those skills, we must also help our students understand that they are working in a special and unique format: the visual format. The goal of the projects suggested here is to promote the discipline of observing while improving technical skill levels. In addition, projects will help students become more aesthetically aware and expressive in their work.

The first half of this chapter examines variations in the use of the still life. Viewing a still life provides students with the opportunity to study a controlled subject without concern for time or movement. In addition, focusing on still lifes can increase students' visual awareness and understanding of three-dimensional forms. They will grasp spatial relationships and composition, and enlarge their awareness of positive and negative space. Finally, having students observe objects in a still life can teach the use of rhythm and repetition of shapes in a composition.

The second half of the chapter covers additional projects—not based on a still life—designed to improve students' technical skills. These projects encourage teachers and students to use the beginning focus of each problem as a jumping-off point for increased innovation and self-expression.

Students who perceive that their physical personal space is respected feel freer to produce work with expressive depth.

Motartcycles

INSPIRATION

This project began with my desire to acquire a visually complicated, single object for students to draw. I began by looking for something special that would demand students' attention. This object would have to be visually engaging, a complex form—the kind found in a machine. I soon realized that what I wanted was a large black motorcycle . . . perhaps a Harley.

Sometimes perseverance combined with the conviction that an idea will work produces the best results. The school year began, and the artroom was still empty. I had canvassed staff at the school, the police, and the local Harley-Davidson retailer—all with no success: no one could provide a motorcycle. I shared my idea with my students and asked them if any of their parents could lend us a motorcycle. I explained the conditions—no one would touch the machine and the door would be locked whenever the artroom was not in use. To my surprise, a parent offered to lend us his sleek black Honda CB750. Early the next morning it was placed in the middle of the artroom. The students' reaction was initially disbelief, followed quickly by enthusiasm for the project.

The contrasts in this value study evolved from Evy's observation.

Evy Bittner, grade 9. India ink wash, 18" x 24" (45.7 x 61 cm).

PROBLEM

Art I students will create a strong visual image focusing on one area of this complicated machine and will explore the art element of value. Students will show an understanding of the structural form of the object.

Advanced-level students will develop strong visual images of the same subject by making choices about the use of expressive and/or experimental color. They will visually explore the complexity of the motorcycle and, as a result, gain a better understanding of its structural form and increase their eye-hand coordination.

TIME FRAME

Two and one-half weeks.

MATERIALS

Art I
- india ink
- watercolor brushes
- 18" x 24" white vellum
- fine-line markers
- plastic palettes for ink wash

Art II, III, and IV
- 18" x 24" white drawing paper
- variety of drawing and painting materials (watercolor paints, felt-tip markers, colored pencils, colored chalk, and mixed media)

Christine used colored pencils to develop this focused composition.

Christine Kallens, grade 11. Colored pencil, 18" x 24" (45.7 x 61 cm).

STARTUP

Provide a visually motivating subject (such as a motorcycle) for observational drawing. Have students view the subject from all sides. Encourage them to spend time observing before they actually begin to draw. The aim is first to create a focus for student observational drawing and then to develop possibilities that elicit diverse results. With beginning students, diverse results occur when students choose their drawing perspective. On the advanced level, various outcomes occur when students choose the media that best suits their personal expression.

PROCESS

Both levels begin at the same starting point. Ask students to pick an area of the motorcycle they find interesting. Then have them visually isolate the area and explore it using line. Explain that because of its overwhelming complexity, students should not attempt to draw the entire motorcycle. Tell students that as they draw their chosen area, they need to find a way to fill visual space with line only. Explain that the use of line will define the relationship of positive and negative shapes they are viewing. In addition, because there will be a natural tendency to have the lines touch all sides of the paper they will help create a strong composition, one in which the image does not appear to be floating.

The goal for Art I students is to increase their drawing skill by developing a focused composition. Follow this with a value study using an ink wash, encouraging students to emphasize contrast. After the developed wash is finished, have students add fine contour lines to the new shapes created from the ink wash. This will help students to focus and reflect upon the effect of the media on their work.

Have Art II, III, and IV students progress to the color stage of their drawing by choosing their media. Encourage them to take risks with expressive and experimental color. Share with students the work of contemporary artists. Use magazines like *Art in America* and *Art News* to raise awareness of the many ways color can be used expressively. Artists such as Janet Fish work with reflected light, and Jennifer Bartlett is known for the bold expressiveness seen in her use of color. Keep on hand examples such as those found in posters, art reproductions, or postcards to illustrate various ways that color can be used.

CHOICES

• section of the subject to draw
• media (Art II, III, and IV)
• creative development of subject

Andy used watercolor and felt-tip marker in a stylized way to break up the form.
Andy Sinclair, grade 10. Watercolor and felt-tip marker, 18" x 24" (45.7 x 61 cm).

Bright, bold, and repeated color and the strong directional linear quality give expressive energy to the windshield.

Melissa Thiele, grade 9. Felt-tip marker, 18" x 24" (45.7 x 61 cm).

RESULTS/OBSERVATIONS

Students showed appreciation for both the form and its structure, an improved awareness of gray scale in value study, and increased skill in the use of mixed and expressive color. Because the motorcycle proved such a visually engaging subject, students wanted to study it. Their motivation and enthusiasm, in turn, elicited strong visual results.

For the most part, students' selection of a single area increased their focus and helped them to produce an accurate representation of the subject. In addition, it afforded greater visual awareness and decreased students' level of frustration. As the drawing progressed, students had the option to change their drawing position if they felt the area they had chosen was too difficult. In the end, all students found engaging areas and produced strong, viable compositions.

CONCLUSION

This project helped students to focus their drawing skills on the structural form of an observed object. It allowed them the freedom to make decisions, which made possible diverse solutions to the compositional and color aspects of the visual problem. Finally, the visual impact of a motorcycle in the artroom proved a dynamic and exciting way to begin the school year.

EVALUATION

Have students reflect on their process by completing a written or verbal critique. Ask: "When you first viewed this subject, did you think you were capable of drawing such a complicated machine?" "What changed in your thinking as you began to develop your image?"

"Was there an aspect of this process that was particularly challenging?" "If so, what was challenging about it?" The evaluation should also consider the degree of gray scale in the value study completed by Art I students and, for advanced students, the ways in which expressive color is seen by the viewer. See also the rubric on page 34.

INSPIRATION

Drawing is a basic means of artistic expression as it helps us to define space, think through ideas visually, and increase our visual awareness. For this beginning still life, objects were placed with a degree of simplicity and strong visual focus in the center of the artroom. The aim was to see if students could first draw a simple image and then use color and compositional changes to create a rich image of greater complexity.

PROBLEM

Part I

Students will demonstrate the use of weighted line to show the effect of the light source on the subject. This will be accomplished as students produce three line drawings, each from a different perspective.

The line variation in Deirdre's work is an example of how weighted line can enhance an image.

Deirdre Coyle, grade 11. Pencil, 12" x 18" (30.5 x 45.7 cm).

Part II

Students will combine the images from the three drawings to create a well-planned fourth composition. In this larger composition, students will convey personal expression through their creative use of color and placement.

TIME FRAME

Part I: Two weeks (eight class periods). Part II: Two weeks (ten class periods). Students spent additional time as needed, either after school or on weekends. Carefully estimate the amount of time needed to complete a project and create reasonable deadlines, as this encourages students to use class time well.

MATERIALS

Part I
• 12" x 18" white drawing paper
• drawing pencils (2B, 4B, and 6B)

Part II
• 18" x 24" white drawing paper
• 18" x 24" tracing paper
• variety of media (colored pencils, pastels, acrylic paint, watercolors, tissue paper, and mixed media)
• hot- and cold-press illustration board, depending on the media selected

STARTUP

Choose simple but visually engaging, objects for the still life. Before students even lift a pencil, provide information on how to plan a strong composition. Share with students methods for maintaining visual interest in their work, such as organizing the elements of design (line, shape, value, color, space, and texture) and using compositional principles (balance, unity, contrast, emphasis, pattern, rhythm, and movement).

Choosing a Center of Interest

Ask students to divide the paper into thirds and place the focal point one third in and two thirds over. The focal point could appear in the lower left, upper left, lower right, or upper right quadrant. Such a division, sometimes called the "rule of thirds," actually creates four potential places for a focal point in the composition. Advise students not to use the center as a focal point, as this will make the subject static and prevent the viewer from seeing the overall piece. Tell them also to avoid drawing strong attention to any one of the four corners, as this will lead the eye away from the artwork.

Developing the Space

Tell students to establish a connection between the size of the subject matter and the overall size of the paper. This can be done simply by

Breaking the Rules

Use examples of the work of famous artists to show students how any set of rules can be broken. One example of an artist's success in "breaking the rules" of composition is found in Monet's painting *The Artist's Garden at Vetheveil* (1880). Monet's use of shadow draws the viewer to the middle of the painting. Despite the placement of the focal point in the center of the composition, Monet's use of color, value, and movement keeps the overall effect lively rather than static. Similarly, Monet's *Le Palais Contarini* (Venice, 1908) shows a very balanced composition divided by the horizon line. The canal on the lower half of the composition and the building on the upper half isolate the centrally located door, yet Monet's use of color, line, and brush technique keep the viewer engaged.

extending the compositional lines of the subject off all four sides of the paper.

The purpose of these guidelines is to help students consider how they use space, both positive and negative. Attentiveness to such compositional planning will encourage students to maintain visual interest by directing the viewer through visual space.

PROCESS

Part I

Emphasize the importance of a strong visual composition, one that successfully uses the overall page and expresses a clear understanding of line variation. Have students view the still life from three different sides or angles. Then have students create three weighted-line pencil drawings on white drawing paper (12" x 18"). You might consider demonstrating an example of line variation through the use of weighted line.

To help students develop the concept of weighted line in their draw-

ings, explain the role of directional light. Demonstrate how to use light gray lines where there is strong light present and dark gray to black lines where the light source is limited.

As they create their three line drawings, have students use a variety of drawing pencils (2B, 4B, and

6B) in order to weight each line. Tell students to stress line variation, focusing on weighted line in each of the three drawings. Because the initial drawing will take longer than the other two, allow four class periods for the first and two class periods for each of the last two drawings.

When teaching students a new concept, it is important to share examples that fit the criteria of your assignment. In this case, share examples of other students' and professionals' work that show both strong composition and weighted line. (Examples of weighted and expressive line can be found in the drawings of artists Ben Shahn and David Hockney.)

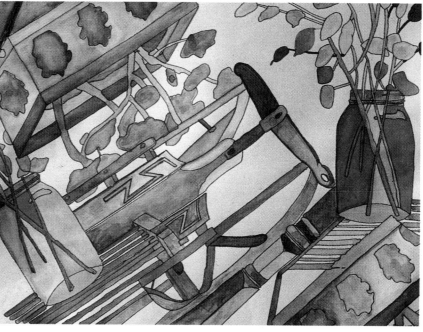

Ray developed this strong angular composition through integration of the elements, good use of media, and repetition of color.

Ray Jones, grade 11. Watercolor, 18" x 24" (45.7 x 61 cm).

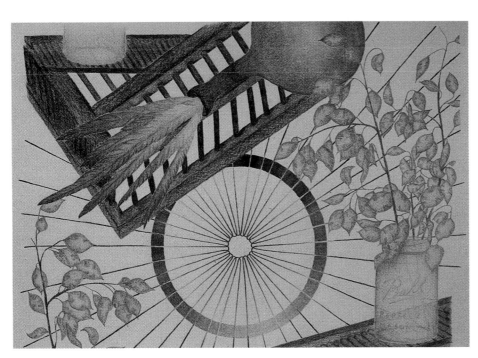

**Lea Kameche used colored pencils to complete her combination composition.
Approx. 18" x 24" (46 x 61 cm)**

Part II

To solve the visual problem, have students look for the strongest elements from each of their three drawings and then combine on white drawing paper (18" x 24") the images to create a new composition. Have them use a large sheet of tracing paper (18" x 24") for the visual planning. Tell students first to look at their work and see how one drawing naturally fits with another. Placing two of the original drawings side by side should soon reveal an immediate flowing relationship between them. The third drawing often becomes more difficult to integrate. Suggest that students use tracing paper as a tool for integrating the third drawing. Have students trace elements of the third drawing and layer these elements over the first two drawings. Then ask students to carefully trace elements from all three compositions as they examine the relationship of forms. Stress composition, with an understanding of balance and visual interest. The final composite drawing will integrate the strongest qualities of the three original drawings. Students should resolve all aspects of the composition on the tracing paper before beginning the final color composition.

In the final stage, tell students to select a medium for adding color to their new composition. Ask them to think about an expressive use of color that would also result in a greater understanding of mixed color. Allow the students to choose from a variety of media options including colored pencils, pastels, acrylic paint, watercolor paint, tissue paper, and mixed media. Illustration board or white drawing paper are also options for the final color stage.

CHOICES

- three different perspectives
- media
- how to integrate the three drawings

EVALUATION

Have students reflect on the process in a written or verbal critique. Ask: "How has the use of line variation enhanced your understanding of how light affects form?" "What did you find most challenging about combining your images?" "How did you resolve the visual conflicts?" "Does your final composition maintain visual interest? If so, how?" See also the rubric on page 34.

RESULTS/OBSERVATIONS

Since students' final color solutions reflected the result of having combined their three drawings, students' work was strikingly varied and personally expressive. The decisions they made to solve composition and color problems added to the success of their results.

CONCLUSION

This project emphasizes both the use of weighted line to show the effect of light on objects, and the use of expressive color and composition. Although the still life students observe is simple, they can develop richly complex compositions.

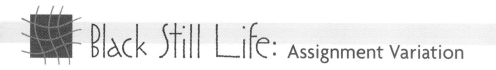

Black Still Life: Assignment Variation

INSPIRATION

What would it be like to create a still life painted entirely in black? Would objects be seen with greater clarity, with the relationship of positive and negative spaces readily apparent? The primary goal of such a project would be to help students understand the value of artistic interpretation. An additional benefit might be that the initial absence of color would enhance the students' decision-making experience when they develop their compositions in color.

PROBLEM

Using the variety of black forms found in a still life, students will create an image and then develop that image into a personal artistic statement. Students will create an image that reflects the spatial relationships of objects and, at the same time, produces a personally expressive work of art. Advanced students will create three color variations of their still-life drawing, each one visually engaging yet different.

TIME FRAME

Three weeks.

MATERIALS

- cans of flat black paint
- 18" x 24" white drawing paper

Art I

- tracing paper
- newspaper
- glue sticks
- fine-line markers

Art II, III, and IV

- variety of media (colored pencils, pastels, felt-tip markers, acrylic paint, tempera paint, watercolor, tissue paper, and mixed media)

STARTUP

Collect items that will create a visually interesting still life. To eliminate color, choose a variety of objects that are already black. Possible items include picture frames, a plant stand, cloth, or an old chair. To add visual interest, consider the size and texture of objects. Borrow a large black wooden box (perhaps from the theater department) and use this as the base—a visually unifying element for the overall still life. Collect a variety of other objects that can be painted without destroying their value. Examples are a window frame, an old tricycle, a step ladder, and an old coat. Spray the surface of each object with two coats of black paint. Arrange a three-dimen-

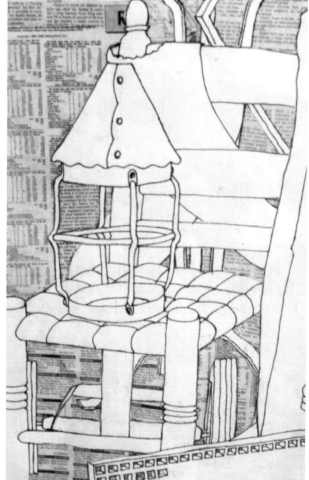

Bill explored negative space by using newspaper while maintaining the fine linear aspect of the drawing.

Bill Smith, grade 10. Newspaper and India ink, 12" x 18" (30.5 x 45.7 cm).

sional composition in the middle of the classroom. You might also want to suspend objects from the ceiling. The still-life composition will become more visually exciting as it nears completion.

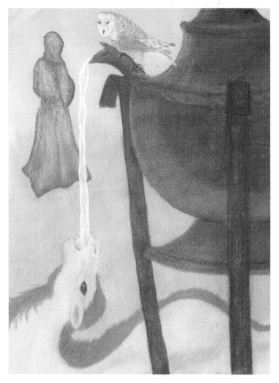

Heather used her interest in fantasy and fairy tales to create this variation of the still life.

Heather Freeman, grade 12. Pastels, 18" x 24" (45.7 x 61 cm).

PROCESS

Instruct students to select an area of the still life they find visually interesting and an area that contains parts of at least three or four objects. As they study the objects, encourage students to observe the defined air spaces beyond the solid forms. Instruct students to draw so that lines extend off all four sides of the paper, thus strengthening the overall composition and enhancing the viewer's focus. Have all art levels work on 18" x 24" white drawing paper.

Art I

The intent of the Art I project is to build students' awareness of the power of negative space and to encourage their personal expression. Guide students as they first use pencil to develop a contour line drawing that defines both the positive and the negative shapes. Then have students trace the negative shapes onto newspaper. This can be done with tracing paper or at the classroom window, a few shapes at a time. Next have students cut the newspaper and paste it to fill the negative spaces on the white paper drawing. Students can use fine-line markers to define all of the original lines. The simplicity of white shapes, black lines, and the overall gray of the newspaper will create a sense of visual unity in each piece.

Art II, III, and IV

Discuss the idea that artists express themselves in different styles and media. For this project, students should have the choice of a variety of drawing materials and painting media, as well as having the option of using mixed media. To increase student expression, expose students to the work of a wide selection of artists in order to show them the many ways artists use media to help interpret their subjects. Share a range of examples from the work of famous artists—from Expressionists to Surrealists—to help students understand how artists use materials and how the materials they use affect their style.

Tell students they will create three color variations of their still-life drawing. Remind them that their choice of media will affect how the viewer sees their work, even if the composition stays the same. Encourage students to take risks by trying techniques or materials they have not worked with before. Allow students to trace their original pencil drawing or come up with another composition for each piece. Most students will trace the original and thus discover that changing the media produces new effects.

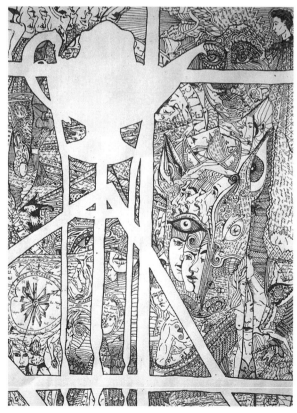

The use of negative space is explored in this project.

Heather Freeman, grade 12. Pen and ink, 18" x 24" (45.7 x 61 cm).

CHOICES

• media (advanced level)
• development of subject

EVALUATION

Call on Art I students to reflect verbally on their creative process. Ask: "Were the negative spaces clearly defined?" "Did you notice the newspaper became a gray value in the final work?" "How did your work show quality in terms of the use of materials?" Have advanced level students use reflective writing to explore the project. Ask: "Which interpretation is most successful and which is least?" "Why?" "What can an artist learn by interpreting the same subject in different ways?" See also the rubric on page 34.

RESULTS/OBSERVATIONS

When the students first walked into the artroom, they responded immediately and positively to the still life. It seemed to have a theatrical presence that demanded attention. For Art I students, the experience greatly increased their understanding of the power of negative space. These students produced engaging images, the result of positive shapes remaining white and being defined by fine black lines, and by the gray tones of the newspaper used to fill negative spaces.

As the advanced-level students created their three images, finished work was hung up in the room for others to see. This made students aware of each other's work and prompted them to ask questions about other students' processes. The learning process became evident as students progressed to their third piece of work, each experiencing a new way of exploring their own composition. Although the idea of completing three pieces may have seemed arbitrary at first, it did succeed in enabling students to explore the concept of interpretation. In addition, because the project encouraged students to experiment in diverse media, students produced diverse results.

CONCLUSION

Creating a still life in black produces a visually striking image, one that clearly defines the spatial relationships between forms. By eliminating (with spray paint) the pre-existing color in the positive forms, students on the Art I level clearly perceived and distinguished between positive and negative shapes. In an effort to resolve the visual problem of creating multiple images, advanced students made countless choices, experimented with many media, and explored styles ranging from Expressionism to Surrealism. The results were varied and innovative personal interpretations—all emanating from a simple black still life.

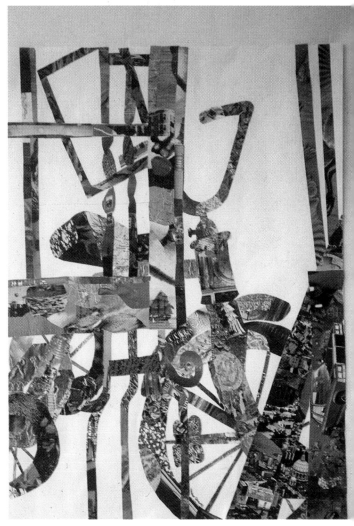

Heather's solution to the problem was to use magazine images to develop the positive shapes.

Heather Edwards, grade 12. Cut paper, 18" x 24" (45.7 x 61 cm).

From Natural Form to Abstraction

The influence of Georgia O'Keeffe is seen in Herbert's pastel.
Herbert Li, grade 9. Pastels, 18" x 24" (45.7 x 61 cm).

PROBLEM

Students will demonstrate a visual understanding of a small part of nature viewed in a new way by enlarging the subject and adding expressive color. The lines students use to develop the subject must touch at least three sides of the paper. (This requirement will encourage students to work large, to consider the use of positive and negative space, and to maintain visual interest.)

TIME FRAME

Two and one-half weeks.

MATERIALS

- 18" x 24" white vellum drawing paper
- variety of drawing and painting materials (colored pencils, watercolor paint, pastels, felt-tip markers)
- object from nature

STARTUP

Begin with a discussion about artists who work from nature, enlarging and abstracting natural shapes. Display the work of American artist Georgia O'Keeffe, whose work from nature shows a progression from easily recognizable forms to abstract ones. Suggest references such as *O'Keeffe—Art and Letters* by Jack Cowart, Juan Hamilton, and Sarah Greenough. Because it is written on a student level, *Scholastic Art* maga-

INSPIRATION

One way to enhance students' understanding of abstraction and expression is to have them enlarge a subject while adding color to it in a creative way. This idea came to mind after viewing the work of American artist Georgia O'Keeffe. Nature, with its intrinsic beauty, has long been an important subject for artists. I wanted to see if students could take natural forms to a more expressive and dynamic level than is generally achieved with a typical rendering of landscape.

Objects from nature serve as the subject for this project. In the example that follows, a collection of deer and cow bones was used. The shapes fascinated students as they tried to identify which animal or part of the animal objects had come from. Two significant pieces, one a cow skull complete with jaw bones, and the other, a large cow pelvis, were placed on white pedestal bases in the middle of the artroom.

zine (formerly *Art and Man*) is also an excellent resource. While sharing O'Keeffe's work with students, point out the subtlety of her mixed color and the scale of her work.

PROCESS

Invite students to observe the sculptural elements of the subject, in this case the cow skull and pelvis. You might provide a box of smaller bones for students to work from. Do not, however, limit students to this selection. Allow students to choose any observable subject from nature (flowers from their gardens, driftwood and shells from the beach, or even a cactus), the only requirement being that they bring the subject they choose to class for observation.

Have students choose their media and encourage them to work on a large size of paper to develop their image. The paper size should be no smaller than 18" x 24", yet it could be larger.

CHOICES

- media
- subject
- overall size

EVALUATION

Have students reflect verbally on what they have learned. Ask: "How does enlarging an object change the way it is viewed?" "In what new ways did you explore color?" "To what degree has your perspective of and appreciation for artists who work in abstraction increased?" See also the rubric on page 34.

RESULTS/OBSERVATIONS

Students observed the impact that enlarging and adding mixed color could have on rendering a simple form from nature. In fact, much of their work resulted in striking, bold images. The project accomplished its aim, which was to help students understand how changes in size and color affect the way an object is viewed. In addition, students acquired a much greater appreciation of artist Georgia O'Keeffe and her rich use of mixed color.

CONCLUSION

Throughout this project students explored, mixed, and blended colors. In the end, they developed a greater understanding and respect for the concept of abstraction. By enlarging a detail and removing and detaching an object from its usual context, students experienced abstraction. (Taken a step further, this process would result in nonobjective art.) Distortion of the form and the use of expressive color add to the transformation of the original object.

Catherine's bold use of color altered both the positive and negative space in this composition.
Catherine Ryan, grade 11. Tempera, 18" x 24" (45.7 x 61 cm).

Regan used colored pencils to develop this large and bold image of pansies.
Regan MacKay, grade 12. Colored pencil, 18" x 24" (45.7 x 61 cm).

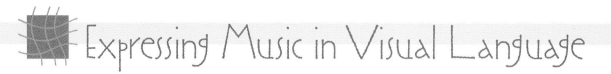

Expressing Music in Visual Language

INSPIRATION

Music can greatly affect our moods and emotions. Historically artists have interpreted music visually. Picasso's Three Musicians *(1921) came to mind as an example of a work of art related specifically to music. The impetus for this project began with the question: Can high school students make the transition from observational drawing to a visual expression of music? The purpose of the color component (Part II) is to encourage students to become more personally expressive in response to music.*

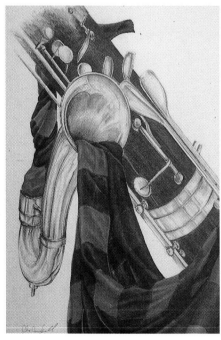

In this realistic pencil rendering, Chris represented the way music flows from the instrument.

Chris Campbell, grade 12. Colored pencil, 18" x 24" (45.7 x 61 cm).

PROBLEM

First students will create a black-and-white image based on observation of musical instruments. Next, students will create an expressive two-dimensional, color image about music that reflects the qualities of a style of music. In the process of making these images, students will confront the visual problem: to make the leap from an observational drawing of a real object to a personal interpretation of the subject matter. Students are to interpret rhythm and mood in a visual language that others will understand. The goal is to encourage students to use the language of art to express a specific musical style.

TIME FRAME

Part I: Two weeks for observational image.
Part II: Two and one-half weeks for color image.

MATERIALS

Part I
- 18" x 24" white drawing paper (80 lb.)
- pen and India ink
- felt-tip marker
- black and white pastels
- drawing pencils (4H through 6B)

Part II
- variety of media options: colored pencils, pastels, oil pastels, acrylic paint, watercolors, tissue paper, and mixed media

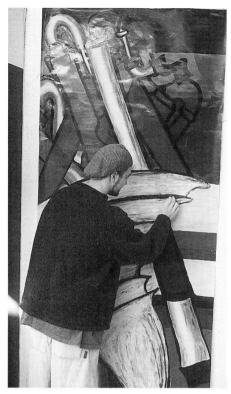

Greg Fishbein used an experimental combination of media in this large work. The focal point is the large shape of a horn. The type of music he chose—ska, an American form of reggae—is both loud and repetitive.

Greg Fishbein, grade 12. Enamel paint, latex paint, and oil pastels, 4' x 8' (122 x 244 cm).

STARTUP

For the observational image, hang a variety of musical instruments from the ceiling, possibly borrowed from the high school music department. To ensure their safety and security, hang them with nylon fishing line (20 lb.). Suggested instruments include a large white sousaphone, a clarinet, a silver flute, a contrabass clarinet, a bassoon, and a violin with

bow. Emphasize the spatial relationship between each instrument by careful placement. The nylon thread will add an unexpected division of negative air spaces. Some students will use these negative spaces in their compositions.

PROCESS

Begin by dividing the project into two parts. In Part I students do an observational drawing of the musical instruments set up in the artroom. The focus of this part of the project is to improve students' observational and representational skills. In Part II, students use expressive color to interpret a musical style.

Part I

The visual process starts with an observational pencil drawing. Have students choose a section of the displayed musical instruments on which to focus. Tell them to do this study as a line drawing, using a 2B pencil, on 18" x 24" white paper (80 lb. vellum). Next have students choose a black-and-white medium to develop the image further. Some of the materials they might use include pen and ink, felt-tip marker, black and white pastels, and drawing pencils (4H through 6B). Tell students to focus on an experimental use of materials rather than a complete value study. To enhance the overall ambiance of the classroom, play classical music throughout each class period. Students' work will result in large and impressive visual statements.

As students complete their first drawing and value study, share information about artists who have visually represented music in their work. Ask students to begin to think about how they also could express qualities of music. While finishing their black-and-white study, have students select a style of music they would like to develop in their color expression. Ask students to think about the kinds of art materials that would help them best express the style of music they have chosen.

Allison interpreted classical music, creating mood through the use of color and rhythm by repeating flowing musical notes.

Allison Holmes, grade 12. Tempera and felt-tip marker, 12" x 18" (30.5 x 45.7 cm).

Part II

Ask students to use color, line, form, or texture to interpret the musical style they have selected. Allow them to use portable headphones to listen to the music. Have students decide on the overall size of their composition and the media they will use. Encourage students to repeat elements that will create visual rhythm and unity in their work. Emphasize well-developed compositions that will hold the viewer's interest. Again, show the work of artists who have responded to music in their art.

CHOICES

- media
- subject—style of music
- size

EVALUATION

A five-point rubric scale was designed specifically for this project. Share the rubric with students and post it in the classroom. The rubric is divided into two parts: (1) the use of art materials and the quality of craftsmanship; and (2) the degree to which students succeed in visually expressing a musical style.

Art Materials and Craftsmanship:

1 Poor use of materials and craftsmanship
2 Below average use of materials and craftsmanship
3 Average or moderate use of materials and craftsmanship
4 Very good or full use of materials and craftsmanship
5 Excellent use of materials and craftsmanship

Degree of Music Expressiveness and Style:

1 Poor attempt at expressiveness
2 Limited attempt
3 Some attempt made
4 Good or very expressive
5 High degree of expressiveness

Have students do a self-evaluation based on this rubric and answer in writing these two open-ended questions: "How would you describe the kind of music your piece of art evokes?" "What artistic elements would give the viewer an indication of the kind of music you chose to express?" Although students' responses to these two questions do not affect their grade, you can use their answers as a way to ascertain their overall learning.

Resources

Scholastic Art (formerly *Art and Man*) has presented the work of three artists who made connections between art and music. You might share with students the work and personal reflections of these artists, or suggest that students research other artists who used music for inspiration.

From *Scholastic Art*:

❋ Pablo Picasso (Spanish), *Three Musicians* (1921)—Cubist painting that uses musical notes as part of the composition. (February 1991)

❋ Wassily Kandinsky (Russian), *Improvisation #30* (1913) and *Sketch for Composition* (1909-10)—Two paintings that use expressive color and line. (December/January 1995-96)

❋ Romare Bearden (American), *Three Folk Musicians* (1967) and *Showtime* (1974)—Both works use collage to express different styles of music. (February 1996)

Two quotes that follow, taken from these issues of *Scholastic Art*, were displayed in the artroom throughout this project.

❋ "Music has been so important in my life that I use musical images in my work as often as I can...To make art you must become a blues singer, only you sing on canvas. You improvise—you find the rhythm and structure as you go along, then the song is you."-Romare Bearden (*Scholastic Art*, February 1996, p.8)

❋ "Color is the keyboard, the shapes are notes, and the artist is the hand that plays, creating vibration in the soul." -Wassily Kandinsky (*Scholastic Art*, December/January 1995-96, p.3)

RESULTS/OBSERVATIONS

Students' solutions to the problem show to what degree they are able to use the language of art to express a specific musical style. During the second part of the project, students were invited to share their own selection of music by playing that music in the artroom for the rest of the class. Students were cautioned to be selective in their choice of music and reminded that offensive language is inappropriate for classroom use.

The music students selected represented a wide variety of styles, including reggae, hard rock, classical, metal, techno, electric industrial, jazz, ska, and classic rock-and-roll. Students were surprisingly opinionated about other classmates' choices and often convinced that their own choice in music was the best. This presented an opportunity for a discussion in which students learned tolerance for other people's opinions and choices.

CONCLUSION

Music does affect our lives. Students, when given the opportunity to express a musical style in the visual language of art, can produce powerful images. In their work students made significant connections between art and musical expression. Variations in media, composition size, and styles of music chosen produced diverse results.

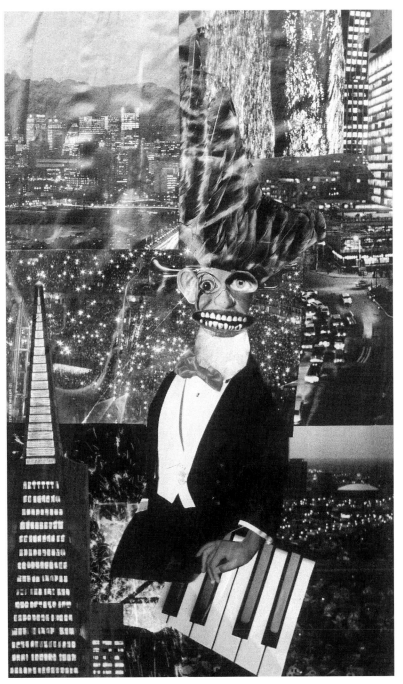

This sophisticated nightclub scene was created from magazine images.
Jackie Kelly, grade 11. Collage, 12" x 18" (30.5 x 45.7 cm).

Trompe-L'oeil in Value Study

INSPIRATION

Often students produce only two shades of gray in their finished drawings. This project arose from a desire to help students learn to produce greater contrasts in value study drawings. The visual problem began with a question, first to myself and then to the students. If we focus on a small subject in a small area, will we be more likely to take the time to study the gray values? From this question evolved a unique problem involving the use of a student-developed miniature still life.

PROBLEM

Students will create a small, personal, miniature still life from a variety of found objects. They will develop an image in pencil that shows high contrast and a wide range in value.

TIME FRAME

Three weeks (15 class periods).

MATERIALS

• 16" x 20" x 1/4" foam core
• tape, pins, white glue
• drawing pencils (H to 6B)

Careful observation is needed to produce excellent results: Heather Freeman at work.

• 9" x 12" white drawing paper
• black illustration board

STARTUP

Ask students to select three to five objects to be mounted on a piece of foam core for observation. The objects do not have to have a common theme, although in some cases related objects will add to the interest of the composition. Explain to students that they should select objects that are no thicker than 3/4". The aim of this project is to create a low relief to be developed with value and contrast. Some possibilities for subject matter are an unusual stamp, concert tickets, keys, or jewelry.

Explain the French term *trompe-l'oeil*, which translated means a "trick of the eye" or "deceiving the eye through optical illusion." Trompe-l'oeil was a popular art form a hundred years ago and is often used and seen as paintings on furniture in country estates in Europe. An example of this type of painting would be the realistic depiction of playing cards or money left on a table surface. The illusion is accomplished through a skillful painting of the subject, using shadow as a device to trick the viewer. The aim of this project is for students to create a trompe-l'oeil value study based on their previously rendered still life.

Share with students examples of trompe-l'oeil art such as those of American painter and illustrator Alan Magee. Two books about his work, *Stones and Other Works* and *Alan Magee 1981–1991* examine contemporary uses of this technique.

The values in Heather's still life show great awareness of both form and shadows.

Heather Freeman, grade 10. Pencil, 9" x 7" (22.9 x 17.8 cm).

PROCESS

Ask students to think about possible objects and then bring with them to class as wide a variety of objects as possible. Students can work either individually or collaboratively to set up their compositions. Have students arrange and rearrange a variety of both two- and three-dimensional forms. Students can eliminate objects they perceive as too complex to work with. The result will be a focused composition that measures approximately 7" x 9". Have students place their compositions on the upper half of a 16" x 20" piece of 1/4" foam core. Then ask students to pin, tape, or glue the objects in place

and tell them that the placement will remain unchanged for the next two and a half weeks. Create contrast between the objects and the foam core by introducing a strong light source (use portable clip-on lights and whatever sunlight comes through the artroom windows) that casts shadows and enhances different textures and dimensions.

Have students start their pencil drawings with a very light gray contour line to establish the composition. Ask them to proceed slowly, moving from the lightest of grays to the darkest. In this way students can

avoid smearing as the development of the rich dark gray value to black comes last. Share with students this statement by author Betty Edwards in *Drawing on the Right Side of the Brain*: "Shading is based on perception of changes in tones of light and dark. These tonal changes are called values." Edwards goes on to say that "a complete value scale will go from pure white to pure black, with literally thousands of minute gradations between the two ends of the scale" (p. 180). Encourage students to use an assortment of H to 6B drawing pencils for this project.

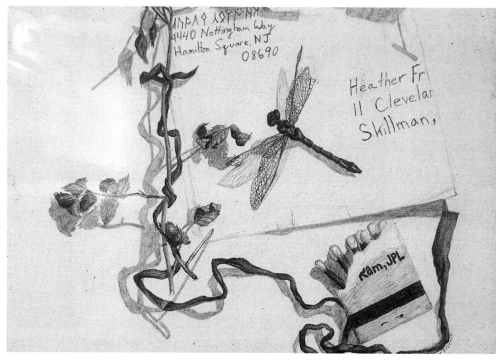

Notice how the development of the shadows adds to the effectiveness of this work.

Heather Freeman, Detail.

Have students mount their finished results on black illustration board for presentation. Students may also choose to double mount their work using a thin border of color between their work and the black illustration board.

CHOICES

• subject and its development
• mounting of finished work

EVALUATION

Encourage students to respond to a verbal critique. Ask: "Is there a clear range of value developed in your work?" "Were you satisfied with your choice of objects or would you have preferred others?" "Which object became the most challenging to draw?" "Why?" "Did working small help you to focus more on values?" See also the rubric on page 34.

RESULTS/OBSERVATIONS

Initially, many students hesitated to begin the problem due to its perceived difficulty. But, day by day, as students became increasingly engaged, they began to feel they might succeed. Daily encouragement proved an important part of the project. As a result of this study of a small and focused still life, students demonstrated greater skill in their use of gray values.

Additionally, the project taught students the importance of planning and adhering to a deadline. Many devoted time outside of class in order to complete the project on time. Sometimes it is difficult to estimate the length of time it will take students to complete a project. Establishing clear guidelines while maintaining a certain amount of flexibility is always important.

CONCLUSION

Students shared a sense of pride and enthusiasm upon completion of their drawings. Working with the miniature still life forced students to focus on gray values. As a result, students produced rich values and experimented with ranges of gray scale.

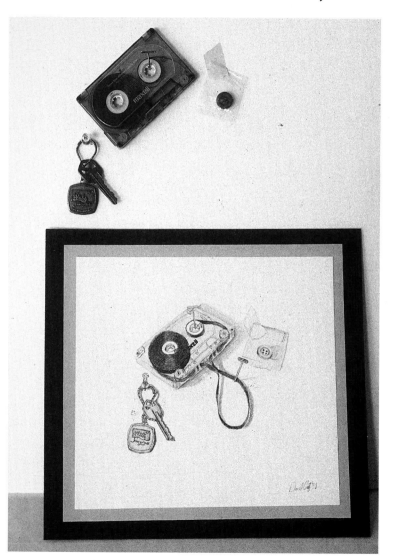

David's completed drawing shows strong contrast.
David Betz, grade 11. Pencil, 7" x 9" (17.8 x 22.9 cm).

Self-Portraits: Value Study and Famous Artists' Styles

INSPIRATION

How can we make the study of art history more relevant to students? I developed a two-part unit in portrait study centered on the theme of the individual's connection to art history.

This project will increase students' knowledge by exposing them to images produced in the past. Students will need to develop new skills and make decisions in regard to the style and media they choose. The question is: "Can high school students really make this visual connection and produce results that show an understanding of another artist's style?"

PROBLEM

Students will understand a famous artist's style well enough first to internalize it and then to incorporate that style into their own self-portrait study. First, students will portray a classmate using pencil. They will then develop a black and white pencil-drawn self-portrait. In Part II, they will create a color image that applies an artist's style to their own self-portrait, demonstrating their understanding of the artist's style.

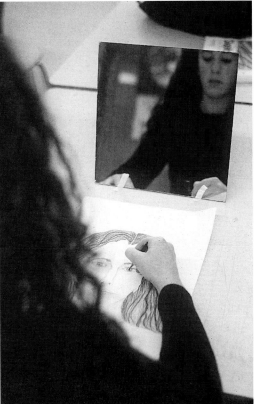

Jennifer Serravallo, grade 11 used a mirror to begin her 18" x 12" value study.

TIME FRAME

Six class periods for the filmstrips/demonstrations and the pencil portrait of a classmate. Fifteen class periods (three weeks) devoted to developing the self-portrait using a famous artist's style.

MATERIALS

Part I
- hand mirrors, one per student
- drawing pencils (H to 6B)
- 12" x 18" white drawing paper

Part II
- variety of drawing and painting materials (watercolor paint, felt-tip markers, colored pencils, colored chalk, and mixed media)
- canvas board
- illustration board

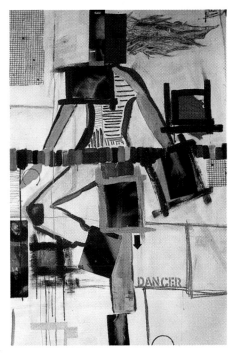

Basing her work on the style of Robert Rauschenberg, Jennifer Serravallo used unique materials—x-rays, tempera paint, markers, newspaper, fabric, and pastels—in her portrait. She began by tracing her body in a ballet position, then added dance movements.

Jennifer Serravallo, grade 11. Mixed media, 4' x 8' (122 x 244 cm).

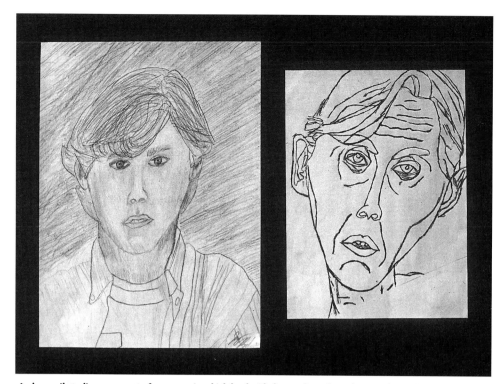

Jay's pencil studies were part of a process in which he decided to evoke sadness, but not depression.
Jay Bulvanoski, grade 11. Pencil, 12" x 18" (30.5 x 45.7 cm).

STARTUP

Show a filmstrip such as the two-part *Drawing a Likeness* (produced by Educational Dimensions Group, Stamford, CT) in which the proportions of the head, the use of line, and the handling of materials are demonstrated as the artist draws models. The filmstrip emphasizes the importance of measurement, the close study of proportions, the use of light lines to measure out those proportions, and shading for tonal values. Alternately, demonstrate the techniques yourself for students. After viewing the filmstrip or doing the demonstration, reassure any students who seem overwhelmed. Inform them that creating a likeness takes time, skill, and increased perception. They

should not expect professional results right away. Explain that they will be evaluated on how well they apply proper proportions and on their development of the value study.

Gather a quantity of resource references for classroom use. Betty Edwards, in her book *Drawing on the Right Side of the Brain* (p. 143), for example, logically outlines human proportions in a way that increases visual awareness.

PROCESS

Part I: Black-and-White Portrait Study

Instruct students in the use of a variety of pencils ranging from H to 6B on white vellum paper (12" x 18"). Emphasize the use of sharp pencils and the importance of keeping the

work clean by eliminating smudging. To prepare students for their self-portrait study, have students spend four class periods doing a portrait study of another student. Encourage students to use this portrait study as an opportunity to apply information from the filmstrip or demonstration and to focus on the proportions of the human face.

Students then work for about a week on the black-and-white self-portrait study. Distribute mirrors, preferably all the same size. (One good feature of self-portraits is that students can't complain about the model moving!) Have students begin by observing the human head, focusing on improving their technical skill by expanding their understanding of proportions. This portion of the project will include a rich use of gray in the value study. After the beginning measurement stage is finished in line and the shading stage is about to begin, show students examples of other black-and-white portrait studies. One example is the Dutch artist M. C. Escher whose drawings will prove both an excellent resource and a visual motivator. Escher's self-portraits demonstrate wonderfully the depth in tone created by rich black to light gray values and the use of white space.

Part II: Color Self-Portrait

Ask students to select a famous artist whose style they will use in their own self-portrait drawing or

painting. Dedicate several class periods to examining art resources from which students can select an artist whose style they like and whose work they want to study further. Most libraries have a good selection of art books and ideally also have a collection of *Art in America* magazines. *Scholastic Art* is perhaps the best resource, as it is written for students and offers a wide range of artistic expression and insight into various artists' styles. Have students make their selection, but try to ensure that no more than two students in each class choose the same artist. Ask each student to have at least two references on their chosen artist in front of them daily as they work.

Remind students that the media they choose to work in should be consistent with that of the artist they have selected. The size of the students' work is optional.

CHOICES
• style
• media
• size

EVALUATION
When students have finished their paintings or drawings, ask them to open their sketchbooks and write reflectively about their process. A few simple, well-constructed questions can reveal how much learning is taking place. Ask: "How would you describe the artists' style you have chosen?" "In what ways did you

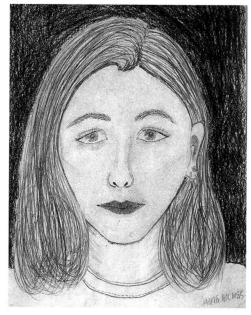

Jackie used pencil for this value study.
Jackie Holmes, grade 12. Pencil, 12" x 18" (30.5 x 45.7 cm).

apply his or her style in your work?" "What did you learn by imitating another artist's style?" This written component will provide a reflective overview of what students have learned. Students' feedback may reveal many similarities in what they learned. As a result of this project students gain:
• an appreciation of the artist whose style they applied to their own work
• an increased awareness of the artist's use of mixed color, use of repeated color to show unity, and overlapping color to show depth
• a sense of how artists focus their viewers through the use of composition, negative space, and background
• an appreciation for the importance of planning and research
• skill with new materials such as acrylic paint
• an understanding of how style affects expression and results.

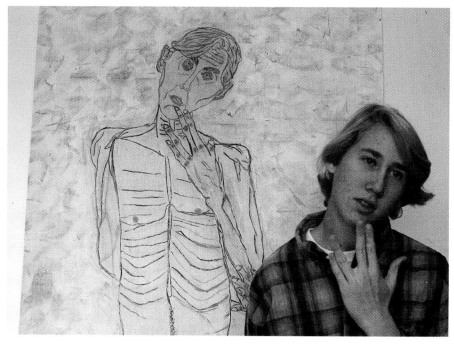

Jay drew his black-and-white self-portrait in the style of Egon Schiele. Like Schiele's work, Jay's self-portrait, with its exaggerated thinness and expressive use of line, is emotionally powerful. The project was a significant risk as well as a challenge that Jay met with honesty.
Jay Bulvanoski, grade 11. Pastels, 4' x 7' (122 x 214 cm).

RESULTS/OBSERVATIONS

For the teacher, allowing students to choose their media can become a logistical nightmare. This is especially true when several classes are using various media simultaneously. Avoid chaos by having all materials well organized in the studio space in a way that allows students daily access, without having to go through the teacher. Student choice means added demands, but teachers' efforts to accommodate those demands will prove worthwhile in the end.

Since the size and media were optional, some students worked 12" x 18" and others as large as 8' by 5'. The varied use of media and mixed media created impressive and diverse results. The artroom soon filled with a variety of artists' styles, among them Renoir, van Gogh, Matisse, Disney, Norman Rockwell, Rousseau, Picasso, Hockney, Wood, Cassatt, Gauguin, Dali, and da Vinci.

CONCLUSION

Students met the objective of the problem, developed visual understanding through observation, and applied that knowledge to their personal expression. The results showed diversity in composition, media, and the use of color. The project, which gave students the opportunity to observe others learning to use new materials, often inspired them to try some-

thing new themselves. In addition, because students work in a variety of materials, the class as a whole develops an understanding of how artists use various media to express themselves.

Helping students resolve technical problems related to style and media is a daily challenge, but is well worth the effort. After the project was completed one student reported seeing new colors in faces

(such as greens and blues) and another said that looking closely at one artist's style had inspired her to do the same with other artists. Students gained valuable insights concerning style and the use of materials, and their completed pieces evidenced quality, patience, and hard work.

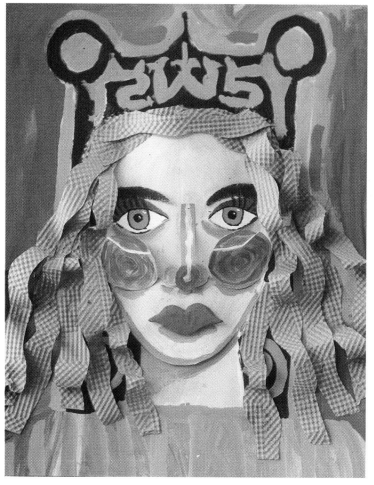

Jackie found a solution to the self-portrait problem by working in the style and media of Red Grooms.

Jackie Holmes, grade 12. Mixed media, 20" x 15" (50.8 x 38.2 cm).

The Richness of Paper

INSPIRATION

The tactile quality of paper, whether handmade or manufactured, makes it an irresistible medium. Over the years I have collected a wide assortment of various kinds of paper. Since most of this paper is costly, it is important to focus its use through a well-constructed art experience that will help students understand each paper's subtle and unique qualities. Such a project could also teach respect for these materials.

PROBLEM

Students will use collage technique to create a composition that shows visual unity and balance. They will increase their awareness of and learn to use sensitively a wide variety of unusual papers. They will then apply this knowledge to an original figure drawing.

TIME FRAME

One week devoted to a series of figure drawings and two and one-half weeks to develop the final collage image.

MATERIALS

- 12" x 18" white vellum
- 16" x 20" illustration board, one per student
- scissors
- white glue
- inexpensive water-color brushes for applying the glue mixture
- tracing paper
- various papers

STARTUP

Acquire an assortment of paper such as Japanese lace rice paper, ogura colored lace paper, dyed unrya chiri paper, German ingres paper, grass paper, tissue paper and common recycled paper. Share examples of paper collages in which the materials used show visual unity through color or texture. Discuss ways of handling the paper such as tearing, bending, folding, and overlapping edges. Find volunteers to model on a daily basis, perhaps students from study hall.

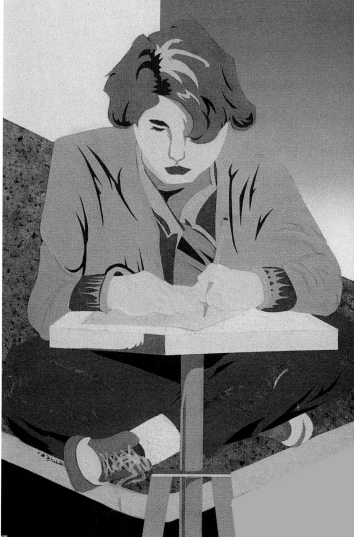

Herbert found his solution in a well-crafted use of cut paper. Herbert Li, grade 10. Collage, 20" x 16" (50.8 x 40.8 cm).

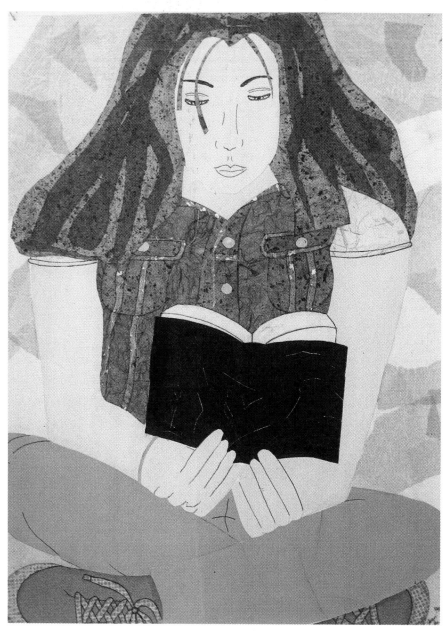

Careful handling of various kinds of paper created success in this project.
Jean Su, grade 10. Collage with felt-tip marker, 20" x 16" (50.8 x 40.8 cm).

will use this figure drawing as a pattern for their paper collage.

After they have selected their line drawing, give students a sheet of illustration board 16" x 20" (41 x 51 cm) and have them transfer their original drawing. This transfer should be done lightly with a No. 2 school pencil to prevent the graphite from smearing.

Ask students to begin the collage process slowly and carefully. They should use their original drawing as a pattern for cutting the various handmade and manufactured papers. This part of the project requires a white glue mixture (two parts glue to one part water), scissors, inexpensive watercolor brushes for applying the glue mixture, and tracing paper as needed. Instruct students to save all unused paper in open shallow boxes for easy access. Have students brush glue onto the illustration board. Then have them carefully apply each cut shape on that surface. Caution students to avoid overusing the glue as this will ruin the subtlety of certain kinds of paper. Store all work on a drying rack and for easy storage during the three-week process. Wash all brushes used for gluing at the end of each class.

CHOICES

- use, color, and texture of paper
- development of image

PROCESS

Have students begin with a series of contour line figure drawings to increase both skill and awareness. Tell students to choose the direction from which they will view the model and encourage them to move freely about the classroom space. Have them produce a series of line drawings on 12" x 18" (31 x 46 cm) white vellum during the week. Students should select one drawing that includes most of the human figure and has a strong composition. They

EVALUATION

Have students respond to a verbal critique. Ask: "Did the quantity and diversity in kinds of paper available cause decision making to be a challenge?" "Is it difficult to create visual unity through this media?" "Was your respect for various papers significantly increased?" "If so, how?" See also the rubric on page 34.

RESULTS/OBSERVATIONS

Students learned that repeating color and texture contributes significantly to the overall visual unity of the piece. While some students chose a monochromatic color range, others achieved visual continuity through repeated texture. Students' results reflected the amount of care they took to complete the project.

CONCLUSION

This project promotes in students a sensitivity to and respect for the quality and richness of paper. Students grow to appreciate the variety of paper as well as how it works in a visual relationship. Increased sensitivity to the human form results from students' enhanced awareness of the subtle differences in texture and color in the papers.

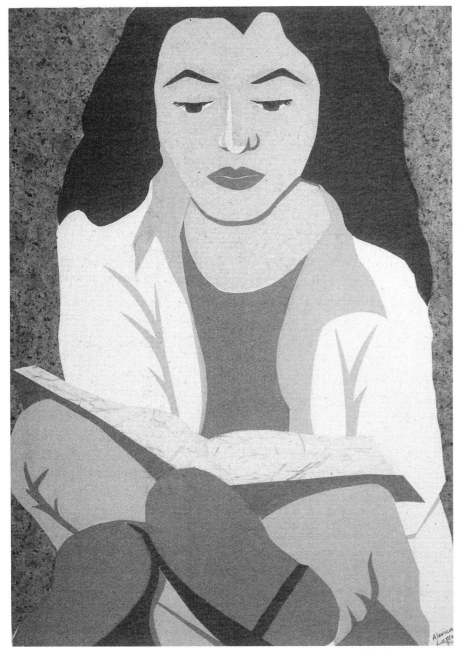

Visual unity in this image was enhanced by a monochromatic palette rather than repetition of texture. Alerica Lattanzio, grade 10. Collage, 20" x 16" (50.8 x 40.8 cm).

Value Study—Shattered Images

INSPIRATION

As creative artist/teachers, we reinvent concepts and ideas every year as we face a new group of students. While inventing new ways to share basic concepts we, in turn, rejuvenate our interest and enhance our skills. I wanted to reinvent the way I taught value study using a fresh approach, one that would give students more decision-making power. My goal was to have students select a subject and develop an image with self-expression.

PROBLEM

Using Cubism as a jumping-off point, students will develop a large, single-subject drawing as a way to develop their understanding of value study. They will increase their knowledge about shades of gray while learning how Cubism can influence their personal expression.

Simple geometric shapes break the insect form.

Joe Contuzzi, grade 10. Pencil, 18" x 24" (45.7 x 61 cm).

TIME FRAME
Two and one-half weeks.

MATERIALS
• 18" x 24" white drawing paper (80 lb.)
• drawing pencils (4H to 6B)

STARTUP

Have students select a subject and produce a large contour line drawing of that subject. Encourage students to focus on a single item such as a car, insect, person, or fish.

Students should place their subject so as to create a compositionally strong image. At this point students have not yet begun their value study. Gather visual examples of Cubism from books or slides.

PROCESS

After students complete their contour drawing, have them consider creative ways to develop value study.

Share with students images of Georges Braque's and Pablo Picasso's paintings. Discuss Cubism in terms of the kinds of images produced, the time line in which Cubism had its beginning, and other artists who worked in the style. The aim is not to focus on Cubism but to use students' understanding of Cubism

Notes on Teaching Value Study

One way to teach value study is to have students select a photograph from a newspaper or magazine to use as a subject. Students work from the established black and gray tones in the photograph and duplicate them with drawing pencils on a sheet of white paper. This copying technique, while of some value, does not significantly increase brain activity as it requires little more than transferring a two-dimensional subject. For this reason, little real learning takes place.

Another way to treat value study is to have students systematically enlarge a selected image. This approach teaches students to use a grid to produce an enlarged version of the smaller object. After making the enlargement, students add the values. This exercise offers more opportunity for learning and forces students to examine changing proportion as well as values.

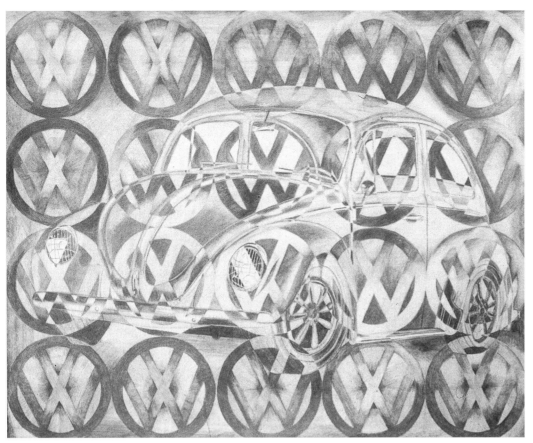

range of gray to each individual shape. Have students proceed from shape to shape and for each shape decide which part will be the richest black and which part the lightest gray. Some will start in one corner of the shape and work to the opposite side and then alternate the black to gray at the next shape. Have students fill the entire paper with values including both the positive shapes and the negative background shapes.

Eric used the Volkswagen trademark as the focal point in this well-developed value study of a VW bug. Eric Bennett, grade 10. Pencil, 18" x 24" (45.7 x 61 cm).

CHOICES

- subject
- dynamics of the altered composition

as a jumping-off point for them to alter their subject matter.

After you have given students this information, ask them to figure out a way to break up their image in a linear way before value is added. Encourage them to think of what shattered glass would look like, or wavy lines of water, the spiral line as seen in a nautilus shell, or geometrical division of shapes such as seen in squares and triangles. These new lines would overlap the line drawing of their

subject. This will alter their initial line drawing by making the shapes more visually complicated. The effect is to create many more shapes, like a giant puzzle.

Then ask students to experiment with gradations of value from rich black, using a 6B pencil to the lightest pencil line using a 4H pencil. With careful attention to each new shape created in the divided image, the element of value is studied.

An extension of this problem is to have students apply the entire

Repeated ocean waves break over the form of the fish. Devi Sengupta, grade 11. Pencil, 18" x 24" (45.7 x 61 cm).

EVALUATION

Have students respond to a verbal critique. Ask: "How is your selected image enhanced by the way in which you fragmented it?" "Do you see the influence of Cubism in your work and in other students' work?" "Was your experimentation and knowledge of value study enhanced in the process?" "Can the viewer still see the main subject after it was developed using this technique?" See also the rubric on page 34.

RESULTS/OBSERVATIONS

Perhaps the most difficult aspect of the problem was breaking up the subject and developing a value study without losing the visual image of the subject. Since every shape needed to be developed, the shading technique created a unified design quality in the finished image. Working large (18" x 24") made this project extremely impressive when exhibited.

CONCLUSION

In this project students made decisions about subject matter, composition, and the way in which value was expressed. Because part of the requirement was that every shape (both positive and negative) be developed in value, students gained an understanding about how to use value, and of the influence of value on the overall design. Depending on the degree of individual decision making, students produced works with more or less self-expression.

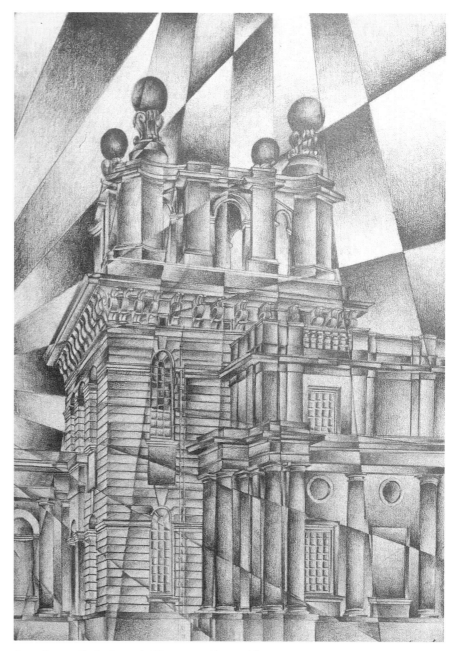

Expressive use of value is seen in this strong architectural form.
Chris Campbell, grade 11. Pencil, 24" x 18" (61 x 45.7 cm).

Three-Point Perspective Drawing

INSPIRATION

When reviewing the principles of one- and two-point perspective drawing in the eleven and twelfth grades, my expectation was that students would remember how to use vanishing points as they progressed in their work. My frustration when I discovered how much they had forgotten led me to do some serious thinking. This was the motivation for a creative problem aimed at teaching perspective drawing.

I wanted to develop a project that required a higher level of thinking, that would help recall students' previous knowledge, and that would add a significant measure of creativity to the picture. The project would review the use of vanishing points while posing a much more complex and demanding problem. The aim was to drive home the principles of perspective and challenge students creatively.

PROBLEM

Students will apply the principles of two- and three-point perspective to a drawing. Students will develop an image of an art museum that will appear to float in space.

TIME FRAME

Approximately two and one-half weeks.

MATERIALS

- colored pencils
- fine-line markers
- 12" x 18" white drawing paper or illustration board

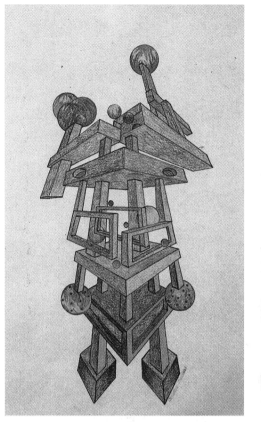

Christine found a solution by creating a balanced, multilevel image.

Christine Kallens, grade 10. Colored pencil, 18" x 12" (45.7 x 30.5 cm).

STARTUP

Review basic information regarding the use of vanishing points in one-, two- and three-point perspective. Share examples generally found in cartooning.

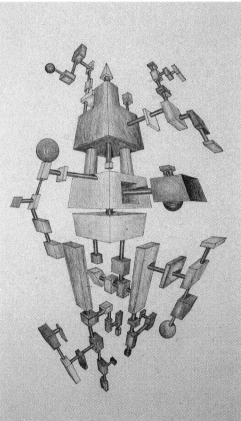

Evan's solution—a floating structure—has a whimsical quality.

Evan Dilluvio, grade 10. Colored pencil, 18" x 12" (45.7 x 30.5 cm).

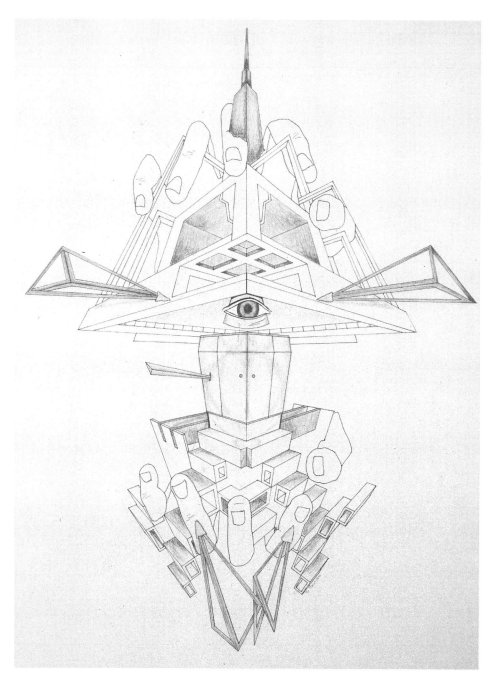

Kris created an eye-catching art museum that makes use of two-point and three-point perspective. Kris Naumann, grade 10. Colored pencil, 18" x 12" (45.7 x 30.5 cm).

structure. Cartoonists use this technique to exaggerate the size and scale of buildings. Once students understand how to use the third point at the top of the page, they will also understand how to place a fourth point at the bottom. This adds drama as it builds both up as well as down. It is at this point the structures appear to float. The fourth point may remain optional but many students choose to use it.

Have students use a No. 2 pencil to begin the process of initial sketches. Allow students to choose the medium they will work with. Have students work on 12" x 18" illustration board or 12" x 18" white drawing paper. Tell students that this is not to be just any art museum but their personal art museum. Ask: "In the future, if people could fly throughout the universe and they came across your museum, would it be visually inviting?" "How do you envision it looking?" "Would it catch them by surprise?"

Some students may express an interest in the field of architecture, so various examples may be shown to increase their awareness. The work of Frank Lloyd Wright is particularly striking to students. They are impressed by the structures and by how long ago the work was actually created. Because Wright's structures reflected his visionary mind, students are motivated to use their own visionary qualities.

PROCESS

In two-point perspective, each point is placed on the horizon line and any horizontal angle is grounded to these points. Explain that the importance of utilizing vanishing points is to create consistent angles in the figure-ground relationship. The third point can be added at the top of the page so that all vertical angles line up to that point. This will exaggerate the angles of any

CHOICES

- media
- development of image

EVALUATION

Have students respond to a verbal critique. Ask: "What makes any structure inviting?" "Will people be attracted to your museum?" "What aspects of this project were the most challenging?" "Were you satisfied with your visual solution to the problem?" See also the rubric on page 34.

RESULTS/OBSERVATIONS

Students who were developing portfolios for college entrance often found the idea of their own art museum very appealing. Students were inspired to take risks and make numerous decisions. This project balanced technical skill with imaginative abilities. Even though a variety of media was available, most chose colored pencils and fine-line markers to highlight the forms they created.

CONCLUSION

Students' understanding of the principles of perspective drawing can balance with the freedom they experience to think creatively and produce highly successful works. Out of frustration can come growth for both the student and the teacher.

In most cases, as artist/teacher, I did the problems along with the students in order to gain a greater appreciation of students' thinking process and to offer suggestions to some unforeseen difficulties. Students observed my willingness to put my work on the line for outside comments and even criticism. This also continues the important theme of being an artist/teacher in the classroom—not always easy to do.

As we all know, the creative process sometimes requires many setbacks before success. Encourage students to keep trying until they have exhausted all of the visual possibilities in the piece of work.

In other words: Don't give up too soon and work the image to death before starting over! Failure is not fatal; instead it is an opportunity to learn.

All of these projects begin with a focused visual problem, stimulating questions, and an open dialogue with students. Projects focus first on developing students' skill levels and then finding ways to encourage the artist within each student. As artists, we understand the significance of being expressive and it is vital that we give our students opportunities to do the same. The teacher plans the creative direction and then motivates the students in that direction. Directions that encourage problem solving and lead to unique expressive qualities will produce the most student learning.

The next chapter addresses methods for helping students to develop significant meaning and self-expression in their work.

CHAPTER 4

Moving from Personal Expression to Significant Meaning

This chapter focuses on developing ways to help students put meaning in their expressive artwork. The chapter starts with developing cognitive understanding, moves to reflecting on the relationship of the individual to his or her family structure, and ends with connecting the individual to his or her heritage and society.

It is the true nature of an artist to offer significant meaning through visual expression. This passion drives artists to express, alter, and recreate their own view of reality. The visual problems we pose can help students connect to the richness and depth inherent in being a creative artist. The aim is to create projects that engage students and foster personal expression.

Deirdre created a symbolic mask after reflecting on her sense of self. See page 77 for her statement about her process.

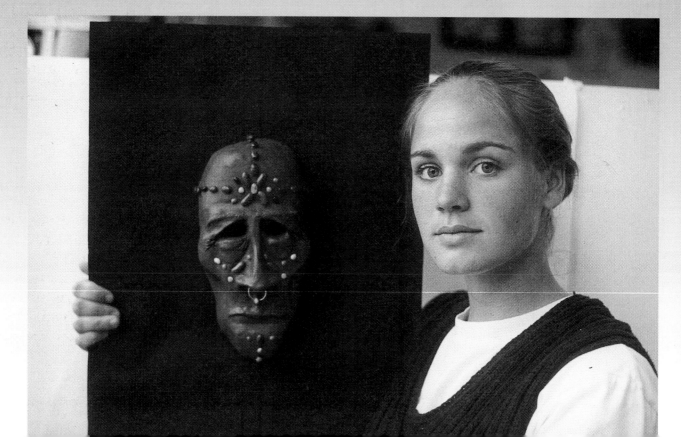

Expression of Personality Through Sculpture

INSPIRATION

How can we motivate students to show personality through sculpture? The idea for this project came as a result of my desire to use sculpture to enlarge students' understanding of expressiveness. After discussing my idea with students, I understood the direction students wanted to pursue but was still uncertain about what results they might create. To direct their efforts, I chose the work of George Segal and Marisol to show as contemporary examples of sculpture.

PROBLEM

Students will create a plaster gauze life mask of themselves. They will express qualities of their personality using the mask and other media to create a reflective sculpture.

TIME FRAME

Two and one-half weeks (thirteen class periods).

MATERIALS

- plaster-covered gauze (plaster craft)
- petroleum jelly (for covering face)
- acrylic paint
- found objects

STARTUP

Show examples of the work of sculptors such as George Segal and Marisol. Share with students the following information about these artists:

George Segal, a New Jersey artist, creates a sense of emotional power by placing his white plaster figures in realistic environments. The power of his work lies in its visual presence, established by the contrast created by white figures set against the darker realistic environment.

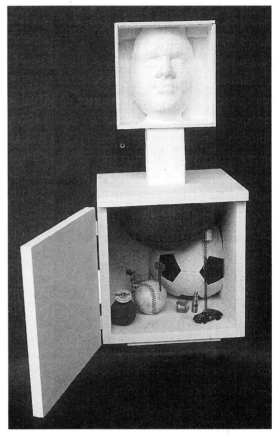

Impressed by the box forms of Marisol, Jay constructed a box sculpture filled with objects that reflect his personality and interests. The baseball and soccer ball are obvious, but others, such as the toy car, toothbrush, and pin, are more subtle. The viewer must translate the visual clues.

Jay Thompson, grade 10. Mixed media, 10" x 10" x 20" (25.4 x 25.4 x 50.8 cm).

Marisol (Mar-y-sol, which means sea and sun) was born in Paris but spent her childhood in South America, with her Venezuelan parents. She followed in the tradition and influence of Picasso, one of the first artists to create sculpture from found objects. Marisol reveals personality through the use of boxy forms and three-dimensional heads. Her work expresses

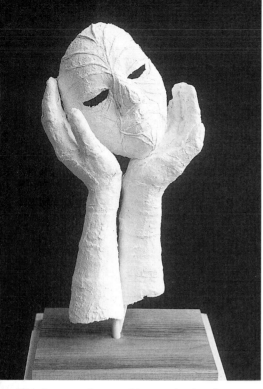

Allison's response has a sensitive, emotional quality, seen especially in the way her hands support her face.

Allison Motto, grade 12. Plaster gauze, 20" x 12" (50.8 x 30.5 cm).

the individual personalities of her subjects. The work of both artists is personal yet abstract enough to be universally understood—bold and expressive, and powerful. Students find the work of both artists visually engaging.

PROCESS

Students begin by creating a life mask of themselves using plaster-covered gauze. The face casting is done cooperatively with two other students. The face casting is a simple process, easily accomplished by having students work cooperatively in groups of three. You may want to first demonstrate the process for students.

Plan the procedure carefully, bearing in mind the time limitations of a class period. Have one student cut the plaster-covered gauze from the rolls into small, 2" squares while the other supplies a container of room temperature water and covers the work table with newspaper. Have the model apply a thin coating of petroleum jelly on his or her face and under the chin, paying extra attention to the hair line and eyebrows. To keep within the time frame of a class period, have two students apply the two to three layers needed to make the life mask. The plaster gauze is dipped into water, applied and smoothed, with each layer overlapping the other to make a strong bond. The eyes and end of nose are not covered, as the lime in the plaster can irritate the eyes. These areas can be easily covered from the inside once the mask is removed from the student's face. Remove the casting in approximately twenty-five minutes; this will allow time for the models to wash their faces while other students clean up the work area.

Even though the face casting is a simple process, students share a sense of accomplishment once it is complete. What is most important is what happens next to the face castings. What are the possibilities? To encourage personal expression, have students plan other materials or castings to use in their sculpture. Encourage them to use found objects or objects brought from

home as well as varied media. Point out that they can select objects or media that express an aspect of their personalities as artists. As usual, some students will have a strong sense of direction while others will ponder the possibilities. As the work progresses, some will be open to discussing their work while others will decide to reveal subtle aspects of themselves and not discuss their meaning. The role of the artist/teacher is to facilitate and support students as they deal with the technical aspects of their pieces.

CHOICES

• development of the subject
• size
• use of varied media

EVALUATION

Have students respond with a group verbal critique. Ask: "Does your work reveal aspects of your personality?" "What elements of yourself did you include in your sculpture that you feel the viewer will easily understand?" "Can the viewer see expression and aspects of your personality in the work?" "What new insights or opinions were gained concerning contemporary sculpture?" See also the rubric on page 34.

RESULTS/OBSERVATION

Students were allowed time to think and reflect on aspects of their personalities, and to gather materials. Students worked well as a group casting each other's faces, critiqued each other's work, and understood that the use of white plaster (left white) gave their results a simple and clean look. This contrast helped students understand the concept that "less is more."

CONCLUSION

High school students are capable of producing personally expressive works, especially when they are encouraged by the process and the work of other artists. Students' work showed visual unity achieved through their use of media. To my surprise, students' sculptures reflected the contrast and visual presence of George Segal and the revealing personality of Marisol—the two artists whose work I had initially chosen to share with students.

This project offers students an opportunity for personal introspection and reflection through analysis and symbolic representation. Students examine their personal values and aspects of their personality, and capture and share some of these with the viewer.

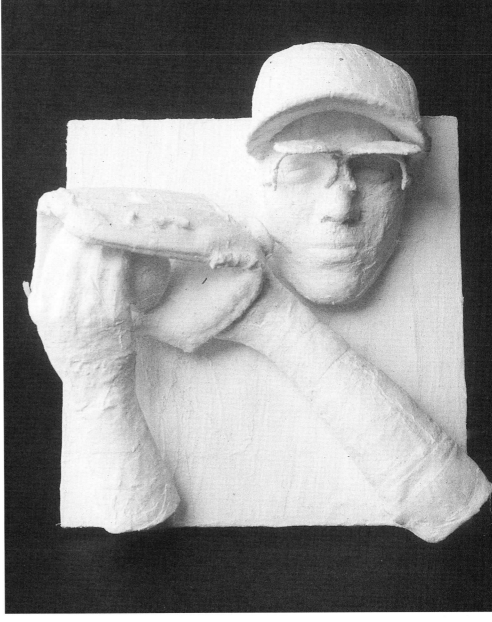

Frank's love of baseball comes through in this well-executed wall relief.
Frank Pinnelli, grade 12. Mixed media, 18" x 16" (45.7 x 40.8 cm).

Creative Photomontage

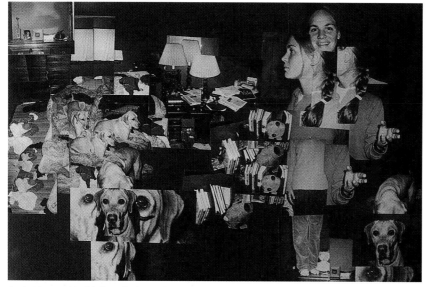

A visual story is told through this unified composition.
Deirdre Coyle, grade 11. Photomontage, 18" x 24" (45.7 x 61 cm).

INSPIRATION

As parents and teachers, we know that the sacred domain of a teenager is their bedroom. It is a place of autonomy and privacy, the space within which teenagers establish their own identity. Since all great self-portraits provide insight into and reveal qualities of the artist as an individual, what better location for a teenager to begin a self-portrait? The motivation and inspiration for this project began with the idea of combining the concepts of Cubism and the photographic style of contemporary artist David Hockney.

PROBLEM

Students will photograph themselves in their own personal environment—their bedroom. Students will use their photographs to create a photomontage that shows an understanding and influence of the style of David Hockney. Students will learn how to effect a visual storytelling quality and will acquire a better understanding of Cubism.

TIME FRAME

Two to three weeks at home to shoot and develop photographs. Two weeks of classroom studio time.

MATERIALS

- throwaway camera or a borrowed camera
- 35mm film (400 ASA if possible)
- 16" x 20" to 18" x 24" illustration board
- X-acto knives
- paper cutter
- scissors
- glue sticks

STARTUP

Students who do not have a camera should either borrow one or buy a throwaway camera. Also, students will need to provide a roll or two of film. Share with students examples of work done in the Cubist style as well as examples of the contemporary photographic work of David Hockney. Discuss the visual influence of Cubism in Hockney's work. This information will provide students with artistic grounding as they develop their own personal expression.

PROCESS

First show students examples of the work of Picasso and Braque and then examples of Hockney's work. Ask: "What do Cubism and the work of David Hockney have in com-

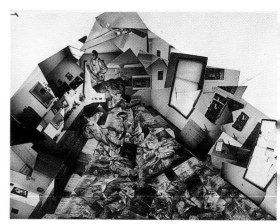

Jason's solution was to show himself appearing to float off his bed.

Jason Saro, grade 11. Photomontage, 18" x 24" (45.7 x 61 cm).

David Hockney and Cubism: Connections and Similarities

✳ Hockney, a contemporary British artist now living in the United States, is most known for his innovative paintings and unusual set design. His portrait photography is like a visual story. Hockney believes that one photo cannot possibly tell the whole story. The photographed individual needs to be placed in his or her environment and given a sense of place and time. The combined effect of many photographs, as well as the use of fragmented images, creates the total visual impact.

✳ Artists working in Cubism sometimes choose as subjects people in fragmented forms, but most often common objects are their focus. These artists freely rearrange their subjects so that the fragmented parts create new visual images.

✳ At its height, between 1904 and 1914, the most significant contributors to Cubism were Pablo Picasso and Georges Braque. Initially the movement focused on the analysis of visual forms and was called Analytical Cubism. Later, as artists felt free to use found materials and paste them onto the canvas, the movement was called Synthetic Cubism. It was at this point that the technique of collage ("collage" is the French word for glue or paste) was developed.

✳ Cubist images were domestic in subject matter and did not have a political agenda.

✳ David Hockney's images are also domestic in subject matter and without a political agenda.

✳ Both Cubists and Hockney broke rules, particularly in the areas of perspective and expression.

mon?" "How many similarities are there?" Explain to students that their photomontage work should include the following:

• The photomontage should show the relationship of the person/subject to the environment in which they are photographed.

• Imagery should be used creatively—by breaking up or fragmenting the original form and bringing it back together to create a new image.

• The photomontage should have a storytelling quality that gives insight into the person/subject.

Encourage students to see their room as it is and note their influence in that space. You may wish to discuss the two opposites—the "neat freak" and the "super slob." Impress upon students that they do not need to change who they are, just reveal it to the viewer. Tell them to share what is important or significant about the space and themselves with the viewer. Remind them that one direct photo will not tell the viewer enough. Students may repeat photographs of a particular part of their room in order to show the importance of a personal item. Such personal items might include pets, a musical instrument, or a stuffed animal. Remind students that many famous photographs include hands due to the particularly expressive quality of hands.

Introduce this project up to two weeks ahead of time to allow students time to acquire the materials they need. Tell students who intend to borrow a camera that they do not need to bring the camera to school; they will need it for only an hour or two at home. Tell students to shoot and develop the film before the project begins. When students bring their photographs to the artroom, the viewing, cutting, and compositional arranging begins. Students may use X-acto knives, scissors, or paper cutters. Encourage students to arrange their photographs on the paper before gluing. Remind them that their arrangement should give insight into themselves as a person/subject. Most students will readily accept this challenge but a few may protest that their room does not represent them because they spent so little time there or because they have matured and outgrown their room. Help these students problem solve. You might suggest that they represent these differences and contradictions visually while staying within the context of their rooms.

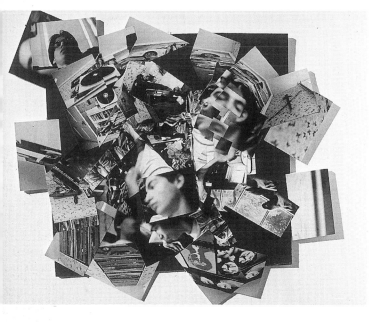

Dan solved the problem by arranging photos—some sharply focused and others out of focus—in a way that suggests circular movement. His work captures many qualities of adolescence.

Dan Fiori, grade 11. Photomontage, 18" x 24" (45.7 x 61 cm).

fragmented images. These images were posted in the artroom for the duration of the project. Using the style and storytelling quality and of David Hockney, students created montages that revealed aspects of their personality.

CONCLUSION

Students' photomontages provided insight into their personalities and their home environments as well. In the end, students' excitement over the images they created outweighed their concerns about disclosing the contents of their bedrooms. The project proved an excellent vehicle for promoting expression, combining photographic media, and relating to a style in art history.

CHOICES

• development of subject matter
• size

EVALUATION

As the students completed their montage they were asked to assess their success based on their understanding of Cubism and of the work of David Hockney. Have students respond with reflective writing. Ask: "How does your work reflect both Hockney and Cubism?" "What would your photomontage tell a viewer about you as a person?" See also the rubric on page 34.

RESULTS/OBSERVATIONS

The most challenging aspect of this project was working with each student to solve compositional problems. To help students avoid a static quality, they were told that the main focus should not be in the middle of the composition and that photos should not look like they were just dropped in. Emphasis was placed on working with the subject

matter so as to direct the viewer's attention and maintain visual interest. As a result, students' works evidenced strong and intentional composition. Students extended this assignment by bringing in advertisements from magazines that also used the technique of

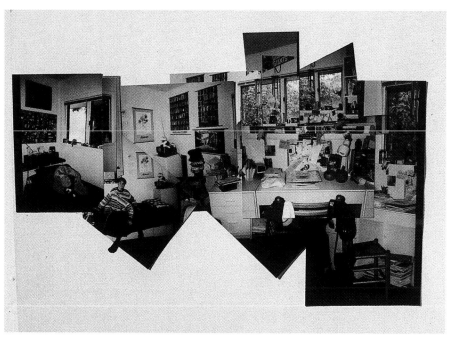

Jessica found a way to reflect some of her personal qualities in this well-organized montage.
Jessica Stanton, grade 11. Photomontage, 16" x 20" (40.8 x 50.8 cm).

Exploring the Landscape of Our Mind

INSPIRATION

The face we show to the outside world is not necessarily indicative of how we feel inside. As humans we are drawn to appearances and rarely share our internal psychological framework with others. As artist/ teachers, we understand the importance of self-expression and realize that students seldom see beyond the surface or have the opportunity to reflect on deeper levels of their developing personalities. It was my sense of the untapped richness and depth in the students I teach that motivated me to develop this project. Experiences that foster trust and revelation provide both teacher and students with the opportunity to learn more about themselves and each other. Because a mask enables us to hide, disclose, and exaggerate, it can provide the ideal vehicle for students as they take the risk of exposing their inner selves.

PROBLEM

Students will create a personal three-dimensional mask that reveals five aspects of their personality. Ask students: "How reflective and expressive about yourself are you willing to be?"

TIME FRAME

Approximately three weeks.

MATERIALS

• variety of media: wire, papier-mâché, paper, clay, copper sheets (for repoussé), plaster covered gauze, acrylic paint

STARTUP

Two things need to happen before the students begin their work. First, discuss and define psychological qualities. Explain that as humans we have physical, emotional, and spiritual sides. Then tell them that as part of this project they will take some time to examine themselves internally from a psychological perspective. Ask students to think about the following: How do you handle life? Are you an open person or are you guarded? Filled with anxiety or calm? Look at other qualities such as perfectionism, outgoing personality, shyness, and anger. Do you allow others to see who you really are or what you are thinking? How does your personal psychological makeup affect your daily life? What do you know about yourself on this level? What are aspects of yourself no one else sees?

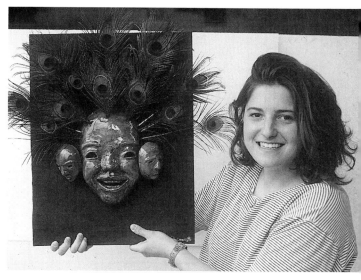

Alerica chose to work in mixed media as a way of showing the varied qualities of her personality.

Begin by asking these and similar rhetorical questions. Students can share their reflections verbally or document them on a more personal level in their sketchbooks. The final and most important question for students to consider is: How can you use artistic language such as form, color, line, and texture to represent aspects of your psychological selves?

Have students view a variety of masks from South America, Africa, and the Pacific Islands. You might also discuss with students the use of masks in our own culture, such as during Mardi Gras in New Orleans and at Halloween.

PROCESS

As students decide on media and direction for their masks project, remind them to consider the amount of time they will need to work in the media they choose. Casting the face in plaster will take only one class period, whereas working in water-based clay, which includes modeling, drying, and firing, will take many more days.

A generous amount of time permits and encourages students to think, plan, and experiment with different media. If students choose clay as their medium, allow ample time for drying, firing, and finishing. Also, give students time to rethink and revise their mask and enhance its strong points.

As they create the mask structure, tell students to think ahead about what colors and textures they will use. Encourage students to think about elements that might hide, disclose, or even exaggerate their chosen psychological qualities. Only after they have thought these questions through should they choose additional media.

As students complete their masks, one significant task remains. Ask students to hand in a page of reflective writing that describes the five psychological aspects of themselves represented in their masks. Have students respond to the symbolic representations that evolved from their choice of media and their use of color and texture. This important part of the learning process needs to be kept confidential. Assure students that their writing will not be shared with any other students without their explicit permission. Students appreciate such confidentiality. (Students, therefore, must give written permission in order for their writing to be included as part of an exhibition of their work.)

CHOICES

- development of subject
- media
- size

EVALUATION

Have students respond in writing to the following questions: How would you describe the five psychological aspects represented in your mask? How did you decide what media to use for your symbolic representations? Do you feel you expressed yourself completely using the artistic language of line, color, or texture? Would you make any changes in your work now that you have reflected on it?

Note that this very important part of the learning process needs to be accomplished confidentially. The students are attuned to the symbolism in their work and some may be very curious about the symbolism in other students' work. No student should be asked to share that information unless he or she is comfortable doing so.

Evaluate the project when students have completed and submitted both the mask and the writing. See also the rubric on page 34.

RESULTS/OBSERVATIONS

Masks are commonly used on the elementary level in art, but this particular problem required of students a more cognitive response than is expected of elementary students. As an artist/teacher, this project allowed me the privilege of seeing the depth and thought behind my students' work. Because they were open and honest in their written reflections, I gained insights about them and they learned about themselves.

CONCLUSION

Masks have been used for centuries and in all cultures. As a means of expression, it seemed the best choice for revealing personal qualities. In an effort to document the process, specific students were asked to condense their writing into a short paragraph so that artwork could be viewed in relation to the writing. Interestingly, although students were reluctant to share some of their insights with their peers, they did not hesitate to volunteer their thoughts to a larger, impersonal audience.

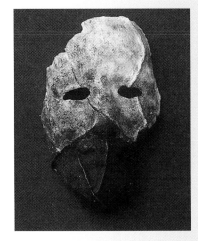

Carl's solution was to use colors to symbolize his emotions.

Carl Lessing, grade 11. Plaster gauze and acrylic paint, life-size.

"I am quite obsessive about many aspects of my life. The missing portions of my plaster mask show my inability to tell people how I really feel, and that really tears me apart inside. The color red shows my frequent anger and its degree. The color blue shows depression usually caused by this anger. Depression is also symbolized by the ridges in the mask. An expression of sadness is also seen in the shape of the eyes."
— *Carl Lessing*

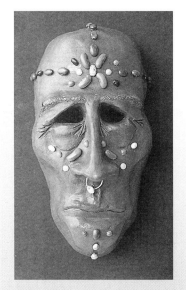

Deirdre used an unusual combination of media to express herself.

Deirdre Coyle, grade 11. Mixed media (ceramic, acrylic paint, dried beans, metal nose ring), life-size.

"I chose to paint my mask brown because I am a mixture of all colors without any features of my personality dominating the rest. The grave expression of the mask expresses my serious attitude while the nose ring displays a spirit of nonconformity.

"In his essay *Walden*, Henry David Thoreau used beans to represent thoughts, the seeds of conviction. I am always thinking and so I decorated the mask with beans radiating from the forehead, as though they were radiating from my mind. The dull brown color that I chose reflects a dislike for ornaments and a penchant for simplistic beauty."
— *Deirdre Coyle*

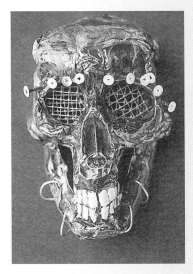

Eric used copper, wire screen, and screws to create his mask.

Eric Bennett, grade 10. Mixed media (copper, wire screen, screws), life-size.

"The overall image of the skull represents getting attention and having fun by doing destructive acts. The multiple screws in the mask represent both the increasing pressure from the outside world and the pressure I put on myself for ideas. Due to this pressure, I keep my feelings and ideas inside which is represented by the cages in the eyes. Because of this, no one sees to the inside. The rings are what lead me to follow others while the white teeth stand for some quality of my individuality."
— *Eric Bennett*

Each material in Josh's mask symbolically represents a part of his personality.

Josh Jones, grade 11. Mixed media (wire screen, wire, paper, marbles), life-size.

"The screen 'skin' on the mask represents a mechanism of protection through which I sift out possibly damaging ideas or actions of other people. I let only a very selective group of people get close to me. The silver and copper wires woven through the screen represent the structure and order within my life as well as my flexibility. The blue and green eyes represent how I feel I'm perceived by different people depending on how well they know me. The movable shells seen in the mouth behind the screen represent my emotions. The colored paper inside my mask represents the flexibility of my mind. The bright colors represent my positive attitude towards life."
— *Josh Jones*

Memory: A Visual Connection

INSPIRATION

As our high school computer lab was being upgraded with new equipment, it occurred to me that computer memory chips might offer possibilities for creative thinking and expression in art. My motivation for this project was an interest in making an intellectual and artistic connection with new technologies and resources like the computer. On the other hand, I realized this could be a very complicated topic to explore. For this reason, I focused on one important aspect of computer technology, an aspect that people and computer technology both have in common: memory. I began to think about how humans and computers use and respond to memory. During this initial thought process, several questions came to mind. How has our perception of memory changed with the increase of technology? Do we only think about memory in terms of "long-term" and "short-term memory" or have we now added words like "capacity" to the way we talk and think about memory?

PROBLEM

Students will think about the concept of memory from the perspective of technology and the human brain. Then they will creatively develop an artistic statement that makes a personal connection to the concept of memory. Students will use the media of their choice to integrate the computer chip into an artistic statement that focuses on memory.

Memory Research

The small computer memory unit or chip called a SIMM (Single In-line Memory Module) holds 256K, which is equal to 64 pages of text. The SIMM relates to "random access memory" (RAM) of the computer because it deals with short-term memory. This type of memory is volatile; if the power on the computer is turned off, the ability to remember is lost. "Read only memory" (ROM), by contrast, exists in the hard drive of the computer and reflects long-term memory. Computer memory is set up mathematically and is designed to retain small bits of information. This is accomplished through the use of electric pulses. We are concerned with quantity of memory in computers because complicated programs require increased memory. Memory chips can add the memory needed to run such complicated programs.

In humans, memory is stored in the largest part of the brain, the cerebrum, which is composed of two cerebral hemi-spheres. Research at Johns Hopkins University has shown that memory is stored in different parts of the brain and any stimulus of our senses will stimulate the neurons in certain parts of our brain. Every memory is made up of many different neuronal connections or patterns created as our senses fire off minute electric impulses simultaneously. It is this repetition of the stimulus that creates a memory.

As humans, we have an electrochemical property (reactions) in our brain, a basic difference in the functions of our memory and our computer's memory. If the chemistry is off balance, the electri-cal connections become impaired and our memory is affected. Drugs can also interfere with normal functioning of specific neuro-transmitters that affect memory and other cognitive functions. Our experience and knowledge through life are permanently encoded within our brains. These memories are part of who we are and how we understand ourselves.

Specific areas of the human brain are linked to long- and short-term memory. Consider the effect of a stroke or head trauma. The inability to identify a person's face or recall a name occurs when certain parts of the brain are damaged. According to author Richard Restak, M.D., "The richness of memory is a reflection of the richness of personality. The more data that can be brought by means of memory, the more enlightened our present behavior, particularly our decision making." (*The Brain*, by Richard Restak, M.D.)

TIME FRAME

One week at home after introduction.
Two and one-half weeks studio time.

MATERIALS

- one memory chip per student
- illustration board
- variety of drawing and painting materials (colored pencil, pen and ink, markers, colored chalk, acrylic paint, watercolor paint)

STARTUP

Acquire obsolete memory chips and share information with students about memory in humans and in computer technology. Discuss the dynamics of human memory and memory as it relates to various aspects of technology. Use these ideas to help students think about the connections between human and technological memory:

- There are similarities and differences in the human brain and the computer.
- Both people and computers have short-term and long-term capacity for memory.
- Both people and computers can lose memory.
- Memory can be defined as storage and integration of information.
- There is a limited capacity of memory in a computer chip.
- The memory chip is a resource much like the reference section of a library.
- Refer students to Salvador Dali's *The Persistence of Memory* (1931).

Ask: "What connections concerning memory can you make?" To help students connect with the concept, ask additional questions such as: "What was your earliest memory?" "Can your five senses (smell, taste, touch, vision, and hearing) trigger a memory?" "What 'triggers' computer memory?" Allow students time to think and plan before taking class time for the project.

PROCESS

Distribute one computer chip (SIMM) to each student. As they hold it in their hands, ask students to think about the concept of memory. Tell students to develop an artistic statement that connects either a personal memory or intellectual idea to the concept of memory.

Have students brainstorm ideas using "mind mapping" (renamed "memory mapping" for this project). Mind mapping is a technique to generate a number of ideas quickly and decide which one offers the most potential. To do mind mapping draw a circle in the middle of the page, write the main idea in that circle, and draw additional circles connected by lines to the circle in the middle. In these circles write additional thoughts connected to the main concept. In the case of this project, students place the memory chip in the center of the paper and then draw a number of lines from it in all directions. At the end of each line a circle can be

drawn in which students write a word or draw a symbol that goes with their main concept about memory. In this way all ideas can be explored to their fullest.

Tell students they will use their three-dimensional memory chip as a significant part of their composition. Students do not have to retain the original form of the memory chip. The chip can be cut, broken, or painted provided it maintains a significant place in their work. Students might choose to have the chip be the only three-dimensional aspect of their work.

Have students choose the materials they will use to implement their ideas. Ask: "What are some ideas and artistic possibilities for exploring the concept of memory?" "Which materials will best help you to develop your concept into a work of art?" Have students complete this part of the project about a week before class time begins. A number of students will be ready to begin developing their ideas before the two weeks of class time begins, while others will need more time to think and plan.

Have students plan the size in which they will work and choose media that will best express their ideas. The most important part of this project is that students create an artistic expression that reflects their concept of memory.

CHOICES

- media
- size
- working in two or three dimensions

EVALUATION

Evaluation is based on originality, technical skill, craftsmanship, and the productive use of class time. Reflective writing, while an important aspect of this project, was not included in grading.

When students finish their visual memory project, ask them to answer several open-ended questions. Ask: "What was the main idea or connection with memory that you developed in this project?" "What do you hope viewers will understand as they view your memory image?" See also the rubric on page 34.

RESULTS/OBSERVATIONS

The project was introduced a full week before the in-class time was given to do the actual work. This allowed students time to brainstorm, think through ideas, plan, and make decisions. Class time was used to resolve media and actual production issues. What appeared at first to be a highly intellectual problem produced diverse solutions—some comical, others thought provoking. In this project, students shared insights concerning the concept of memory and produced inspiring results. As they moved from exploration of a concept to the creation of an artistic statement, students made visual connections on abstract levels.

CONCLUSION

Structuring assignments carefully is vital to the success of classroom projects. Begin any problem-solving project by first brainstorming ideas. See how many connections students can make before formally introducing the concept. In this way, the teacher gets some sense of the potential of a particular idea. Try to approach the project without preconceived notions concerning its outcome. This will allow the element of surprise for both students and teacher.

In many ways I went blindly into this project, not really knowing if students could either incorporate the memory chip into their work or integrate the concept of memory into an artistic image. I did believe that all students would be able to make connections to memory, and I also understood that decision making would be a significant issue for students as they completed this project. Should students pick an actual memory to work with, or deal with a concept related to it? In addition, students would need to decide how to integrate the chip into their compositions and select the appropriate media to develop their ideas.

Students produced work that was both successful and highly expressive. The project helped students make connections that were both rich and meaningful. Some dealt with early childhood memories (both positive and negative) and blocked painful memories, while others focused on concepts such as loss of long- and short-term memory or connections with present day technology.

About twenty projects were exhibited in the media center of our high school. The students whose work was selected for exhibition typed a paragraph summary, taken largely from their reflective writing done in class. This paragraph accompanied their work and gave the viewer greater insight into students' work. I felt particularly proud that students not only agreed to exhibit their work but further disclosed themselves in the personal statement that accompanied it. One student, who used mirrors in his image, wrote: "The mirror represents the action of memory and remembering, because remembering is like reflecting back on something you know"

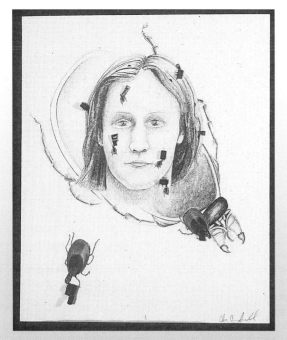

Chris documented his personal struggle with memory loss that resulted from his bout with Lyme disease.

Chris Campbell, grade 12. Pencil and colored pencil, 12" x 18" (30.5 x 45.7 cm).

"Four years ago I was diagnosed with Lyme disease. This piece represents the slow deterioration of my physical and mental well-being. The ticks running away carrying pieces of a computer chip represent the damage done to my memory. My face in the picture remains expressionless, even though ticks swarm all over. This represents my helplessness. I could do nothing but rely on pills and IV antibiotics. My face itself is embedded in a tick. This represents the fact that Lyme disease can never be entirely cured." — *Chris Campbell*

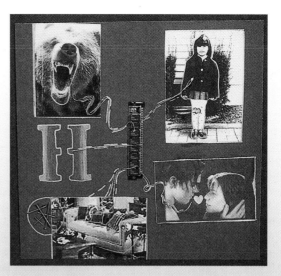

An early childhood memory was the catalyst for this solution in which Georgia used photocopies, wire, a silver pen, and a nail.

Georgia Cochrane, grade 10. Mixed media, 10" x 12" (25.4 x 30.5 cm).

"My project connects to my earliest memory, which was getting stitches when I was three years old. Our living room was under construction so there were nails everywhere but that didn't stop me from jumping on the living room sofa. One day my parents left the babysitter with specific instructions not to let me jump in the living room for fear I'd get hurt. My babysitter had other things on her mind when she invited her boyfriend over. Without any supervision I managed to jump on the sofa, fall, and land on a nail. I was rushed to the emergency room with a bleeding knee." — *Georgia Cochrane*

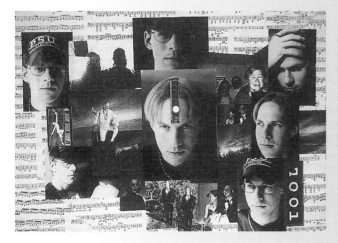

Smith Freeman utilized black-and-white photographs, photocopies of music, and a small round mirror placed on the memory chip for his reflections about adolescence.

Smith Freeman, grade 10. Mixed media, 18" x 24" (45.7 x 61 cm).

"The pictorial collage represents the different feelings and expressions I have felt in the past. One of the feelings I tried to portray is the typical adolescent 'the need to find myself' idea. The only true way for one to find one's self is through memories and putting them together. My main idea is of self-discovery and remembrance of who I was, am, and will become. I hope the viewers will be able to recognize more about who I am beyond what I seem like day to day. Maybe they can also see some of themselves in me." — *Smith Freeman*

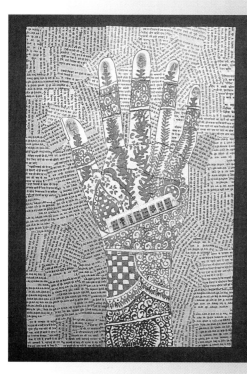

Jyoti responded by using Indian newspaper, henna, and personal photos to show her connection to her Indian culture.

Jyoti Agarwal, grade 10. Mixed media, 12" x 18" (30.5 x 45.7 cm).

"I chose to use henna for this project because of the recent trip I took to India. It represents my Indian culture and what I learned while I was there. The henna dye was used to create a design which leads from the memory chip to the ends of the fingers. Each finger has a drawing of my different Indian memories as it not only shows how important memory is but how all my Indian memories are based upon the Indian language." — *Jyoti Agarwal*

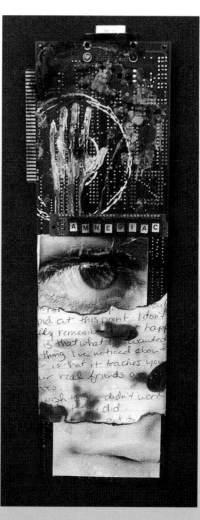

Lance chose to solve the problem by making a statement about blocking out painful memories.

Lance Harrington, grade 12. Mixed media, 4" x 15" (10 x 38 cm).

"This piece deals with the theme of a conscious amnesia, or the willful loss of memory. The imagery represents the scarification of a sacred or pure state and the horrible desecration of innocence. Sometimes these are best forgotten."
— *Lance Harrington*

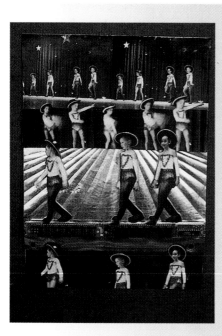

Melissa used metal from a discarded computer as the stage and personal photos to visually portray her memories of dancing. The placement of the chip deals with her memory of the sound of tap dancing.

Melissa A. Chung, grade 10. Mixed media, 9" x 12" (22.9 x 30.5 cm).

"I have been dancing for thirteen years. When I was seven years old, I devoted two evenings a week for my tap and ballet classes. Each spring the dance school held a recital for all the dancers' family and friends. I have many fond memories of dance class but the most important one is the feeling of being young and free. This project represents a time in my life when the most important things were performing and having fun with friends." — *Melissa A. Chung*

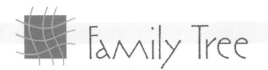

Family Tree

INSPIRATION

Families are a diverse group of people, often embodying a range of human qualities and attributes. We need to be sensitive to the fact that families are now seen in a variety of ways. Family structures can include blood relatives, adopted parents, single parents, foster families, older siblings, grandparents, gay parents, and other combinations of people.

Because family members can have such a great impact on each other, it is important to take time to reflect on and, perhaps, better understand family members. The dynamics of our present society can create great stress, which in turn, can dramatically affect families and family structures. As artist/teachers, we understand the importance of developing artistic skills and expression. It is also important to acknowledge the relationship of that artistic skill and expression to current social and political issues. A mixed-media sculpture problem was developed in order to help students understand

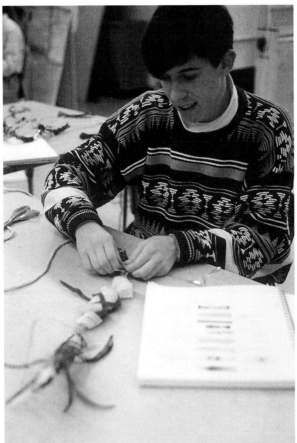

Josh Jones, grade 10, refers to his documented information from his sketchbook as he develops his symbolic family tree.

this relationship. The visual problem is structured to encourage students to look at the infrastructure of families and express the relationships they see in art.

Since one definition of family is a group of individuals who can trace their descendants from a common ancestor, this project calls for a linear model that will capture

this linear aspect of family structure. The project involves both creating a work of art that symbolizes family members as well as using writing to learn more about both process and product. The aim of this project is to help students develop artistic skills, gain personal insights, and make connections that will positively affect their lives.

PROBLEM

Students will create a vertical, linear, and symbolic family tree sculpture with the emphasis on line, color, and texture. Students will look at, identify, and represent the attributes of each family member in visual language. Students are to identify the most significant people in their families, think about the influence exerted by each of these people, and represent that influence symbolically in art.

TIME FRAME

Three weeks.

MATERIALS

• clothesline, 10' per student
• variety of materials to start the process (string, wire, steel wool, plastic wrap, aluminum foil, lace, felt, yarn, and leather strips)

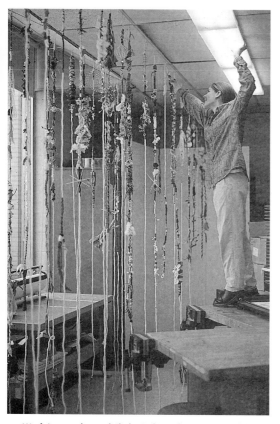

Work is stored on a daily basis from the artroom ceiling.

STARTUP

Simplify this potentially complex project by breaking it into parts. Have students start by producing in their sketchbooks a chart that lists in outline form each member of their family. Beside each name (or coded initials) have students include a column for line, color, and texture. Tell students to identify family members in terms of what kind of line or lines they are, color or colors they embody, and textures that best represent them. Students might represent these people by artistic media (colored pencils, markers, etc.) or describe their qualities in terms of line, color, and texture. Since some information will be difficult to share, giving students the option of referring to people by coded names will provide a degree of confidentially. Have students refer to the chart in their sketchbooks as they begin the process of articulating the first family member.

PROCESS

Have students select materials that can be bound, wrapped, or tied around the clothesline and that show the kinds of lines, colors, and textures students have decided best represent individual family members. Students will need diverse materials to make this project work. Ask them to bring to class anything that could be "wrapped." Suggest "leftover" materials from home, such as yarn, ribbon, string, and wire. Encourage any material that shows diversity. Also include materials such as steel wool, plastic wrap, aluminum foil, lace, felt, and leather. Distribute the 10' long clothesline to each student to use as an armature for the wrapping. The rope will provide an overall unified structure for the project. If your artroom has a drop ceiling, you can tie a loop at one end of the rope so that works can be hung from the ceiling for daily storage. Paper clips shaped into hooks and attached to the metal supports between the ceiling panels make this possible.

Before they begin the project, give students the following general guidelines concerning their writing: Write legibly and in complete sentences. Address the questions asked. Use a code word or symbol to identify family members, rather than the person's name so that privacy is respected.

Have students choose their material for the first person and starting at the top of the rope, bind it to the rope by wrapping or tying. After the first section is finished, ask students, using their sketchbooks as a journal, to reflect on their visual representation. Ask: "Why did you choose the specific line, color, and texture to represent that person?" "Did you fully represent that person with the artistic materials you used?" "Did your ideas or concepts change from the original outline?" "If so, why?" As they reflect on and evaluate their work, have students decide whether or not they are satisfied with their visual statement. If they decide it is not complete, have them develop it further. As they finish each representation, have students write a paragraph or two reflecting on their visual statement. Have them do this for each person they represent, before they move on to the next person.

Encourage students to look at each other's visual work as it hangs from the ceiling and observe its diversity. Some students' work may show similarities among family members by repeating in individual representations elements of line, color, and texture. Some may choose to develop sections on grandparents and significant persons who have died.

The last section of this vertical sculpture adds root structures to show that each family tree has its own heritage or roots. Have students tie short pieces of thick and thin rope to the bottom section of the sculpture. This will create a sense of the roots spreading from the sculpture onto the floor. Students should then wrap the roots with neutral or earth colors. These root structures will add visual unity to the individual projects, as well as to the overall combined class sculpture.

When each student's work is finished, hang it as part of the class unit from the ceiling. You might use a 3/4" piece of foam core that originally measured 4' by 8' to support the collection of individual sculptures. Cut the foam in halves, each measuring 4' square. About twenty-five family tree sculptures will hang from each of the 4' squares. These squares form the base of the work and are suspended from the ceiling using wire attached to each corner. Individual family trees will be 10' tall and when hung should be spaced 9" from the next tree unit. This will allow both the creators and viewers to see individual family trees brought together to symbolically form a larger community.

CHOICES
- materials
- development of subject

EVALUATION
Have students critique their work using reflective writing. Ask: "What did you learn about your relationship to your family?" "Did you gain insights into specific family members?" "If so, what did you learn?" "If you were to do this project over, what revisions, if any, would you make?" "What aspects of the project surprised you?" See also the rubric on page 34.

Fifty family trees. Mixed media, 10' (306 cm).

RESULTS/OBSERVATIONS

Students created a symbolic representation using the visual language of line, color, and texture. As in all new experiences, the first attempt (both the visual representation and the writing) was the most difficult and time consuming. After students had completed their first representation, the rest of the project went smoothly. One student noted that intuitive learning took place: "I noticed adding materials unconsciously and later seeing that they worked well in describing that family member." Another student was pleased that the project dealt with other aspects of life as well as art. Still another stated, "I am amazed to have a new outlook on my different family members. This project may have even brought me closer to some of them."

CONCLUSION

Beginning this project was like walking into uncharted territory. Initially some students, especially those whose families had experienced struggles and conflicts, resisted the project. I reassured these students that the project would engage them in a process of reflection and understanding and that would perhaps have a healing effect. And it did!

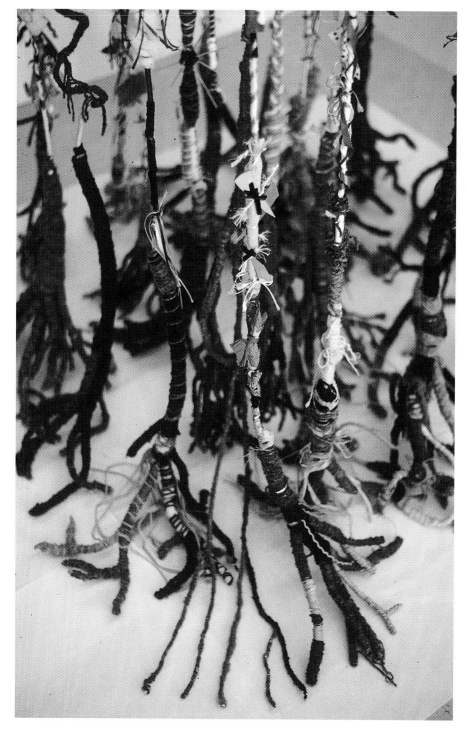

Roots were intentionally developed in a neutral color to show that we all share similar human qualities.

Reflective Writing

Reflective writing forces students to take time to think about and answer the question: What was learned from this experience? When they express their thoughts in writing, students use a different part of their brains than the part they use for visual expression. Asking students to do reflective writing, therefore, helps them to express themselves on another level. For the teacher, students' reflective writing will provide valuable insights concerning students' thinking and learning process. It can also work as a catalyst for future projects.

Develop nongraded open-ended questions such as:

✳ What was the most difficult aspect of this project?

✳ If you could do any part over what would it be?

✳ How did your ideas evolve and what did you discover as your ideas changed?

✳ What were the most and least difficult aspects of this project?

Ask students to write a paragraph or two using complete sentences. Keeping this part of project ungraded will encourage students to give completely honest responses. The writing can be submitted as part of students' sketchbooks or handed in on a separate sheet of paper. Assure students that their work is confidential and will be shared only with their permission. Designate approximately one half to one whole period at the end of the project for students to complete their reflective writing. Students who need more time can finish at home and bring their writing in the next day.

Below are some reflective writing responses from 10th, 11th, and 12th grade students:

What did you learn about your relationship to your family?

✳ "Seeing the similarities of one to another as well as the differences."

✳ "My father section is short because he is away on a lot of business trips."

✳ "I could see how clearly the family fits together."

✳ "My family is very strong willed and we are very similar people."

✳ "I can see more clearly how we all fit together in my family."

✳ "I think more about the family and how we get along."

Did you gain insights about specific family members? If so, what did you learn?

✳ "I learned that my mother is really a complicated person."

✳ "When I look at my father I see a reflection of myself."

✳ "My new insight into my family is that my father loves me more than I thought and he will always do what is best for me."

✳ "I see myself in each of the significant family members."

✳ "There are great similarities in family members as well as differences."

✳ "Realized maturity level differences in siblings."

If you were to do this project again, what revisions, if any, would make?

✳ "I would have spent more time on details and finding out what these people are really like."

✳ "I also would have looked to find more materials to express each person."

✳ "I wished I had worked harder on the depth of each person."

What aspects of the project surprised you?

✳ "Many of my family are very similar in line. This structure was originally found in each of my grandparents."

✳ "I was able to make relationships and personalities visual rather than verbal. Because of this I could see the differences between people."

✳ "[I was] most surprised when I realized my father [who had died] is still so much a part of my family."

✳ "How objectively and truthfully I was able to describe and portray my family."

✳ "How much I really know about each one in my family."

✳ "How well one could represent people just by using line, color, and texture."

Family Structure Seen Through Shape and Form

INSPIRATION

Is it possible after representing significant family members symbolically in shapes to then combine those shapes to create a three-dimensional sculpture? That was the question posed to advanced-level art students. The question required students to reflect on the changing structure of American families, the new family units that result from divorce and remarriage, new roles for women outside the home, and increased responsibility for men in the task of child rearing. In addition, today's families are mobile— whether due to job relocation or moving after retirement—and, as a result, often dispersed over the nation, if not the world.

With so much instability in the family structure, it is important that the students we teach develop new understandings concerning the relationships that most affect their lives. Although the idea of creating sculpture based on the concept of family structures may seem abstract, my personal experience with students motivated me to develop the project. I was convinced that this process would help students reflect on their family unit and see how they personally fit into the overall construct.

To solve this problem, Deirdre worked on a large scale. She discovered that her placement of shapes in this sculpture conveys a lot of meaning about her family.

Deirdre Coyle, grade 10. Foam core, 2' x 1 1/2' x 1 1/2' (61 x 45.9 x 45.9 cm).

"I intentionally made my mother the tallest shape in my structure because she is the one who has the most impact and influence upon all the other members of my family. The repetitive circles in the sculpture show a need for affection and a desire to give it away. I made my project huge because my family is very loud and everyone likes the spotlight. I was surprised at how well simple shape configurations can represent complicated personalities." — *Deirdre Coyle*

PROBLEM

Students will create a three-dimensional sculpture using foam core shapes that symbolically represent their family structure, and express how they see themselves fitting into that configuration.

TIME FRAME

Two and one half weeks.

MATERIALS

Part I

- 12" x 18" oak tag
- scissors
- masking tape

Part II

- 1/4" foam core sheets ranging from 16" x 20" to 40" x 32"
- metal straightedge
- X-acto knives
- straight pins
- five-minute epoxy
- white gesso

STARTUP

In order to increase students' awareness of contemporary sculpture, share with them examples of various artists' work and discuss the artists' styles. Explain the differences between additive and subtractive sculpture. A good resource for examples can be found in *Art In America* magazine, which periodically produces an issue that focuses on sculpture. Another source is *Sculpture* magazine, published by the International Sculpture Center, Washington, DC.

PROCESS

Begin by breaking the project into steps. Have students first list qualities about significant family members including themselves. Then have them draw shapes that would best represent each person. Discuss examples of how this might be done, giving students time to think about their own family members. For instance, a gentle person could be represented with curved or flowing shapes; anger could be represented as sharp angular shapes. A structured person could be represented with geometric or repeated shapes. Warm personality traits might be better shown with rounded forms. A controlled or contained person could be represented as a shape within a shape, utilizing negative space. Ask students to use their sketchbooks to draw a series of shapes that best represent each person in their family. Since people are multifaceted, a number of shapes may be needed to give a full symbolic representation. There is one restriction students must observe as they develop their projects and that is to avoid obvious symbolism such as arrows, hearts, tears, peace signs, or question marks.

At this introductory stage of the process, explain that some artists, like Henry Moore, work from small models and then enlarge. Since many sculptors work this way, ask students to do the same. Because this project focuses on shape, have students use oak tag paper, which is stiff but easy to work with, for their small models

(or maquettes). Have students make their small models approximately 8" in size using scissors and masking tape. Remind students to refer to the symbolic shape drawings they made in their sketchbooks as they create their mini-models. The objective is to construct a combination of shapes for each person and then to place these shapes together to form one flat unit. Each family member or unit will be put together with the others to form the whole sculpture. Tell students also to consider the size relationships of each individual unit. Ask students to think about the following questions: "Who is the most significant person in the family?" "Would you represent this person with the largest set of shapes?" "Where are you in relationship to the rest of the family?" "What are your shapes?" Allow time for students to make adjustments to their mini-model so that the final visual statement shows individual family members together forming a whole family unit.

When students finish their small oak tag models, have them create the final sculpture in white foam core board. Foam core, a more expensive material, will enable students to construct larger works due to its strength and thickness. It is often the material used in three-dimensional design and sculpture models. Have students cut the foam core using X-acto knives and metal straightedges. Use leftover illustration board and cardboard to protect

desktops while cutting. Tell students to connect one shape to another with five-minute epoxy and straight pins. White gesso can be used to cover the exposed pin heads.

Tell students they will be limited in their use of color. Because the focus of the project is symbolic representation of family members through shapes and combining those shapes to make a three-dimensional form, finished sculptures will remain white. However, allow students the option of using one small accent color. The color could be used symbolically to highlight a focal point in the sculpture. Provide acrylic paint for those who want to add one significant (symbolic) color.

CHOICES

• development of structure
• size
• one accent color (if desired)

EVALUATION

This project is designed to engage students in a thinking process in which they reflect on their family structure and their relationship to their family. As part of this reflective process, students write. Students initially identified the shapes they would use to represent various family members in their sketchbooks. Now, have them use their sketchbooks as a journal in which to answer reflective questions. Ask: "How do you see your family fitting together?" "How do you see yourself in relationship to that structure?" "If you used a color,

what is its significance?" "Were there any surprises for you as you created this sculpture?" As they reflect in writing, students will deal with family dynamics and each family member's unique personality. Their challenge is to represent the unique personalities of various family members and still see the family as a unit. See also the rubric on page 34.

RESULTS/OBSERVATIONS

From a technical perspective, the foam core proved difficult to cut while maintaining a clean edge. X-acto blades dulled very quickly. In some cases very fine sandpaper helped keep edges as smooth as possible. The daily emphasis was on good craftsmanship, safety in the use of X-acto knives, and keeping the work clean.

Students had to do quite a bit of thinking to complete their projects, and their results reflected that intense thought. Students realized which family member had the strongest influence and which member or members gave the most support to the family system. Their finished products showed great variety in size, shape, and conception of family structure. Students' responses to reflective writing questions evidenced considerable insight concerning their families and their relationship to their families. Because the written response was not graded, students' comments were honest and revealing.

CONCLUSION

Because I understood that this project involved a visual sharing of personal relationships, I felt that it was important to share with students my family of origin. As the students began working on their small oak tag models, I developed a foam core example that reflected my family when I was in high school. This structure represented symbolically my father, mother, brother, their relationship to each other, and my perceived relationship to them. I explained to students the meaning of each set of shapes I used to represent various family members and how each unit related to the others. The only piece remaining to be added to the sculpture was the representation of myself. I then verbally reflected with students on how my family fit together and the symbolism of the shapes I chose. My example not only provided a model for students, but it motivated them to complete their own sculptures.

The project was a success. Students all related to the concept. And, all students had something very personal to bring their developed image.

Jackie's solution touches on the way artists use intuition and the subconscious as they create works of art.

Jackie Holmes, grade 12. Foam core, 9" x 9" x 20" (22.9 x 22.9 x 50.8 cm).

"The surprise that stands out in my mind is how the subconscious played a part in my artwork. Although I tried to show my family as I worked, I still was amazed at the final outcome—the structure literally and physically represents my family, especially in the support system."— Jackie Holmes

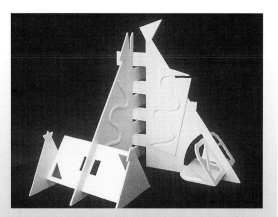

Andrew blended similar shapes to create a form that he sees as a visual representation of his family.

Andrew D'Alessandro, grade 11. Foam core, 20" x 20" x 20" (50.8 x 50.8 x 50.8 cm).

"I see a big tie between my parents. I see my parents fitting together in an interlocking pattern that leans together. They support each other. If you take one of their structures out, the other would fall down." — Andrew D'Alessandro

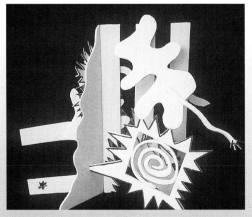

Alerica found her solution when she explored color and shape to describe her family's intense qualities.

Alerica Lattanzio, grade 10. Foam core and acrylic paint, 15" x 12" x 20" (38.1 x 30.5 x 51 cm).

"I used red (as a symbolic color) on all of the spiked areas to represent strength, stubbornness, and even hostility. Every person in my family has this quality."
— Alerica Lattanzio

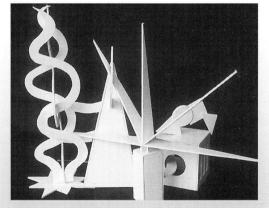

Regan was able to show diversity in each shape while maintaining overall continuity in the final piece.

Regan MacKay, grade 10. Foam core, 18" x 20" x 15" (45.7 x 50.8 x 38 cm).

"My sisters and I are all very different from each other. However, my mother, represented by a supportive pyramid in my sculpture, ties us all together in a loving way. This is represented with a flowing line that originates from her structure." — Regan MacKay

Protest Art of the Nineties

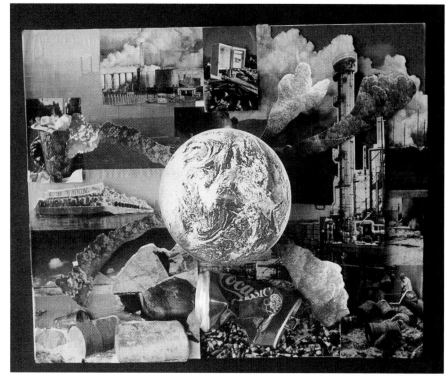

Stan used a soda can and magazine images to make a statement about how pollution affects our world. Stan Su, grade 12. Mixed media, 18" x 20" (45.7 x 50.8 cm).

INSPIRATION

Being myself a product of the sixties, I wondered were there any social or political problems that today's students felt strongly enough about to protest. Cognizant of our society's obsession with getting ahead and acquiring material wealth, I became intrigued with discovering what my students thought was important to them and their larger community. Was there an area or topic that they felt passionately about? If so, would they want to develop a work of art in order to express those feelings?

PROBLEM

Students will create a low-level relief with the image based on a current social or political issue that they feel deserves attention. Students will create a visual protest image without the use of words.

TIME FRAME

Two and one-half weeks.

MATERIALS

- recycled magazines, newspaper images, photocopies
- 15" x 20" foam core board
- a variety of drawing and painting materials (watercolor paint, pastels, colored pencils, felt-tip markers)
- 18" x 24" white drawing paper

STARTUP

Gather a variety of recycled materials. Ask students to brainstorm current political or social issues and to consider how they might develop one visually. To encourage students to look beyond themselves and relate to the society they live in, discuss with them issues that affect society such as poverty, pollution, ecological stability, or international relationships. Ask students: "How can you respond artistically to the issue you feel strongly about?" Encourage students to work on a variety of social and political issues.

PROCESS

Begin by giving students creative control of their protest statement. Allow students to choose their subject, any tools needed, media, and size of work. Encourage students to take risks and combine materials. Remind students that their goal is to express their views on their chosen issue without the use of words and to achieve the strongest visual image possible. Students should select media they feel will best produce a strong visual impact. To increase the challenge, ask students to work in a low-level relief with the images raised

no higher than 1 1/2". Developing the concept in relief allows the artist to direct the viewer's attention to significant areas of the sculpture. Remind students that their composition needs to be clear and readable. The viewer should easily understand the issue and the artist's viewpoint on this issue.

CHOICES
- subject
- media
- size

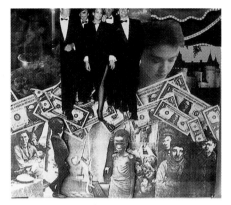

As we look at the "haves" and the "have nots" in Peggy's work, we see the relationship between money and poverty.

Peggy Tinimes, grade 11. Mixed media, 18" x 20" (45.7 x 50.8 cm).

EVALUATION

Have students respond in a verbal critique. Ask: "Did you create a strong visual image that the viewers will easily understand?" "Was the subject of the protest obvious?" "What makes the image visually readable to the viewer?" "What aspects such as color, composition, or subject add visual impact?" See also the rubric on page 34.

RESULTS/OBSERVATIONS

Because they chose varied subjects and media, students produced diverse results. Independent decisions led to greater ownership of their work. Students interested in science were encouraged to share their work with science classes. This gave science teachers and students an opportunity to see how art and science relate to each other and thus provided another level of relevance to the project.

CONCLUSION

Because the project gives students many opportunities to make decisions, it enhances their sense of power and commitment to the choices they make. The art teacher gains insight into and appreciation for the belief systems of his or her students and experiences the satisfaction of watching students move from being teenagers to young adults by dealing with issues that relate to the larger world community.

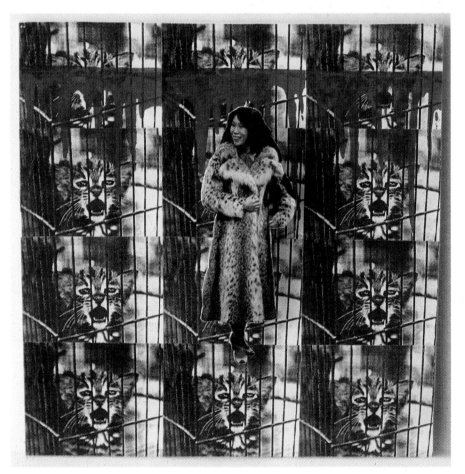

In her strong, focused composition, Margo looks at the killing of animals and issues about animal rights.
Margo Griffiths, grade 11. Mixed media, 18" x 20" (45.7 x 50.8 cm).

INSPIRATION

At some point most of our ancestors were part of the immigration process. So where did we come from? My desire to increase students' awareness and appreciation of family history, family roots, geographic location, and the use of art to express these connections motivated me to develop this project. I wanted to involve students in a problem-solving project that would encourage them to "figure out" the relationship of art to a body of information. Included in this reflection is the important realization that the ancestors of many African-Americans experienced a forced removal from their homelands. The impact of mass immigration, as well as the subsequent migration that was imposed on Native Americans should also be taken into account.

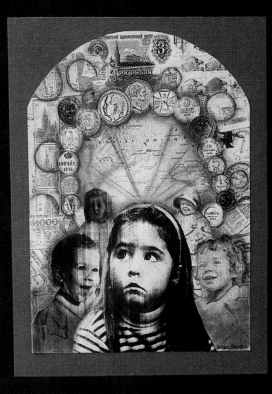

Jessica's childhood photo provided a way to share international connections through a child's eyes.

Jessica Stanton, grade 11. Mixed media, 8 1/2" x 11" (21.6 x 28 cm).

PROBLEM

Students will research and acquire images related to their families' origins and use these to develop a two-dimensional photomontage. They will create a visually unified composition that shows a clear visual relationship to their heritage.

TIME FRAME

Studio time: two and one-half weeks.

MATERIALS

- photocopier
- a variety of drawing and painting materials (watercolor paint, pastels, colored pencils, felt-tip markers)
- 15" x 20" illustration board
- white glue
- scissors and X-acto knives

STARTUP

Share the following objectives with students. Their task is to develop an image which relates to these objectives. Students will:

- understand the role of immigration in U.S. history.
- understand that they and their family have roots and a heritage.
- understand that previous generations of Native Americans and African Americans were affected by the European colonization of this country.
- understand that each culture has a rich heritage and it is this richness that makes our country unique.
- understand that maps are tools for tracing family history, for following the pattern of the movement of large numbers of people, and for understanding the larger world.

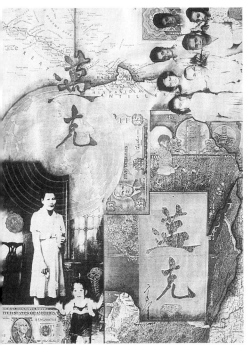

Michael used a map and red line to connect his family origins in Haiti and China.

Michael P. Chung, grade 12. Mixed media, 15" x 20" (38.1 x 51 cm).

PROCESS

Students will spend three weeks acquiring the raw data and imagery even though they do not as yet have a clear understanding of what they are going to create. This will pique students' curiosity and serve as an excellent motivator.

Ask students to talk to their families, find out whether their families immigrated and if so, from what country and when. For those whose families did not immigrate to this country, ask students to find out as much as they can about their family history and heritage. Begin this introductory part of the project three weeks before any actual class work begins. The time allotted for out-of-school planning will impress upon students the impor-

tance of the forthcoming project. Encourage students to contact relatives for additional family information. Ask students first to document those countries that are most significant to their family's history and heritage. Students can go to automobile clubs, travel agents, the library, or the Internet to gather maps, pictures, and other information. Have students photocopy these geographic world locations. Suggest that students reduce or enlarge these photocopies depending on their significance to their family history. Encourage students to make their map study as specific as they can, including cities or towns if possible.

Two weeks before the project is to begin, ask students to collect old family photos and documents such as birth certificates, passports, etc. as well as family heirlooms. Teachers need to be aware that for a variety of reasons students will be limited in researching some locations. If locating a specific region of the world is the only possibility then use that as the main reference for visual images and heritage. This part of the project requires awareness and sensitivity on the part of the teacher.

Take steps to assure that these important materials are handled carefully and safely returned undamaged to families. Secure the use of a photocopy machine for the artroom for two to three weeks or get permission for students to use

the school's copy machine. (Students may, of course, also do their photocopying outside of school.) With this safeguard in place, students can assure their parents and relatives that materials they brought to school will be returned home the same day. In addition, making photocopies will allow students to move, sort, and arrange images in a way that allows them to see the overall family structure. Discussions will ensue between students as they ask questions such as: "Which side of the family did that belong to?" "How old is this photo?" "Who owned this locket?" "How many people are in your family?"

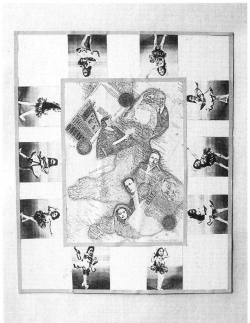

Lynn Marie used images of herself as a young dancer and maps and family photos to show her family heritage from Italy.

Lynn Marie Zazzu, grade 10. Mixed media, 15" x 20" (38.1 x 51 cm).

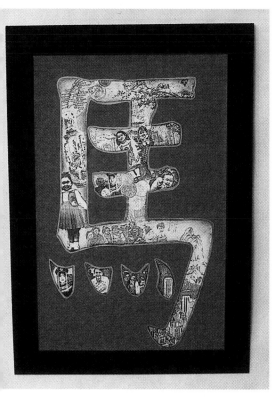

By filling in the letters in her family name, Carol created her visual connection to her heritage.

Carol Ma, grade 10. Mixed media, 12" x 18" (30.5 x 45.7 cm).

Have students research the iconography and important symbols of countries significant to their family history (for example, stamps, money, photos of architecture and significant monuments located in the library or brought in from home). One week before the actual studio work begins, remind students to bring to class the materials they have collected as well as a photo of themselves at any age—a photograph that they like. The photo that students choose will show how they see themselves in relationship to all of the other images and artifacts they have chosen. Tell students to copy the photograph of themselves, reducing or enlarging it as they see fit.

After students have copied all of the above, have them begin by arranging and rearranging, enlarging or reducing, according to the significance of each piece of information. Draw students' attention to the fact that in the process of photocopying detail is lost. Tell them that this can work positively for some creative surface techniques, but not for all. As the combined images are photocopied, have students use gesso to soften one image into another or to eliminate unwanted gray areas. Suggest that they use fine-line black markers to make the linear connections before adding color.

Remind students that they are to put together a visually unified composition that relates to these objectives: understanding the importance of immigration in U.S. history, understanding their own and their families' roots and heritage, understanding that Native Americans and African Americans were affected by the mass movements of people into this country, understanding that the richness of varied heritages is what makes this country unique, and using maps as a tool for learning about the larger world. Explain to students that their task is to connect all the ingredients—the maps, the icons, the heirlooms, the objectives, and themselves. Their compositions have to be strong to maintain the viewer's interest.

Encourage students to use any media they choose—felt-tip markers, watercolor paint, pastels, col-ored pencils, and combinations—to pull their imagery together. Students may choose from a variety of media. Students can work directly on the actual photocopy or create a montage of photocopies glued onto illustration board using white glue. In either case, the use of line and color should be significant factors in the development of their compositions.

CHOICES

- subject matter
- size
- media

EVALUATION

Have students respond to a verbal critique. Ask: "To what degree did you increase your knowledge of your heritage using maps and world geography?" "How did you unify the images you photocopied?"

At the completion of the project, assess the degree to which students have increased what they know in relation to project objectives and the use of media. On a single page, create a series of statements dealing with immigration, maps, locations, and the use of media. Use a five-point (Likert) scale to rank student responses. Have students rank their increased understandings from 1 (the lowest) to 5 (the highest). See also the rubric on page 34.

Our Origins as Seen through Mixed Media

Using a Likert Scale to Evaluate Student Learning

Have students rank each item on a scale of one to five in a way that indicates the degree to which they have increased their knowledge as a result of this project. Students should do the evaluation anonymously, being aware that their responses will not affect their grades. Ask students to make any additional comments at the bottom or on the back of the evaluation sheet. When students finish their evaluation, determine a mean score for each statement.

1=Low; 5=High

1 My understanding of immigration as an important part of the history of the United States

2 My understanding of my family roots and heritage

3 My understanding of where my family came from (countries, states, regions, cities, etc.)

4 My understanding that maps are tools that help us understand the larger world

5 My ability to use maps to trace family history.

6 My knowledge and awareness of geographic locations

7 My ability to meet the objectives of this project

8 My knowledge concerning the use of media (photocopies, mixed media, etc.)

RESULTS/OBSERVATIONS

Students found this project challenging because it forced them to find a creative solution that conveyed accurate information related to the project's objectives. Some students contacted family members all over the United States and had information mailed back to them during the three weeks before the studio time began. Students felt they had expressed their own individuality in their work and made significant connections to their own heritage. As they carried out their independent research, students engaged family members in their process, which produced a strong interest among family members in the final collages. Some families were enthusiastic enough to have the work professionally framed and hung in their homes.

The Likert Scale results proved that significant learning had taken place, with the mean scores for each statement ranging from 3.9 to 4.1. Students' additional comments confirmed an increased awareness and understanding of maps, family, heritage, and international connections.

CONCLUSION

This project enabled students to make significant discoveries concerning their relationship to their family and their own perceptions of the world. The new ideas students developed added depth to their work. The success of this project lay in students' ability to make strong artistic and personally meaningful statements.

The personal nature of these projects enabled students to achieve significant insights. The problems encouraged risk taking and creative problem solving. Students made the leap from expressiveness to creating art with significant meaning—a meaning that speaks a truth about the artist/creator that is so big it can be heard by others.

In this chapter we explored how students move from individual expression to significant meaning in their artwork. In chapter 5 we will look at ways to develop the spirit of cooperation among students with a focus on creating art for public spaces.

5

Connecting With Others in Cooperation

In an effort to encourage students to work together as a group, I wanted to develop cooperative learning projects that would be enriching in terms of both the experiences themselves and their artistic content. Much emphasis has been placed in recent years on cooperative learning, but creating such experiences in the area of art can prove challenging. On the high school level, working in large cooperative ventures is often met with resistance, especially from opinionated students whose major goal is to be individually creative. Working cooperatively, however, can be a positive experience for students pro-

vided the teacher thinks through all aspects of the project, allows students to be part of the decision-making process, and takes steps to motivate students.

The projects in this chapter explore such topics as connections between the individual and Native American cultures, the concepts of freedom and environmental balance, and art history. Each project gives students the opportunity to work together on a common goal and helps them develop a sense of citizenship, responsibility, and community values.

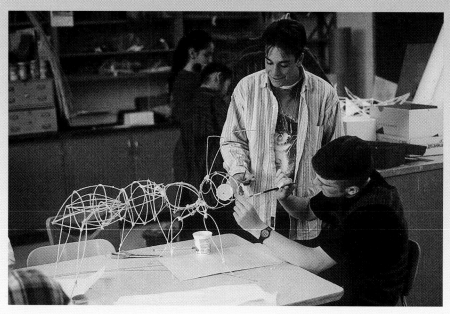

Greg and Chris work together to create this linear form, part of a kinetic sculpture. See page 113 for project details.

Greg Fishbein, Chris Danforth, grade 10. Wicker reed and rice paper, 10" x 8" x 18" (25.4 x 20.4 x 45.7 cm).

Contemporary Conceptualization of a Totem Pole

INSPIRATION

Driving into the parking lot of my high school, I noticed a brick wall that is part of the library. It occurred to me that this large blank wall might be an ideal setting for an outdoor artwork. For years I have wanted to work on an outdoor sculpture. This urge combined with the desire to help twenty-five high school students work cooperatively on planning, designing, and building such a structure motivated me to develop this project.

PROBLEM

Each student will develop a symbolic image that represents who they are or an aspect of their personality. Students will work together, combining these images to create a series of symbolic totem poles.

TIME FRAME

Two and one-half weeks.

MATERIALS

- ³/4" plywood finished on both sides: three sizes precut (1' square, 1' x 2', or 2' square)
- sandpaper
- various size brushes
- oil-based paint
- nuts and bolts

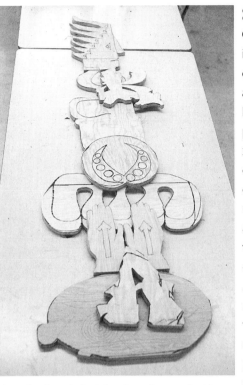

Ideas of various students have been drawn and cut in plywood and are laid out on tables in the artroom.

STARTUP

Obtain a site for the finished totem poles to be displayed. Gain any approvals necessary. Precut 4' x 8' sheets of plywood into 1' square, 1' x 2', or 2' square so that each student can have one section. Secure the use of the wood shop or a band saw for cutting the plywood. Have students research Native American art. Their research should provide them with an understanding that totem poles are designed using an animal, plant, or object for which a group feels a special affinity. Often, a mythical ancestor of the group or clan is included. Students should also understand that totem poles have a social purpose of connecting groups and serve as important components in the heritage of certain cultures.

Share examples of Native American art and ask students to think about ways of simplifying the basic design concepts of this art. Students' understanding of visual simplification will add a contemporary quality to their final sculptures.

Explain that the project is to be done in parts in order to allow each individual to contribute to the final product. The individual

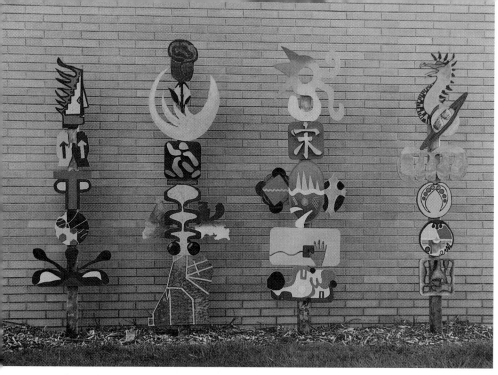

Twenty-five students came together to create these contemporary totem poles. The finished work shows the various symbols students used to represent themselves. Like the Native Americans who positioned their poles at entryways, students placed these poles outside the doors of the school library.

Students, grades 10, 11, 12. Plywood, oil paint, 4" x 4" poles; 8' x 1' to 2' (244.8 x 30.6 to 61.2 cm).

parts are to be created in plywood and then assembled to create a structure that represents a contemporary conceptualization of a totem pole. Students will further understand that their sculptures are meant to incorporate some of the same qualities relating to social groupings and symbolism that play such an important part in the Native American totem poles.

PROCESS

Have students begin by thinking about what symbols would best represent them. Suggest they make many small sketches before making a final decision. Initials are acceptable as imagery. Tell students that they may share the meaning of their symbols with classmates or keep

them private. After they develop the symbol on paper students will transfer it to 3/4" plywood.

The plywood should be of good quality, finished on both sides. The students choose from three sizes of precut plywood (see Startup). First, have students draw the image using pencil on plywood. Then, students work together to cut out each piece. If possible, let two students go to the wood shop at a time. The wood is then sanded, primed, and painted with oil-based paint in the artroom. (Keep artroom well ventilated.)

Discuss with students that all sculpture needs to have a sense of visual unity. Remind students that because the symbols they have created are so varied, they must carefully think about their use of color.

After discussion, students may decide to limit their color scheme in order to show the unity of the overall form. Have students discuss and decide the color range they will work within, such as from blue to green. Have the class vote and work within the range agreed upon by the majority.

Plan for four poles (or adjust the number according to your chosen location), and ask each student to develop possibilities for the final results of the project. As the oil-based paint is drying on their individual pieces, give the class a sheet of paper divided into 2" squares. Ask each student to draw their individual design into one square. When every student is finished, make photocopies, giving each student a copy of the entire class's work. Then, ask students to cut up the grid of 2" paper images. Help students envision what the final structures might look like by having them arrange and rearrange these images. Have students finalize their individual designs by gluing the 2" squares onto another blank sheet of paper. Students then share their ideas of how the poles might be structured with the class.

After they consider the many possibilities, ask the class to choose, by consensus, a design for the poles. The designs, done first on paper, are then laid out with the wooden shapes on the artroom tables. All students thus have another opportunity to arrange and rearrange their

design possibilities. Suggest to students that what they are doing is like working with an unusual set of building blocks. A class discussion follows, which can explore overall structure, design, and visual balance.

Once again, before the ideas are finalized, have students vote on which construction works best because of its overall visual design. Each piece is then bolted to the vertical pole. For final presentation paint both the metal bolts and the wooden poles to add to the quality of craftsmanship and sense of unity. Have students select the exact location outside the school where they would like to place the sculpture. Suggest they also consider the order in which they will place the poles. At each step of this project do whatever you can to increase

students' involvement in the decision-making process. This is critical if the project is to be a success.

CHOICES

- development of personal image
- color
- size
- development of final design and placement

EVALUATION

Have students reflect on the process. Ask: "How difficult was it to work with the entire class and together reach decisions?" "Do you feel that the color, varied forms, and placement came together?" "What creates the sculpture's visual impact?" See also the rubric on page 34.

RESULTS/OBSERVATIONS

The group decision-making this project required focused students on the need to work cooperatively. Without a spirit of cooperation among students, many important discussions would have never taken place, nor would compromises have been made. Some students revealed quite a bit about the individual images they were developing, while others were markedly reticent. The four contemporary totem poles came together to form one large visual piece, which was placed on permanent display near the front entrance of the library. (Native Americans also placed their totem poles at entryways.) In the end, students felt proud that they had worked together to create a sculpture for permanent display.

CONCLUSION

It is critical when planning a project such as this to include all participating individuals' images. Due to the symbolic nature of the subject, this can prove challenging. Because students take part in decision making they have a sense of ownership in terms of the overall project. Students' cooperative efforts produced strong images and encouraged supportive interactions among students.

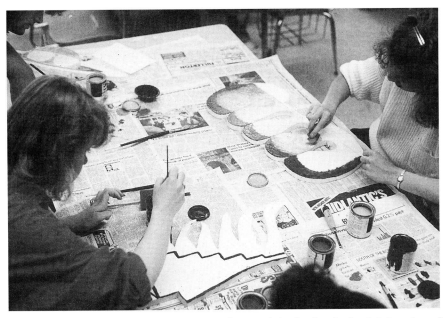

The artroom became a series of work stations as students sanded, primed, and painted their sections of the final work.

Yumi (YOU-ME) Sculpture Garden

INSPIRATION

The motivation for this project came from the sudden and tragic death of a talented foreign exchange student from Japan. Her name was Yumi Shibatani (pronounced You-Me). Her very presence as well as her special character was a gift to all who knew her. She personified integrity and hard work. She was a diplomat, never judgmental, always willing to accept and show respect for others. She also excelled academically and her artistic talent was recognized by the state of New Jersey and displayed in SchoolArts Magazine ("Value Study and Famous Artists' Styles," p. 36, Sept. 1994). Her outstanding qualities provided an opportunity for students to create a special remembrance of her, a remembrance that—like her—made a connection between cultures and people.

The major goal of the project is to show likenesses between people and cultures and, at the same time, illustrate the unique nature of each. Hopefully, after completing this project, students will have gained an increased respect for and understanding of other cultures. Students are asked to problem solve concepts such as, "How do we make a connection between the you that is you and the me that is me?" "How do we concretely and visually create a project that portrays a bridge between cultures?" "What has all of this to do with international diplomacy?" Students are then asked to translate their answers to these and other complex questions into symbolic sculpture.

As a part of each project, introduce a few thought-provoking questions. See also the view on page 13.

PROBLEM

Students will select a single river stone to paint, paying careful attention to its natural markings. They will create a design that includes two main elements: one a circle (symbolic of unity) and the other, a significant line (representing connectedness) between forms. Each student's stone will be placed in relation to other students' painted stones in a way that creates a visually connected yet movable sculpture.

TIME FRAME

Approximately three weeks.

MATERIALS

- smooth river stones
- gesso
- oil-based paint
- spray varnish

STARTUP

Select river stones that are of a size that can be easily handled. The stones may be purchased at a stone quarry. Research Japanese culture to better understand the Japanese sense of design and how it affects garden spaces specifically. Discuss with students ways to represent the concept of connecting with other cultures.

Cultivating Meaning in a Sculpture Garden

Creating a garden that reflects an Asian influence begins with both viewing and researching Asian gardens. I have been fortunate enough to study and visit the famous Ryoanji Garden located in Kyoto, Japan. This meditative garden is connected to a Zen Buddhist temple. It is comprised of fifteen rocks and white gravel. Its essence is meant to symbolize the spirit of Zen.

Often these gravel gardens center on significant rocks which symbolize the steep mountains of Japan. The concentric circles of raked gravel around the rocks represent water. Zen Buddhists spend hours on the repetitive activity of raking gravel. The purpose of this repetition is to clear one's mind of the mundane concerns of life and produce a state of pure concentration.

Research also has connected the Zen garden to Shinto mythology. This mythology holds that gods manifest themselves on earth in certain sacred places, such as a particular tree or rock. "A single rock of distinctive shape can be set apart as sacred to honor the divine spirits called Kami."
(Bruce A. Coats, "In a Japanese Garden," *National Geographic*, Nov. 1989, p. 647.)

PROCESS

Share with students information about Japanese gardens. Point out the beauty and asymmetry of their style. Focus particularly on Zen meditation gardens as a place to clear one's mind. Inform students that they will be developing a rock garden using smooth river stones. Explain that stone offers a quality of stability and a sense of importance. Help students understand that in Shinto mythology a spiritual quality is found in each rock. As there is a uniqueness in every human, there is a uniqueness in every rock. When these are brought together, new relationships are formed. The garden that they create will show the uniqueness of their individual artistic expressions, as well as the new relationships that are formed as the river stones are placed together.

In the initial planning stage, the idea is to create a changeable sculpture and to have students participate in designing the overall form. This part of the process is consistent with the concept that "a Japanese garden is never finished, because each site is shaped and modified by successive owners." (Bruce A. Coats, "In a Japanese Garden," *National Geographic*, Nov. 1989, p. 655) Tell students they will be given opportunities in the future to restructure the stones to create new formations.

Ask students to select a stone whose texture, grain, or size inspires them. Suggest they examine the stone's unique imperfections. At this point, tell students to include two visual elements in their designs. The first is a significant line that runs over their stone, and the second is the inclusion of at least one circle as part of the image. The line will ultimately show a connection between individual students' work.

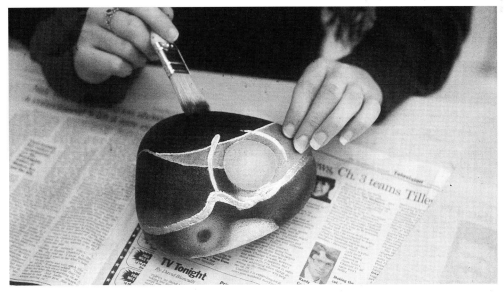

Obtaining background information adds to the depth of a project.

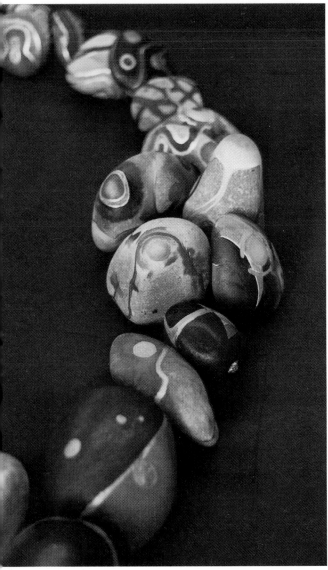

This portion of the final work shows the visual connectedness and richness of color.

It is important that students study the natural form of the stone, noting its grain, texture, and color. Have students first use pencil on the stone to create the line and a circle. Students then apply gesso (painting ground) onto the areas that will be painted. Tell students that they will use oil-based paint because this material will withstand outdoor weather. In order to give students time to think about color selection, encourage them to progress slowly through this part of the project. Suggest that students not paint the entire stone and instead let the natural color show. In this way, the viewer will see more of the natural qualities of each stone. As they progress through this project, students discover the rich texture that can be developed with the use of color media as well as from the stone itself. Tell students to consider carefully their use and application of color. Use two coats of clear varnish spray as a finish on the stones when dry. (Spray stones outside, not in the artroom.)

This line should be painted gold and is a metaphor for a thread of light passing through the different elements. The circle shows continuity— no beginning or ending either in concept or design.

CHOICES
- individual design
- color
- final arrangement

EVALUATION
As students move toward completion of the project, ask them to reflect on their creative process. Ask: "Do your individual designs make the viewer want to pick up your stone and turn it over to see more?" "Do you see a continuous flow in the design or in line and color?" Remind students of the two main elements their designs should include (line and circle). Encourage students to see the stone as two parts, two people, or two cultures that have come together. Ask: "Does the sculpture reflect the goals of the project?" See also the rubric on page 34.

RESULTS/OBSERVATIONS
When the work was finished, the fifty-five advanced-level students placed their stones together on a large paper surface in the artroom. They knew the final location would be outside the school, but did this in order to evaluate the overall sculpture. Class discussions followed as the students arranged and rearranged the stones evaluating and reconsidering the overall composition. The final compositional placement of the stones consisted

of a circle demonstrating the sense of unity. Students cooperatively worked to connect the significant painted line in each stone to the next person's, thus showing a visual connection between the individual stones. They were then asked to discuss the project and write at least one page in which they reflected on their process. Many students commented on powerful feelings concerning the personal connection of all people, in spite of differences. After students had completed their evaluations, the sculpture was placed as a unit outside on the school property. Students chose the location and as a group decided to maintain the image of a circle for this outside placement. They chose to place the sculpture in a courtyard close to the artroom, which gives art students the opportunity to arrange and rearrange the structure at a future date.

CONCLUSION

Because many students did not know this foreign exchange student, I understood that concepts would be an important aspect of the design of this sculpture. The goal was to enhance students' understanding of Eastern and Western cultures, to encourage them to think of cultures in relationship to individual qualities, and apply these understandings to their dealings with others. Many students agreed that the experience of working cooperatively helped them become aware of differences (among the stones; among human beings) and similarities (among the stones; among human beings). I can't help but think that Yumi would have been touched by the quality and beauty of the students' sculpture.

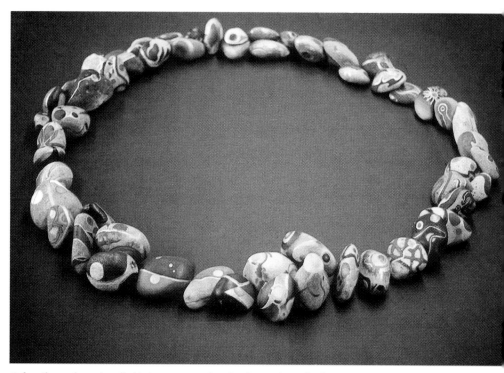

Before the work was installed in its permanent location, it was given a final critique in the artroom. By working cooperatively, students created a symbolic work that exemplifies greater cultural understanding.

Students, grades 10, 11, 12. River stones, gesso, oil-based paint, varnish, 11' in diameter (336.6 cm).

Architectural Clay Relief

INSPIRATION

As Americans, most of the architectural styles we are exposed to date back only 200 years. To make students more aware of architectural styles and forms we need to expose them to a much broader range—architecture that dates back thousands of years. The motivation for designing this project was my desire to enhance students' understanding of age, texture, and design forms as these relate to architecture. To do this, I would ask students to research architecture and then to create an image that reflects what they have learned.

PROBLEM

Students will research and identify architectural styles throughout time and across the globe. They then create a ceramic, low-level relief tile that visually responds to a particular style. Students will work cooperatively to design and combine each individual tile to create one large wall unit.

TIME FRAME

Two and one-half weeks.

MATERIALS

- terra cotta clay
- 4' x 8' x 3/4" or 1/2" plywood
- commercial adhesive and caulking gun
- ten wing bolts for mounting
- bonding agent
- dark red wood stain

STARTUP

Acquire resource books, architectural images, and materials. Begin with a discussion of architectural styles and how they vary according to time frame, location, and architect. Have students explore styles that show the influence of Greek and Roman, early Christian, Romanesque, Gothic, Renaissance, and Baroque architectural forms. As students view and discuss these examples, share with them information as to how styles differ (for example, differences between Greek and Roman columns or Romanesque arches and Gothic arches).

PROCESS

Have students do a few small sketches of styles they like. Then have them decide which specific style they want to work with and develop a 6" square, pencil-drawn image. Because of the small size students are working within, they need only look at only a section of the architectural structure they have chosen to study. Have students document the time frame, name of style and country, and influences on that style.

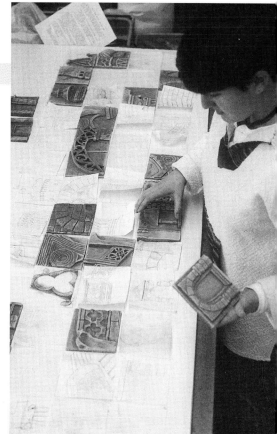

Here students are arranging finished tiles.

Share with students the article "Italian Architectural Influences," by Mary Lou Alberetti (from the summer 1991 issue of *Ceramics Monthly*). The article features large wall units that show contemporary clay reliefs representing various architectural styles. When students complete their sketches, have them begin working in clay. Tell them to start by wedging, measuring a 6" size of the clay square and then designing the low-level relief. Suggest that they view their pencil drawing and a photocopy of the original image daily, using it as a reference point. To help students work out the final arrangement of the completed piece, post each 6" drawing on a

large foam core panel each day. Bear in mind that some students may find it quite challenging to work with and make connections between various styles of architecture. Remind students that the goal is not to create a building; rather, an engaging visual montage of styles. Have students decide where their image would work best in relation to other images. At times, students may need to add lines to the clay to show a visual connection to other students' images. The necessity of working cooperatively will produce many discussions among students as to how composition problems should be resolved. If time permits, encourage students to create two tiles. This will help any areas that need a stronger visual connection in the overall composition.

The work in clay is dried and fired at 05 cone temperature; no glaze is used. Before cutting the plywood pieces, remember that the clay will shrink ten to twenty percent due to the quantity of water in the clay and the temperature in firing. The tiles will be mounted on the large plywood pieces. The plywood is cut lengthwise in half and then the ends trimmed to fit the contour of the end tiles. Have students stain the plywood with a dark red wood stain that enhances the color of the fired clay. Use a commercial adhesive in a caulking gun to attach tiles to the plywood, except those tiles that will be positioned over the support holes. Before hanging, drill and countersink approximately eight holes. Use wing bolts to hang the two units as one long relief. Install the two long panels, and then glue the eight remaining tiles. This method prevents the bolts from showing. Also, measure the wall space and make necessary adjustments to the artwork before hanging.

CHOICES
- architectural style
- placement and composition of final unit

EVALUATION
Have students respond with verbal critique. Ask: "How was your knowledge of architecture broadened through this experience?" "What did you learn as a result of completing this project?" "Are you now more interested in varied architecture styles than you were before this project?" See also the rubric on page 34.

RESULTS/OBSERVATIONS
Students benefited from the experience of making decisions cooperatively and together created a visually unified wall relief. The final wall relief consisted of sixty individual tiles. Each tile was 6" square, 3/4" thick. When combined they

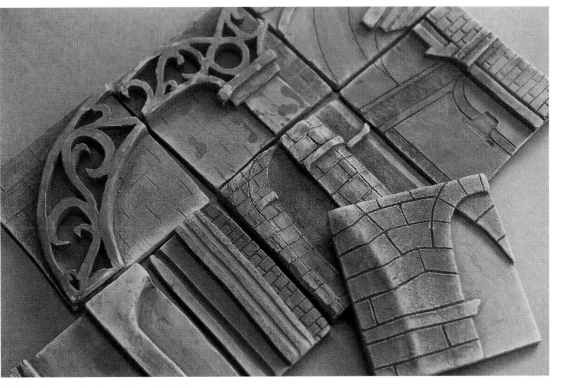

This view shows a selection of bisque-fired tiles.

extended approximately 13'. The students enhanced their knowledge concerning different kinds of clay and the time and temperature required for firing. The thickness of the plywood was 3/4", and in retrospect, 1/2" thick would have worked as well. An additional goal of the project was met: to draw attention to the importance of foreign language and culture in our school curriculum. The site selected for the specific wall unit—above student lockers in the foreign language hall—now permanently displays students' work.

CONCLUSION

As the students began the process I was not sure if the small focused size of 6" would be successful or that they could bring sixty tiles together to form a workable unit. As the work evolved and was finalized, my doubts proved unfounded.

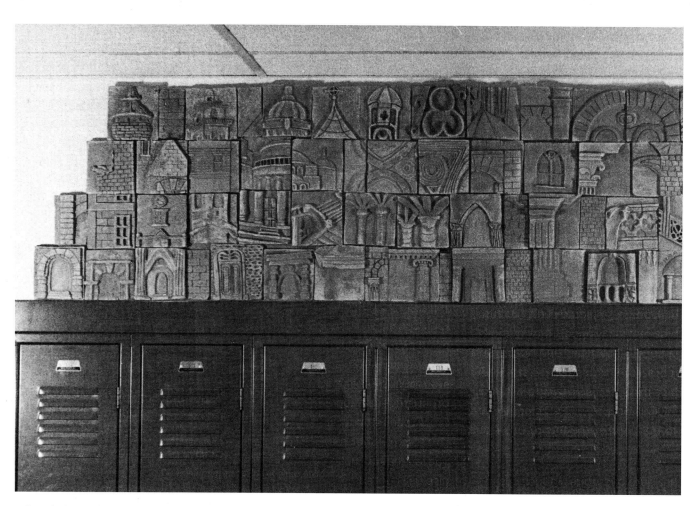

Each student created an architectural tile. Working cooperatively, all students arranged the tiles together in this wall-mounted unit. The wall unit is displayed above the lockers in the foreign language hallway to promote greater awareness of other languages and cultures.

Students, grades 10, 11, 12. Terra cotta, plywood, 2' x 8 1/2' (61 x 274 cm).

Tower of Freedom

INSPIRATION

As Americans, how much do we appreciate the concept and our experience of freedom? Can we as artists/teachers help our students to be aware of the freedoms that they enjoy? This question grew out of the first of two visits I made to Russia. On a cold night in November 1989, I had dinner with two Russian families in St. Petersburg (then Leningrad). We discussed issues important to them such as *perestroika* and *glasnost. Little did we realize that on that very night the Berlin Wall was falling and a process was beginning that would require the restructuring of all Eastern Europe. My visit to Russia planted the seed, but the final articulation and execution of the project came much later. My motivation for developing this project was to raise awareness about freedom.*

In this country, freedom is a highly valued, yet under-appreciated concept. How do we, as educators, help our students grasp the complex ideas embedded in the word "freedom"

Allison developed a statement about the need for personal freedoms in China.

Allison Post, grade 11. Mixed media, 30" x 20" (76.5 x 51 cm).

and enable them to demonstrate their understandings in ways that others can understand? This project was created to address that question. It involves students in a democratic process that culminates in the creation of a work expressive of the concept of freedom.

PROBLEM

Students will reflect on the general concept of freedom, and select one particular freedom they value to use as the subject of a visual representation. Each student will then work cooperatively with the rest of the class to create a three-dimensional freedom tower.

TIME FRAME

Three weeks.

MATERIALS

- foam core (16" x 20" up to 20" x 30")
- illustration board, various sizes
- a variety of drawing and painting materials
- long, straight pins
- 2" wide, clear tape

STARTUP

Ask students to respond in writing to the questions that follow before meeting for a large group discussion. Focus students on ideas that will support the project by asking questions such as: "What is freedom?" "Who has it?" "What are its symbols?" Have students respond in writing as this will encourage each student to think seriously about what freedoms are important to them. Teacher-directed questions will elicit more questions from students. Ask questions like: "Why do we have censorship?" "Who has the

Evan's solution focused on how the individual can find freedom from violence in American society.

Evan Dilluvio, grade 11. Colored pencil and watercolor, 30" x 20" (76.5 x 51 cm).

right to take away freedom?" "Where does my freedom end and yours begin?" When students meet to begin class discussions, list students' answers and ideas on large pieces of paper. Hang these on the artroom walls and keep them there for as long as class discussions continue, thus enabling the students in various art classes to share thoughts, responses, and insights with each other. Discussing freedom can be both challenging and exciting. Talking about freedom may lead to other topics such as individuality,

political issues, freedom or the lack of it in particular countries, and issues related to artistic expression. Broaden the class discussion to include such topics as an international milieu of freedom (as exemplified in a unified Germany), the release of political prisoners, the future of China, or the restructuring of the USSR.

Use the work and experience of the American photographer Robert Mapplethorpe, to discuss artistic censorship. Expand the discussion by including other artists who also used art forms to express a longing for freedom. Use Pablo Picasso's *Guernica* (1937), as an example of an antiwar statement expressing the artist's loathing not only of war but also of the governments that bring it about. Explain to students that Picasso felt so politically exiled from Spain, his homeland, that he chose to leave Spain and live in Paris. Ask: "Can you imagine yourself creating an image so strong as to force you to exile yourself from the country of your birth?" As a result of their study and class discussions students begin to understand art as a powerful means of expression and a vehicle for raising the political awareness of others.

PROCESS

Have the class discuss what this project might become. Remember that encouraging, listening attentively to, and respecting student input is critical; you cannot discuss freedom while setting restrictions that limit individual expression. Students may discuss symbols of freedom (such as the American flag, the American eagle, and the Statue of Liberty); colors that suggest freedom (red, white, and blue because these are seen in the flags of democratic countries as

Issues of freedom in intimate relationships are the focus of this work.

Heather Freeman, grade 11. Watercolor, pen and ink, 30" x 20" (76.5 x 51 cm).

well as in freedom flags); concepts or issues related to freedom (bridges because they make connections, chains being broken, wings in flight, and walls coming down); and available materials. Remind students that they can address issues on a local, national, and/or international level.

Some possibilities for the overall project include a large paper quilt similar to the AIDS quilt, a flag waving through some large interior space of the school, or perhaps a puzzle in the shape of the earth. For this example project, much thinking and rethinking took place before students decided on the idea of a Tower of Freedom. For the Tower of Freedom, each student creates an individual two-dimensional work of art that will later be combined into a group effort. The final piece is to be both large and three-dimensional. This large, tall structure shows visually the idea that freedom is both powerful and complex. As they participate in the process, students realize that their individual expression will become part of one large visual presentation.

At the end of the discussion ask each student to pick one aspect of freedom they would like to develop. Tell them to focus on the idea they have chosen and explore and develop it using paper or illustration board. The size may range from 16" x 20" up to 20" x 30". Discuss the use of color with students. Students may choose from a variety of drawing or painting materials, but a sense of visual unity will be necessary to pull the piece together. Students may decide to use red, white, and blue somewhere in their composition. Have students mount their final work on 1/4" foam core board. The foam core will later support individual images on the final tower.

Lead a class discussion for the purpose of deciding on a potential location for the tower. A library might provide a good location. Building the tower around an existing pillar or support beam would be ideal. After clearing any necessary permissions, install the tower. Have student volunteers build a floor-to-ceiling, five-sided structure on which student images attached to foam core will be placed. As they decide where to place their individual pieces, encourage students to consider how they might add visual interest to the piece as a whole. Use 2" straight pins to join the individual pieces in groups of five. Attach the next level, also using pins. For additional stability use clear or semi-transparent tape on the exposed edges of the foam core to connect each individual panel. You might also attach additional foam core to an interior pillar to insure stability.

CHOICES

- development of subject
- size
- media
- use of color
- design of structure

The Freedom Tower being constructed in the 14' high library space.

EVALUATION

Develop a questionnaire that invites students to reflect on their process, the product, and their understanding of freedom. Ask: "What did you hope people would see or learn as they viewed your work?" "After completing this project, what new insights have you gained concerning the concept of freedom?" "Do you see the Freedom Tower affecting or influencing others in their appreciation of freedom?" Students are asked also to comment in writing on any other aspect of this project. You may wish to use the rubric on page 34.

Student Responses

Reflective writing assignments can challenge students to consider their expressive intentions and to anticipate the reactions of their viewing audience. Here's what students said about the Tower of Freedom.

✻ "The piece that I did was on child abuse. People do not always think of freedom as it refers to young children. This piece shows how adults or parents can take away a child's freedom. They take away the child's right to be healthy."
–Stephanie Johnson, grade 9

✻ "It's one thing to put up this tower for all the world to consider–but it's up to the world to take time to consider it."
–Heather Freeman, grade 11

✻ "I think it will open up people's minds. Americans so often think of freedom as defined in the Bill of Rights. Yet there are many other types. I think it will also make people realize what they have."
–Allison Post, grade 11

What did you hope people would see or learn as they viewed your work?

✻ "I hope people will learn about new freedoms they haven't thought about before and think about them."
–Kelly Schoeffel, grade 10

After completing this project, what new insights have you gained concerning the concept of freedom?

✻ "Freedom comes in many different forms. People have many different views."
–Evan Dilluvio, grade 12

✻ "I see freedom to be not only a single effort but a group effort." –Darrell Sweet, grade 12

Please comment on any other aspect of this project.

✻ "I think the tower idea is excellent. The overwhelming effect of a tower dedicated to freedom should have a strong impact on people who look at it with open minds."
–Darrell Sweet, grade 12

of this project was that history teachers brought their classes to the library to view the tower, identify the themes expressed in students' work, and use the tower as a starting point to discuss the concept of freedom. My students felt proud of their individual and group accomplishment. Students had produced strong, high-quality work and received positive feedback from the school community.

CONCLUSION

Because the topic opens up endless possibilities, as teachers, we need to remember that it can elicit heated discussion from students. This is what freedom is all about—expressing different opinions and developing new levels of tolerance and acceptance. The cooperative process empowered students, which in turn resulted in the creation of a striking image.

RESULTS/OBSERVATIONS

Students addressed a wide range of issues connected with the concept of freedom (freedom of speech and choice, censorship, future freedoms for countries and developing countries, oppression, prejudice, child abuse, violence, and freedom of artistic expression) and used a wide variety of media in their work. Students expressed the hope that others viewing the tower would gain new insights into the meaning of freedom. One unexpected result

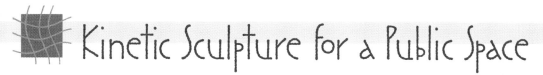

Kinetic Sculpture for a Public Space

INSPIRATION

Frequently people express their appreciation of the simple, dynamic qualities and the effortless floating of forms that are characteristic of the mobile structures created by artist Alexander Calder. I developed this project because I wanted to extend students' understanding of sculpture beyond static structures to those that show movement, balance, and visual interest. Creating a mobile sculpture helps students understand light, balance, and our perception of objects that move in space. The project also introduces students to the idea of time and its effect on visual perception.

To increase students' environmental awareness, use insects as a theme for this kinetic structure. Inform students that there is both ecological balance found in nature and artistic balance that is seen in mobile structures. Insects are visually complex, show great variety, and have small body structures that lend themselves to close observation. Their countless numbers and variety offer endless possibilities. Their physical qualities have both a linear aspect and a three-dimensional form that shows volume.

PROBLEM

Students will create a model of an insect of their choice. The linear structure will be covered selectively with rice paper, exposing the interior structure as well as the exterior form of the selected insect. Students will work cooperatively to combine these structures to create a series of five large mobiles that are site specific for public viewing.

TIME FRAME

Four weeks.

MATERIALS

- natural wicker reed, lightweight, round
- white glue
- white or natural color string
- rice paper
- 10 lb. fishing line
- 1/4" wooden dowel rods, 36" long
- 1/4" steel rods, 5' and 6' long
- "snap" fishing swivel

STARTUP

Secure visual resources about insects and a video on Alexander Calder. (An older, but excellent, video is *Mobile by Alexander Calder*, produced by the National Gallery, Washington, D.C. in 1979.) List the following goals to help students focus on the purpose, process, and content of the project.

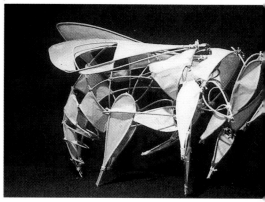

Chris's well-defined creation considers the form and structure of a bee.

Chris Campbell, grade 10. Wicker reed and rice paper, 9" x 8" x 13" (22.9 x 20.4 x 33.1 cm).

Students will:
- understand what kinetic sculptures are and how time affects viewers' perceptions of them.
- understand symmetrical and asymmetrical balance.
- understand the relationship of this project to art history as a result of their in-depth study of Calder and his influence on other artists.
- understand the importance of art in public spaces.
- gain a greater understanding of three-dimensional structures.
- increase their awareness of the environment and the world of insects.
- understand that art functions as a means to increase knowledge in all content areas. (Students will gain specific scientific knowledge as a result of this project relative to the structure of insects.)

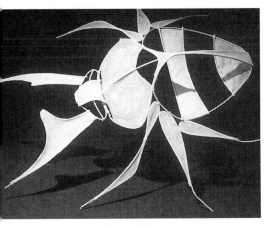

The form was created from wicker reed and then rice paper was added to complete the work.

Collaborative project. Wicker reed and rice paper, 6" x 12" x 14" (15.2 x 30.5 x 35.7 cm).

PROCESS

Students begin by researching the variety of insect forms, using the resources of the science department as well as the library and Internet. As they begin their initial line drawings, show students the work of Alberto Giacometti and Henry Moore. Both sculptors offer a loose linear drawing style that exhibits a quality of created volume, which the artists later translate to their sculpture. Point out to students that the way Giacometti and Moore express volume in their drawings is quite different from the way they express it in their sculptures. Ask students to analyze the work of both sculptors. Help them to understand that Moore uses large fluid forms to create mass, while Giacometti uses tall linear structures to imply volume and create a sense of power. During the opening phase of the project, show students a video that deals with the significant contributions of Alexander Calder. (A video will

work better than still images because it shows the movement in Calder's work.)

Have students first look at insects as linear skeletal forms, while soaking the wicker reed in water for thirty minutes to insure bendability. Then have them develop the insects into small three-dimensional linear sculptures. Guide students to bend, cut, and tie the wicker with string. After each section is knotted together, have students apply white glue to the intersections, adding strength to the overall structure. As the insects take form, emphasize visual planes by gluing white rice paper over sections of these skeletal forms. Rice paper has both strength and durability. Using watered-down white glue over the rice paper planes

after they have dried will add to the overall strength of the form. The addition of rice paper can be done symmetrically, but let students decide what they think would look best. Encourage students to cover about half of the structure as this will allow the viewer to appreciate both the linear aspect and the overall form. For aesthetic reasons and to focus the viewer on the structure of each insect, leave the color of the materials natural.

When finished, have students begin the process of combining their individual units to form large mobiles. The individual three-dimensional projects are hung with 10 lb. fishing line from 1/4" wooden dowel rods, 36" long. Have students problem solve as a group to decide which six to eight insects to combine to

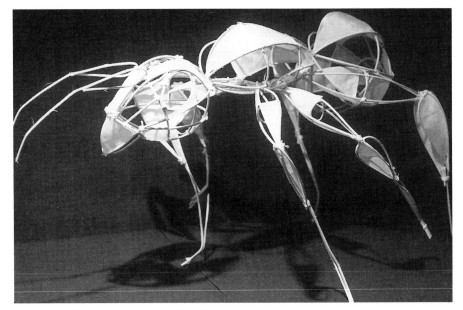

By placing the legs at an angle, students found a way to suggest movement.

Collaborative project. Wicker reed and rice paper, 12" x 10" x 19" (30.5 x 25.4 x 48.4 cm).

produce each mobile structure. Use 5'–6' steel rods (1/4") at the top part of the mobile. At the end of each dowel place a "snap" fishing swivel to create greater mobility. Remind students that balance, design, and movement are all important aspects of the final piece. Construct the combined units in the middle of the artroom. Have students work together to decide where to install the mobiles and then to obtain necessary permissions. Large, open, vaulted ceiling spaces are ideal.

CHOICES

- specific subject and its development
- overall final structure

EVALUATION

Ask students to examine their insect structure and evaluate it in terms of how closely it resembles the original visual example from which they worked. Have students reflect on their process. Ask: "Was your insect structure well constructed?" "Can the viewer identify clear differences among the varieties of insects?" "How difficult was it to physically and visually balance each mobile?" See also the rubric on page 34.

RESULTS/OBSERVATIONS

Students worked through this problem well. Their major stumbling block, which occurred during the first three days of construction, involved the initial bending and tying of the wicker forms. Most students experienced a fair amount of frustration as they began the linear form. It was hard for students to conceptualize a complete three-dimensional model as the form was first being developed. Line by line, each piece of bent wicker was tied to form a shape and connected to another. After overcoming this hurdle, the rest of the project went smoothly. Students' work was placed on permanent exhibition in the school hallway leading to the new science wing. The location proved ideal as the hallway with its open, high ceiling offered excellent light and it was an area frequented by students and visitors alike.

CONCLUSION

Fifty high school students understood, developed, and worked cooperatively to create five large mobile structures. Students increased their awareness of the structure of insects and of balance in the environment as they created their mobiles. The balance and rhythm of students' completed pieces serves as a metaphor for the cooperative spirit that made it possible to create this large and complicated floating structure.

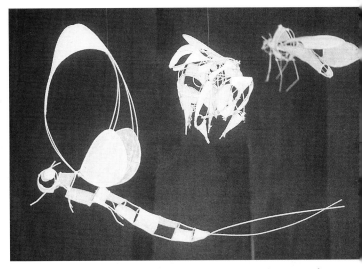

Each completed and balanced mobile is composed of six to eight insects. About forty-five insect structures were used to create five large mobiles.

Famous Artist Chairs

INSPIRATION

Every year I develop a specific art history unit for the studio classes, and every year I look for an innovative slant that will engage students enough so that they actually learn the content. Finding a vehicle that will motivate students is a challenge. This project took shape as a result of a discussion I had with a school principal who had recently visited the "Louisiana," an outstanding art museum located in Humlebaek, Denmark (near Copenhagen). One of the exhibits that most impressed him was one that handled chairs as sculptural objects. Together we discussed chairs as metaphors for support and comfort and as visually compelling structures. We agreed that art can indeed function as a resting place in a chaotic world. Thus were the seeds planted for the conceptualization of what was to come!

Before I had developed a clear vision of the project, I started the hunt for chairs. I began by telling students, faculty, and neighbors that I was looking for old wooden chairs.

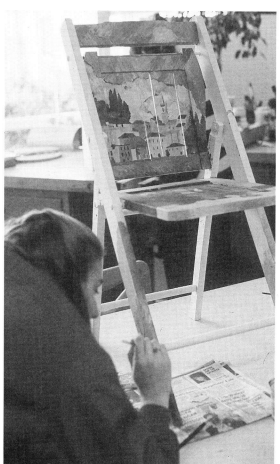

Allison's passion for the work of Paul Cézanne and her understanding of his style are reflected in her chair. Although Allison chose to work alone, she met all three aspects of the assignment: the research paper, painting, and presentation.

Allison Post, grade 11. Acrylic paint over white latex, 33" x 19" x 17" (84 x 48.4 x 43.3 cm).

It did not matter if the chairs were broken; all were acceptable. Unfortunately, after six months of searching, I had only three chairs to show for my efforts. I then realized that I needed to redefine the project. If different chairs were not available, possibly chairs could be

located that were the same. Finally, I found seventeen identical chairs in the basement of a local church. The chairs hadn't been used in years, and for a small cash donation they were mine.

PROBLEM

Students will select a famous artist to research. They will learn enough about the artist's style to apply that style to a chair that they will transform into a sculptural artwork. Students will work cooperatively with another student to paint the entire surface of the chair.

TIME FRAME

One week for research and writing.
Approximately four weeks to paint and four days for presentation.

MATERIALS

- chairs
- white primer
- selection of oil or acrylic paint
- various size brushes

STARTUP

Have students prepare the chairs by cleaning them thoroughly and applying white latex paint to them as a base. Direct students to give each chair two coats of paint.

Give students a typed prospectus for the project. The outline should cover the overall concept, working time line, writing element, painting

tips, final presentation, and evaluation. Divide the project into three parts: research and writing, actual painting, and verbal presentation. Instruct students to choose one famous artist on whom they will focus. They will work to understand the essence of that artist's style (i.e., the artist's use of design elements and principles), and then work in groups of two to paint those stylistic qualities onto one white wooden chair.

PROCESS

To discourage students from picking an artist just by name, select examples of fifteen artists whose works represent a variety of styles. Number each artist, and post examples of their work onto a large display board. Selected artists might include: Claude Monet, Vincent van Gogh, Paul Gauguin, Marc Chagall, Georgia O'Keeffe, Paul Cézanne, Salvador Dali, René Magritte, Pablo Picasso, Frida Kahlo, Piet Mondrian, Paul Klee, Gustav Klimt, Mary Cassatt, and Georges Seurat. Spend a few minutes explaining the unique style of each of these artists.

Give students a blank sheet of paper and ask them to write on it their own name and the names of two artists they would like to investigate. Allow students a first and second choice as students will be paired based on the artists they want to investigate.

Because students will be paired and work together cooperatively,

limit the total number of chairs. Try to have only one chair per artist in each class as this will increase the number of artistic styles represented. There may be a few students who want to pursue an artist that no one else has chosen. These students need to agree to meet the same requirements as other students who are working in pairs.

Have students begin by researching their chosen artist. Tell them to find out when the artwork was done and to investigate major influences on the artist particularly in terms of color, composition, and concepts of his or her artistic expression. Suggest that students answer the question, "Why is this person famous?"

Require that students provide at least three reference sources for the artist whose work they will explore. It is essential that both students in each group do the work and then combine the information each has gathered. Partners need to decide

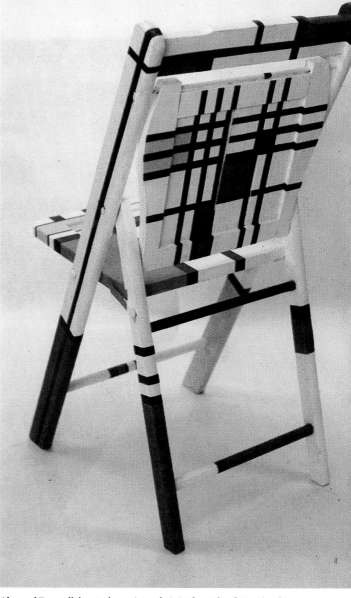

Alex and Tom collaborated to paint a chair in the style of Piet Mondrian.
Alex Snoog, Tom Laskowski, grade 12. Acrylic paint over white latex, 33" x 19" x 17" (84 x 48.4 x 43.3 cm).

which person will type the final presentation. Tell them to plan on approximately two pages of writing. The research and writing takes place during the first five class periods. Students should save their writing for the presentation.

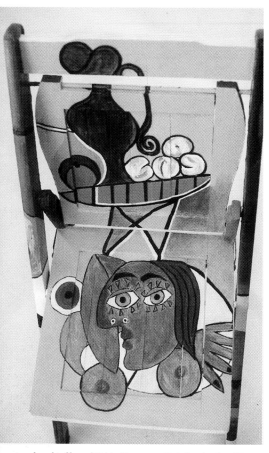

Janel and Jeff used Pablo Picasso as their inspiration. They incorporated Picasso's various styles in their solution.

Janel Snowden, Jeff Trivino, grade 12. Acrylic paint over white latex, 33" x 19" x 17" (84 x 48.4 x 43.3 cm).

Encourage students to combine their talent to create a painted chair that embodies the essence of the chosen artist's style.

Have students begin their work slowly, using pencil on the chairs and developing images by combining the artist's subject matter chosen from a variety of works. As they move into the painting stage, stress the importance of having the artists' work in front of them. This reference will enable them to understand the artist's use of color, brushstrokes, and overall composition. Ask: "What is the essence of this artist's style?" "How are you achieving it?"

Remind them to paint all surfaces with a concern for color, composition, and style. Use acrylic or latex paint, and apply a clear varnish spray finish when the project is completed.

Finally, have each pair of students present their work to the rest of the class. Suggest that they explain who the artist was, what his or her influences were, and the style in which he or she worked. Their presentation should also address why students created what they did and how their finished work reflects the chosen artist's style. Allow groups approximately ten minutes each for their presentations.

CHOICES

- famous artist
- development of images
- interpretation of style

EVALUATION

Tell students that each element of the project (writing, painting, and presentation) will be evaluated and that each member of the student pairs will receive the same grade. This, hopefully, will motivate each student to take responsibility for his or her share of the work. Have students respond with verbal critique. Ask: "What aspect of your work best represents the style of the artist?" "What did you find most challenging about working in pairs?" "What elements of your work demonstrate success in this project?" See also the rubric on page 34.

RESULTS/OBSERVATIONS

Students completed the written portion of the project within the time frame allotted. Many added visually exciting covers to their reports. I read through their first drafts, made suggestions, and then asked a member of the English department to read through students' final submissions and make comments. The painting aspect took twice as long as projected—approximately four weeks. But the end of the marking period forced a deadline, and students put in extra time—chairs, paint, and brushes were taken home.

Some students were challenged by aspects of working cooperatively: for example, trying to combine their individual painting styles and, at the same time, match their styles with the style of their chosen artist. Throughout the project, students and faculty periodically visited the artroom to see students' progress, make comments, and decide which chairs they liked the best.

The inclusion of a written element, a hands-on painting experience, and a verbal presentation gave the project balance. Students learned about painting, artistic expression, and art history, and gained a sense of real accomplishment. In the end, students' completed chairs functioned as a metaphor for a group of artists sitting together—all similar in structure, yet remarkably different in expression.

CONCLUSION

Because I was curious about how difficult the project would be and what pitfalls it might entail, I couldn't resist picking an artist to work with myself. Paul Gauguin was my choice primarily because no one else picked him, but also because I wanted to see if I could duplicate his rich use of color. Participating myself, I soon realized that wrapping imagery around the form of a chair was not as difficult as I imagined it would be. What proved challenging was trying to achieve color and unity in an object viewed from a distance. Gauguin worked on some fairly rough surfaces, which showed in the texture of the paint, whereas the chairs we used were smooth and a sense of texture was difficult to achieve. A rougher coat of gesso would have helped overcome this difficulty.

The projects in this chapter focused on problems that develop students' thinking skills and their ability to work together cooperatively. Projects stressed the importance of the artist/teacher participation. In the Famous Artist Chairs project, for example, my personal involvement made it easier for me to dialogue authentically with students. Three projects required reflective writing. Other projects focused on cultural connections (Yumi Sculpture Garden), valued concepts (Tower of Freedom), and art history (Famous Artist Chairs).

Projects forced students to work cooperatively to create a final product. Traditional artistic expression focuses on the individual. These projects encouraged students to think beyond traditional categories by working together to complete a work of art. Students learned that engaging more than one mind results in the creation of something far greater than what students had anticipated.

To the extent that technology and global business relationships continue to bring society closer together, our students need to understand the importance of establishing cooperative relationships. We can help students learn to work cooperatively by creating problem-solving experiences that require group decision making and the acceptance of individual differences.

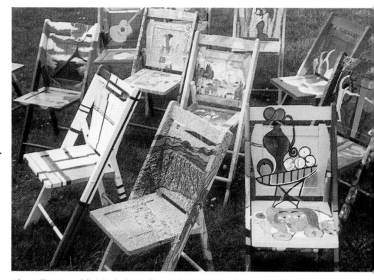

The collection of finished chairs shows the diversity of artists' styles from which students chose to solve this design problem.

6 Advocacy for the Arts

This chapter celebrates the creativity of individual students and of the collective group in relation to the school environment. In this chapter, we begin with projects that inspire the individual and then move on to projects that call upon group creativity. The culminating exhibition of students' work serves the dual purpose of sharing students' work and enhancing the artistic awareness of the larger community.

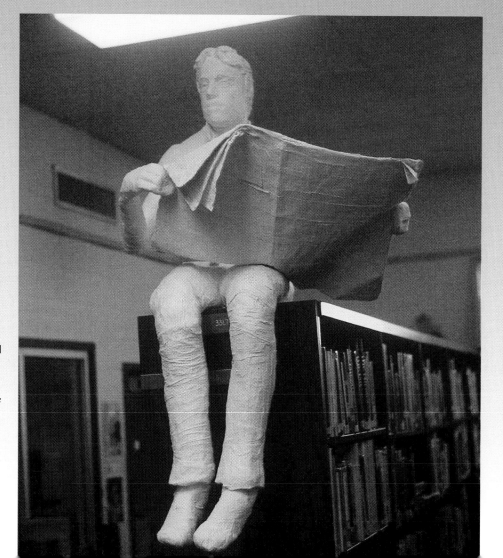

This sculpture of a student is placed above the periodical section in the library. The figure, momentarily distracted from reading the newspaper, peers over the corner of the paper. The sculpture is freestanding.

Students, grades 10, 11, 12. Plaster gauze, life-size.

Collaboration, Concept, Creation: Special Projects for Gifted Students

INSPIRATION

Gifted art students, like everyone else, can lose focus and direction if they are not challenged. Sometimes, as teachers we lose sight of this because these students work hard and always seem to produce great results in a short amount of time. As teachers, we need to be acutely aware of the developing style, interests, and potential of our gifted students. We need to develop individualized programs that motivate them and challenge them to perform to their potential.

PROBLEM

Students will select an artistic direction for a highly individualized form of self-expression and create a series of images that they feel driven to express.

TIME FRAME

Not easily measured. It may take students many hours to create their multiple images.

MATERIALS

- variety of drawing and painting materials (colored pencil, pen and ink, markers, colored chalk, acrylic paint, watercolor paint)

STARTUP

There are a number of ways to develop an individualized program. Start with an individual student conference. In this conference, express your interest in the student's work and help him or her set goals for future work. The role of the artist/teacher is to offer positive support in such areas as time spent, materials to be acquired, and concepts to be explored. To help students find the time they need to complete the project, encourage them to use any free moments such as study hall periods and before or after school. Suggest that they borrow or buy the materials they need to continue their work at home over weekends and holidays.

PROCESS

Ask students to think of a subject area that interests them. Have them explore the concept in depth and choose a direction for their work. As students decide the media they will use, suggest they maintain consistent visual imagery throughout their series of pieces. Some students may use only one medium. Others may choose more varied media and focus on a theme that connects the various pieces. As a facilitator for the process, support students in their decisions, answer questions related to media, and listen as they plan the direction of their work. Work with students to develop a schedule and plan for acquiring materials.

To enhance students' awareness and understanding of their own decision making, development of ideas, creative process, and final critique of their work, allow time for reflection. Providing reflective time supports student growth in that it encourages higher-level thinking skills and makes analysis and evaluation an integral part of the problem-solving process.

Listening attentively to each student will help keep students focused on their process rather than on the teacher's agenda or expectations. Encourage students to take risks. Challenge students to surprise themselves with what they create.

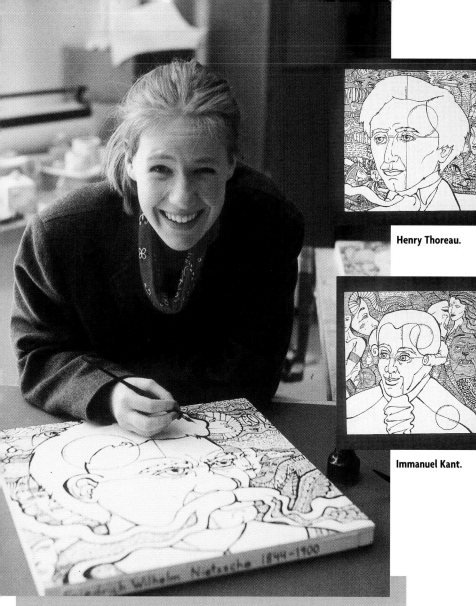

Henry Thoreau.

Immanuel Kant.

Heather drew a series of stylized portraits of famous philosophers. As a textural element, each portrait includes writing by the philosophers and Heather's responses to their ideas. Her portrait studies are sophisticated in both concept and execution.

above, Heather at work on Friedrich Nietzsche.

Heather Freeman, grade 12. Pen and ink, 2' x 2' (61.2 x 61.2 cm).

below, Heather's work is exhibited above the library entrance.

CHOICES
- subject and its development
- media
- size

EVALUATION
Have students reflect on the overall success of the process and their final results. Ask: "Did you accomplish what you set out to do?" "What aspect was the most difficult and how did you work through that?" "Does your work show an increased understanding of the subject you chose?" See also the rubric on page 34.

RESULTS/OBSERVATIONS
Working with gifted students can be a challenge in that it demands from the teacher focused attention through personal conferences, help acquiring materials and work spaces, and time for critique. It requires a commitment from students also who are required to do all class assignments as well as this additional work. Completed projects provided students with a substantial body of established work.

CONCLUSION
Providing personal attention to students can produce dramatic results. As we work with individual students from initial concept through final creation, we inspire and motivate them to take their personal expression seriously. This project worked well with gifted students because it asked them first to narrow their focus to one area of interest and

allowed them to explore that area within whatever framework and media they chose. Each student with whom I have worked in this manner has achieved a new understanding of what it means to be an artist.

Dan Fiori created a series of portraits of famous musicians. His goal was to create visual imagery that evoked the qualities of the music as well as the personality of the musician. His results show varied studies and a clear understanding of musical style. Each portrait is expressive and sophisticated.

Dan Fiori, grade 12.

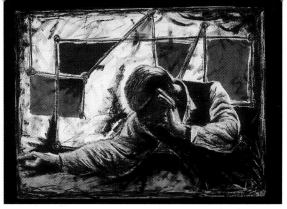

Igor Stravinsky. Charcoal, acrylic and oil pastel. 26" x 36" (66.3 x 91.8 cm).

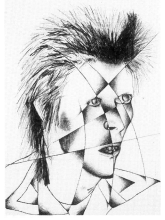

Star Dust: David Bowie. Pencil, 15" x 20" (38.1 x 51 cm).

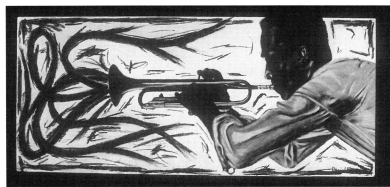

Miles Davis: Kind of Blue. Acrylic on wood and pastel, 12" x 36" (30.5 x 91.8 cm).

Thelonious Monk: Monk's Dream. Acrylic, 15" x 20" (38.1 x 51 cm).

Examples of Two Students' Work

The two students whose work is described here chose to create portraits of famous people. Their portrait studies integrate personal qualities of their subjects with their own personal vision of what these people represent.

Heather Freeman worked to develop stylized images of famous philosophers using pen and ink as her chosen medium. Each composition included writing as a textural element rather than as a message to be read. Individual conferences helped Heather clarify her direction and purpose. After spending hours in the library compiling background information, she decided to create a series of images of philosophers whose work interested her. She selected a range from Confucius to Nietzsche and included Socrates, Plato, Descartes, Hume, Kant, and Thoreau. Heather researched time lines, read from each philosopher's work, and located images of what the philosophers might have looked like. Working on 2' square masonite panels mounted on ³/₄" white pine strips gave her work visual consistency and a raised panel quality. As the work developed she brought together her unique

drawing style, the philosophers' portraits, and the textural writing. The writing consisted of her own and the philosophers' responses to selected ideas. The end result was a unified body of portrait studies, sophisticated in both concept and execution. These were displayed above the entrance of the school library.

Dan Fiori, an accomplished jazz musician as well as expressive artist, worked consistently throughout his high school years to develop his gifts in both art and music. After individual conferences, Dan decided to develop portraits of famous musicians he had studied—Stravinsky, Monk, Bowie, Davis, and Coltrane. He made sure he had a clear understanding of each musician's style and researched images of them. He chose to work in a variety of media including pencil, acrylic, oil pastel, and charcoal. He also chose varied surfaces for his images–paper, canvas, and plywood. The finished portraits were sophisticated in both their imagery and expression.

A Visually Inviting or Repelling Environment

INSPIRATION

As an artist working in mixed-media sculpture, I am interested in how artists use unusual materials to create powerful or imaginative images. One artist in particular, the American Joseph Cornell, inspired me and became a jumping-off point for developing this visual problem. Cornell's work invites the viewer into his personal and small world. Space and the use of materials becomes relative as the viewer is absorbed in the feeling of Cornell's created box forms.

PROBLEM

Each student will create a small, focused space that is either visually inviting or visually repelling. This focused artistic statement will be limited to the interior area of a 5 1/2" foam core box.

TIME FRAME

Approximately two and one-half weeks.

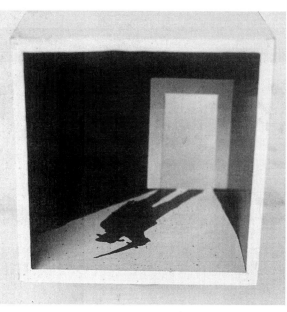

Peter created a repelling quality in the knife-wielding shadow that is seen on the floor but not in the doorway.

Peter Vanzino, grade 10. Cut paper and tempera, 5½" x 5½" (14 x 14 cm).

MATERIALS

- foam core sheets
- X-acto knives and new blades
- white glue
- straight pins
- variety of drawing and painting materials (colored pencil, pen and ink, markers, colored chalk, acrylic paint, watercolor paint)

STARTUP

Before class, create an empty foam core box to show size during the introduction of the project. Research and share the work of artists who use mixed media or recycled materials, as well as examples of Surrealism. Show students examples of Cornell's work. Explain that Cornell's work has its origins in Surrealism and that the artist's juxtaposition of both two- and three-dimensional images in contained boxes has been a significant contribution to American art. Examples of Cornell's work (see especially *Medici Slot Machine* (1943) and *Observatory* (1950), both of which show three-dimensional surreal environments) can be found on the Internet and in Dore Ashton's book, *The Joseph Cornell Album.* Show also the work of other contemporary artists who use found objects and work in confined spaces.

PROCESS

Have students begin by thinking of a place where they would like to spend time or the exact opposite, a space in which they would never want to spend time. Display the 5 1/2", empty, white foam core cube during the introduction to this project. Leave one side of the box open so students can see the available space inside. Tell students they are going to develop the interior space to create a unique environment that is either visually inviting

or visually repelling. Discuss the possible uses of the interior space during the introduction to the project. Encourage students to use any materials or mixed media they choose to develop their personal concept.

Use the following questions as a focus for a class discussion. Ask:
• What would be a personally inviting or repelling space?
• What materials would show these qualities?
• How could the use of color, line, and texture play a part in developing this space?
• How can this limited space be organized for the greatest visual impact?
• What found objects or materials will work to develop your ideas?

Decide the size of the foam core box based on the amount of available foam core. Boxes larger than 6" may detract from the focused concept in the work. Make the size of all boxes uniform to add a sense of continuity to the overall assignment. If the teacher is working with large numbers of students, there are many benefits to working small—such as ease of storage, quantity of materials required, and the ability to display more of students' finished results.

Give students sheets of foam core and ask them to measure very carefully before cutting it. Use new X-acto knives or blades to insure the cleanest possible cut on each edge. Use white glue and straight pins to build and secure each box.

Students can decide if the box should go together as a unit first or if each side should be created and connect as the work progresses. Open each box on one side. This open front can be made smaller if desired. Also, if desired, the back of the box can feature holes to increase light in the interior space. Other than these changes, the boxes remain intact. Have students bring to class objects and materials to go in their boxes. As materials and images are developed, have students decide what they will place in the foreground, middle, and background of that interior space. Emphasize good craftsmanship, including the overall quality and use of materials (for example, hiding the way materials are joined or attached).

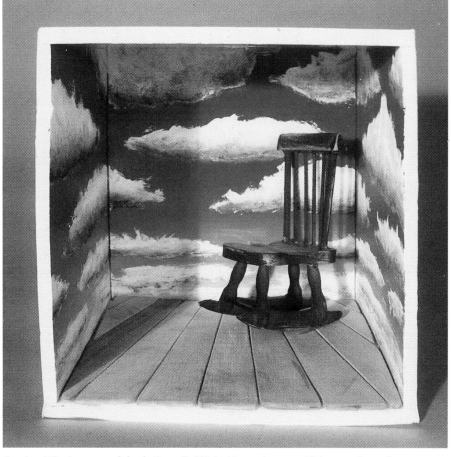

Imagine sitting in a room of clouds. Dan called his inviting environment *Welcome to Surrealism.*
Dan Fiori, grade 11. Acrylic paint, wood, 5½" x 5½" (14 x 14 cm).

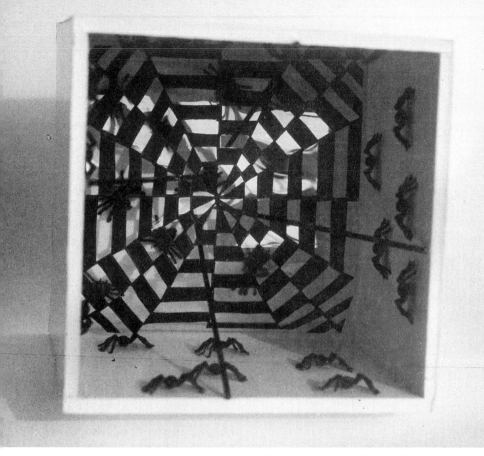

The mirror in the interior space reflects the spider, giving the impression of many black spiders.
Ron Tobia, grade 11. Mixed media, 5½" x 5½" (14 x 14 cm).

EVALUATION

Have students reflect on their working process. Ask: "What will indicate to the viewer that your space is inviting or repelling?" "How is your interior space developed to get that feeling across?" Have students pick another student's work and discuss its strengths and weaknesses. See also the rubric on page 34.

RESULTS/OBSERVATIONS

In many cases, students decided to construct five sides of the foam core box first in order to give themselves more time to decide what they would place in that created space. Most students left completing the shape of the opening on the final side, the one the viewer looks through, to last. A number of resourceful students brought in objects or materials from home (such as old toys, marbles, mirrors, and objects from nature) to place in their box. Other students relied on artroom materials to draw, paint, or construct their ideas for their interior spaces.

Initially, I thought that most students would choose to make their space repelling. However, students quickly realized they could not rely on gimmicks (such as blood and guts) because these would produce images with little credibility and, in some cases, images that were more humorous than serious. Creating the tension needed to effect a repellent environment proved difficult and in the end, the class produced an almost even number of inviting and repelling visual statements.

CONCLUSION

Because the theme of what attracts and repels interests the adolescent mind, students were immediately engaged. Working small makes the problem more challenging but probably a 6" or 7" foam box would work as well. Limiting the space to 5 1/2" x 5 1/2" helps students to focus on content and craftsmanship. The small size affords the opportunity to change one's ideas or surface treatments quickly and also reduces the quantity of materials used. Students' results were diverse and engaging.

Connecting with Dreams to Create an Artistic Expression

INSPIRATION

We spend about one third of each day in the altered state of consciousness called sleep. During sleep we go through a dream cycle about every ninety minutes. The most dramatic aspect of sleep is dreaming. For this project I began with the premise that dreams are a universal experience—a part of the human condition. A general format for this project came from the idea of creating a dream structure, a structure that would incorporate individual work into a visually unified piece. To connect the concept of dreams and visual presentation, I needed to research sleep and dreaming.

PROBLEM

Students will create a visual reflection of their personal dream world and develop two artistic, 6" triangular visual statements. Students will decide how to stack individual dream structures to create a collective dream structure. The structures should give tangible form to the illusive quality of dreams and the fact that they are a shared part of the human experience.

TIME FRAME

Two and one-half weeks.

MATERIALS

- 6" x 18" black and/or white paper (80 lb.)
- scissors, X-acto knives
- tape, glue sticks
- variety of drawing and painting materials (colored pencil, pen and ink, markers, colored chalk, acrylic paint, watercolor)

STARTUP

Three weeks before beginning the project in class, have students begin to keep track of their dreams. Have them use their sketchbooks as a dream diary—writing, drawing images, or creating symbols—for a period of three weeks. Students should:

- list words that describe images connected to specific dreams.

Patrick used various papers and cellophane to create a reflective lake in his dream.
Patrick Shannan, grade 11. Mixed media, 6" (15.2 cm).

A large face appears behind a falling window, creating a surreal effect. Chris used gray cardboard to construct the window and magazine images for the background.
Chris Campbell, grade 12. Mixed media, 6" (15.2 cm).

- list emotions and feelings.
- list images or create symbols.
- use the language of art to express qualities of a dream image or sequence. That is to say, with what color, line, texture, or form would describe your dream?

Have students also reflect on their daydreams. Ask: "What is it like for you when you sit in a class and your mind starts to drift?" "How is that drifting different from dreaming while you're asleep?" Ask them to think about the visual qualities of their daydreams. Ask: "What parts of the daydream are in focus?" "What parts are elusive or unclear?"

Alerica's dream images feature both a fear of falling and the joy of flying.

Alerica Lattanzio, grade 12. Mixed media, 6" (15.2 cm).

Encourage students to list this information on the left-hand side of their sketchbooks and to draw on the right-hand side. Encourage them to refer to these notes throughout the project. In this initial sketchbook stage each student needs to develop at least three dream images. These images can include overlapping subject matter or images that come in and out of focus. Suggest that students ask themselves the question, "What creates dreamlike qualities?" Provide adequate thinking time before using studio time for the pro-

ject. If students have difficulty recalling dreams, suggest that they think back on significant childhood dreams or recall recurring or recent dreams. Ask them to document those dreams in their sketchbooks. Since each person's dreams are unique, emphasize that there are no wrong answers.

PROCESS

Introduce the project by showing the size of the triangle form. Provide varied materials for students to use as they explore their imaginative images. Available media might include magazines, varied handmade and manufactured papers, as well as a selection of drawing and painting materials. Share current research about dreams with students. Provide examples of dream-influenced artworks such as *The Persistence of Memory* (Dali, 1931) and *Personal Values* (Magritte, 1952).

Give students a sheet of 6" x 18" black and/or white paper to use for the main body of the project. One possibility is that the two colors could represent good or bad dreams, day or night dreams. It is up to the students to decide what significance, if any, they choose to give color. Fold the paper twice to form a triangle, 6" long on each side. When folded in a triangular form the heavy paper (80 lb. or stronger) will stand on its own. Have students choose media that will help them connect the feeling or mood of a specific dream to the visual image they are creating. Students will create two multi-faceted images that will become part of the larger class structure.

Ask students to pick one side of the triangle and to create on this side a window into their dream world that will creatively invite the viewer into that small space. Suggest that students think about this as they develop the interior space of the folded paper. As they explore the essence of their dream and name its qualities, they will develop a clearer sense of what shape their windows should take.

CHOICES
• development of subject
• media

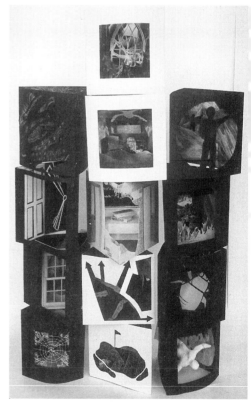

This group structure of dream images was constructed to give students a chance to appreciate the many different approaches and unusual solutions developed for this project.

EVALUATION

Have students describe the essence of their dream or dreams. Ask: "Do your images come close to representing those qualities visually?" "Will others be able to draw from your artistic statement some of the emotions you experienced?" "How have you made it possible for viewers to do this?" See also the rubric on page 34.

RESULTS/OBSERVATIONS

Students learned to represent in a visual format what at first appeared to be a random juxtaposition of images. They created images with emotional content, such as fear of falling or the exhilaration of flying. Although it seemed that some of the students literally stopped dreaming when this assignment was given, others had a flood of dreams. As a result of this project, students developed greater understanding of how artists have historically been influenced by the power of dreams and how their dreams, in turn, affected the images they produced.

CONCLUSION

Sometimes it is difficult to recreate images that are in our minds, and when these images occur in dreams, it can be even more difficult.

Students were asked to break down the feelings, textures, and imagery of their recorded dreams—then, symbolically and using juxtaposition, to reconstruct those qualities for their artistic statement. They were reminded that there are no wrong answers.

Since we are the creators and producers of our own dreams, they can offer us insight about who we are. Producing an artistic image gives the dream creative form. Thus, the project both encourages expressiveness and increases students' skill in the use of art materials.

Dreaming

Dreams are experienced during the REM (rapid eye movement) stage of the sleep cycle. The REM stage in the sleep cycle occurs about every ninety minutes. Researchers have divided dreams into three basic types: wish fulfillment, problem solving, and products of spontaneous brain activity.

Dream researchers in Toronto have concluded that, because of the increased brain activity that occurs during the sleep cycle, intensive learning occurs during this time. While we dream our brains are trying to make sense out of this increased activity. This explains why, the dream experience produces both random images and varied feelings. Dreams also help us to sift through thoughts, cope with stress, and fix in our memory the day's experiences. Researchers discovered that individuals whose sleep was interrupted during the REM stage tested poorly on standardized tests and concluded, based on this information, that dreaming affects how the human brain functions. Researchers agree that humans need REM sleep and that dreaming, in essence, helps us to learn.

Dreams have been described in *Psychology*, by Lester M. Sdorow, as a "story-like sequence of visual images that commonly evoke strong emotions." Dreams often combine and juxtapose images in an illogical way. Dream experiences leave us with a variety of feelings such as comfort, fear, confusion, or a sense of opportunity. Things that are impossible in real life can seem perfectly normal in dreams. We can fly or even talk to a giraffe and perceive this all as quite normal. By recalling and reflecting upon dreams we can gain insight into ourselves.

For thousands of years humans have reflected on the significance of their dreams. The great pharaohs of Egypt had dream interpreters. Sigmund Freud is famous for making the analysis of dreams an important element of psychoanalysis. According to the psychiatrist Carl Jung, the dream is "the small hidden door in the deepest and most intimate sanctum of the soul." Remind students that artists, especially Surrealist artists such as Salvador Dali, Max Ernst, and René Magritte, often incorporate dreams into their artistic expressions.

BUY ME! BUY ME!—A Creative Look at Advertising

INSPIRATION

We live in a highly commercial society filled with a seemingly endless variety of any given product. Being bombarded by commercial images can be exhausting. On the other hand, these images can also inspire creativity.

PROBLEM

Students will develop a product that they think is needed in today's world or perhaps a product for future use. They will create a two-dimensional magazine advertisement and a three-dimensional package design for this new product.

TIME FRAME

Two weeks for the magazine image. Approximately two and one-half weeks for the three-dimensional package design.

MATERIALS

- a variety of drawing and painting materials (colored pencil, pen and ink, markers, colored chalk, acrylic paint, watercolor paint)
- 9" x 12" white vellum (80 lb.)
- railroad and illustration board, variety of sizes
- 12" x 18" gray bogus paper
- glue sticks

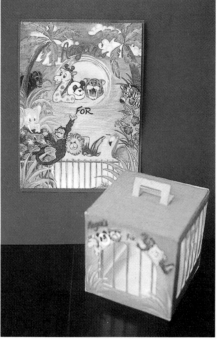

Regan's solution—*Regan's Zoo in a Box*—advertises miniature creatures you can take home. "Why settle for just your ordinary kitten when you can take home a miniature monkey, tiger, lion, rhino, or zebra?"

Regan MacKay, grade 10. Colored pencils, box: 7" x 7" (17.8 cm x 17.8 cm); advertisement: 9" x 12" (22.9 x 30.5 cm).

STARTUP

Research and share advertising campaigns that show imaginative artistic qualities. Magazines, newspapers, consumer products, billboards, and store displays are all useful sources.

PROCESS

Ask students the following questions: "What makes any product desirable or visually attractive?"

"What aspects of the product would cause you to take a second look?" Ask students over a weekend to go to either a shopping mall, a toy store, or a supermarket to answer those questions. These locations afford the opportunity to see similar products. Instruct students to wander through the aisles and notice what catches their eye. Ask students to think about the qualities that command their attention. Could they sense that because of stiff competition many products seem to jump off the shelf shouting: "Buy Me! Buy Me!" What gives that impression or makes that possible?

Begin the class with a random selection of advertisements and discuss the striking qualities of each. Select examples that cause the viewer to look again and even read the information about the product being sold. Ask: "What visual elements or design qualities has the advertiser used to generate interest in the product?"

Follow with a discussion asking questions like: "What attracts you to a product?" "How important is the visual presentation of the product?" "Are you aware that certain age groups are targeted in advertising?" Use this discussion as a jumping-off point for exploring the problem stu-

dents will solve. Ask questions such as: "What product do think we need in today's world?" "How about a product for the future?" "How could you develop an advertisement for such a product?"

The project is divided into two parts. In the first part, students create a two-dimensional layout design for a magazine (9" x 12"). In the second part, they develop a three-dimensional package design, approximately 6" in any one direction. Encourage creative ideas for a future product. Serious or humorous solutions are also acceptable. For both parts of the project, stress the readability of lettering, strong composition, and craftsmanship in the use of materials. Tell students that a major requirement is personalizing the product. The student's name, first or last, must be included on his or her product design. In this way the product also becomes more readable as an advertisement, and students feel greater ownership of the project.

Students choose the media they want to use to develop their products. Offer students a variety of materials, such as colored pencils, watercolor paint, felt markers, pastels, and mixed media. Encourage the use of computer-generated lettering to give their work a profes-

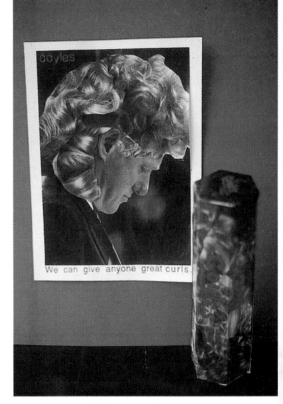

Coyle's Curls promises to give anyone curls, even Bill Clinton.

Deirdre Coyle, grade 10. Collage, box: 2¹⁄₂" x 12" (6.3 x 30.5 cm); advertisement: 9" x 12" (22.9 x 30.5 cm).

sional presentation. Distribute white drawing paper for the magazine advertisement. Heavy white paper such as railroad board can be used for the package design. Use gray bogus paper to work out a rough copy of the size, folds, and tabs for gluing. Glue sticks are handy for attaching the final projects.

CHOICES

• subject
• size for package design
• media

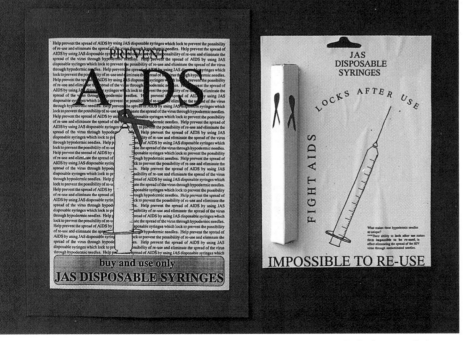

Jennifer's serious response to the problem was *Jen's Disposable Syringes.* They lock after use, which prevents the spread of transmittable diseases such as AIDS.

Jennifer Serravallo, grade 10. Colored pencil, felt-tip pens, 8" x 10" x ³⁄₄" (20.4 x 25.4 x 1.9 cm); advertisement: 9" x 12" (22.9 x 30.5 cm).

EVALUATION

Have students reflect on the process. Ask: "What do you see in your work or in the work of other students that makes the product visually appealing?" "Would you be motivated to buy any of these products?" "If so, why?" "Will any of these products add something significant to society?" Ask students to look at the power and craftsmanship of the overall design. See also the rubric on page 34.

RESULTS/OBSERVATIONS

Giving students the freedom to choose their subject matter allows for greater decision making, but in this case some students had a hard time selecting one idea. Students chose from a variety of possible themes and subjects—some serious, some humorous. Topics included high technology, fantasy, social issues, and personal products. The task of developing creative solutions to visual presentation problems elicited discussions about our society and products to which we are attracted. This project had obvious and clear connections for students who want to pursue advertising as a career.

CONCLUSION

The value of this project is that it increased students' visual awareness concerning both two- and three-dimensional advertisements. Students became more aware of what visually attracts people to products and what makes products desirable. Many students were surprised at the aptitudes they discovered in themselves and as a result developed an interest in the field of advertising.

Michelle invented a way to protect people from the sun's "evil rays." This product— *Shells' Shades*—brings attention to the need to protect our eyes.

Michelle DiDonato, grade 10. Colored pencil, box: 7" x 14" x 3" (17.8 x 35.7 x 7.6 cm); advertisement: 9" x 12" (22.9 x 30.5 cm).

Creating New Landscapes
• Miniature • Mixed Media • Collages

INSPIRATION

Creating artwork in the form of landscape using the school setting as the focal point was the challenge of this project. The aim was to move students to think beyond what is immediately in front of them to create on a more expressive level.

Time restraints or preconceived ideas can, at times, make the classroom feel restricted. In this case, my preconceived ideas centered on the media and location appropriate for landscapes. When I think about artistic expressions created from landscapes, two things come to mind: painting classically and working in the outside environment. Working with numerous students and limited time and materials, I soon realized that outdoor painting would be impossible. I needed to shift my thinking so as not to feel limited. I wanted students to think about creating landscapes in a more imaginative way. For this reason, I decided not to rely on the local school setting or to use paint as a medium for this project.

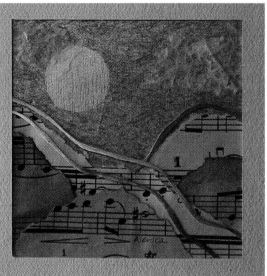

Alerica's landscape shows unified color, although she used diverse materials—sheet music, wire, and other kinds of paper.

Alerica Lattanzio, grade 12. Paper collage, watercolor, pounded wire, 3" x 3" (7.6 x 7.6 cm).

PROBLEM

Students will create a series of three small paper collages using cut or torn paper that represents different qualities of landscapes. These imaginative landscapes may, if students choose, incorporate another media. One landscape in the series is to be monochromatic.

TIME FRAME

Approximately two and one-half weeks.

MATERIALS

- assortment of papers: handmade Japanese lace, newspapers, rice paper, tissue, foil, common recycled newspapers, and newspapers in foreign languages (to add visual textural qualities)
- craft wire—gold, silver, and copper (20 gauge)
- white glue (two parts glue to one part water)
- heavy paper or illustration board

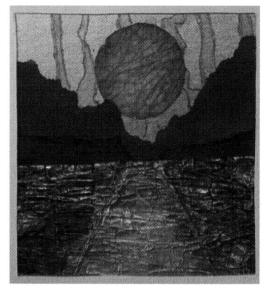

The stains produced by watercolors capture the setting sun and unify this composition.

Eric Bennett, grade 11. Paper collage, watercolor, 3" x 3" (7.6 x 7.6 cm).

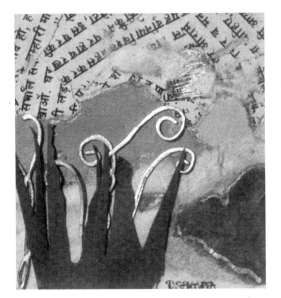

Devi's imaginary landscape, created with newspaper in the sky and foreground, has an Asian influence.

Devi Sengupta, grade 11. Paper collage, watercolor, 3" x 3" (7.6 x 7.6 cm).

STARTUP

Acquire a vast assortment of papers of different textures, thicknesses, and colors. Share with students images of landscapes created by famous artists. Hang reproductions of landscapes by artists such as van Gogh, Dali, and Monet in the artroom during the project. Discuss these works in terms of composition, expression, color, and line. Demonstrate collage techniques, such as cutting, tearing, overlapping, and gluing.

PROCESS

Ask students to begin thinking about what makes up a landscape. Suggest they consider color, light, and texture as these apply to mountain ranges, the ocean, or the desert. How could they show the visual qualities of hot or extremely cold climates? Could the same

landscape be interpreted in different ways to show seasonal changes?

Landscape collages can be realistic, expressionistic, abstract, or symbolic. Suggest producing a series of landscapes for two reasons: (1) it will help students understand the value of multiple images, and (2) it will teach students how to create strong and repeated compositions in small spaces. This project requires a minimum of three landscapes. Each is to be no larger than 3 1/2" square and no smaller than 2" square.

Because of size limitation, students should give careful consideration to composition. The size limitation will help students create a focus for their work. Have students make a basic viewfinder by cutting a 3" square from the middle of an 8 1/2" x 11" sheet of manila paper. Suggest that students place the viewfinder daily over the unglued torn paper image. Using this viewfinder will help students isolate the best composition. When they use the viewfinder, students should decide if they want to stay at 3" or go slightly larger or smaller. Remind students to store their work carefully on shelves and in class drawers to avoid the shifting of the unglued compositions. Students begin the gluing process only after they have designed their final composition.

Have students use watered-down white glue (two parts glue to one part water) to finalize the overall composition. Tell them to also con-

sider as they glue the kind of paper they are using. Use watered-down white glue over tissue paper or other thin paper. With foil paper, apply glue only on the reverse side as glue will dull the foil surface. With very fine paper (such as lace paper), dot small areas with enough glue to secure the shape; using more glue will destroy the subtlety of this delicate paper.

Tell students to select papers with as much variety as possible for their compositions. Remind them that the aim is to use paper of different thickness, diverse colors, and varied textures.

Some students may wish to select another medium to add to the paper. Students might use, for example, thin craft wire in gold, silver, and copper colors. The wire adds both linear definition and color. Encourage students who use wire to create line variation by hammering the wire to alter its original form. The subtlety

Rich, subtle color combined with texture produced this engaging image.

Zevin Rosser, grade 10. Paper collage, watercolor, 3" x 3" (7.6 x 7.6 cm).

of the hammered metal surface works well with the irregularities of the handmade paper.

Watercolor paint may be used as a staining technique on the various kinds of paper. Using a color wash will also help to create a sense of overall visual unity in a monochromatic landscape.

In the final stage of the project, have students present all three landscapes in simple white mats. Use heavy white paper in lieu of expensive mat board (size: 10" x 12"). Ask students to measure the paper and cut the exact square size they need for their work. Both the top and left and right sides must be of equal distance with a generous amount left at the bottom of the mat. The exterior paper dimensions of 10" x 12" never change, offering visual unity to the final presentation.

CHOICES

- collage paper
- development of subject
- additional media

EVALUATION

Have students respond with verbal critique. Ask: "Has your view on landscape changed as a result of this project?" "How does working small affect results?" "How did your skills and aesthetic awareness increase as you worked on this series?" "What is the benefit of working with varied papers and what effect did it have on your work?" See also the rubric on page 34.

RESULTS/OBSERVATIONS

Many students appreciated the value of creating in a series, as it helped them to see their work as a process rather than only an end result. Students felt confident that if they thought and worked small they could easily complete the three assigned landscapes. This confidence resulted in many students creating a total of four or five collages. Additionally, the small composition made it easier for the student/artist to direct the viewer's attention. The size also heightened the importance of good craftsmanship in the use of materials. For many students the project increased tremendously their understanding of composition and their sensitivity concerning the use of materials. This became apparent when they compared their first collage with their last. For some, the exact measuring and cutting of the mat proved the most challenging aspect of the entire project.

CONCLUSION

In some cases, the simplicity of cut or torn paper, combined carefully with another medium produced very impressive results. What surprised me most was discovering that my sense of what students would learn was confirmed in students' own responses to the project.

The personal influences that students bring to problems are a significant part of their solutions. Although the landscape in the geographic area

Melissa used lace and foil paper combined with fine wire to create this mountain landscape.

Melissa A. Chung, grade 10. Paper collage with pounded wire, 3" x 3" (7.6 x 7.6 cm).

Kristi created a strong composition by layering torn paper for an illusion of depth.

Kristi Dudek, grade 10. Paper collage, watercolor, 3" x 3" (7.6 x 7.6 cm).

where I teach is visually uninteresting, many of my students had extensive travel experiences which enhanced considerably what they could contribute to their creative landscapes. Some students created very sophisticated visual images.

Integrating Images

INSPIRATION

As art teachers, we are known for our assorted collections of materials, all with creative possibilities for upcoming student projects. Therefore, I welcomed a student donation of five Vogue magazines and planned to add them to my pre-existing collection of magazines. I soon realized, however, that all of these particular magazines were from European countries. Other than the obvious language differences there was one other marked difference between the European magazines and similar fashion magazines published in the United States: the Europeans used very few words in their fashion advertisements. Instead, the model provided the sum total of information on the page, and this information was visual. This difference in the concept of advertising inspired me to develop the project that follows.

As I planned project possibilities, I thought of extending a small portion of one image in a way that would force students to focus on integrating a part of the existing photo into a larger creative context. Some students may find integrating an idea or media difficult, but with some encouragement and assistance they can produce a unified piece of work.

PROBLEM

Students will incorporate part of a photographic image into a new composition integrating the smaller image into a larger context. Students will focus on enhancing their technical skills by blending existing visual information, expanding the photographic image, and developing a creative composition.

TIME FRAME

Approximately two weeks.

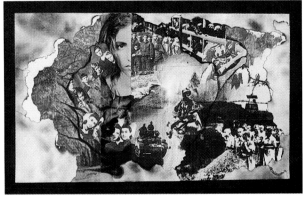

Lynn solved the problem by using photocopies, burnt paper, and charcoal to create a powerful Holocaust image.

Lynn Winningham, grade 10. Paper collage, charcoal, pen and ink, 12" x 18" (30.5 x 45.7 cm).

MATERIALS

- color magazine photos—no words
- varied media
- 12" x 18" inch sheet of white vellum
- glue sticks

STARTUP

Acquire magazine pages featuring photographic studies of models. Select photos from pages that have very few words accompanying them. Cut the images of the models down the middle into 2" strips. Make sure that each 2" section of the photo includes part of a head and body. The photos naturally give information about the pre-existing full page, such as color, line, and texture. Students may get two usable strips of the photographic image from each page.

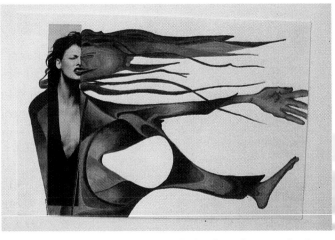

In his imaginative solution, Nick freely used colored pencils to extend and distort the image.

Nick Christoff, grade 11. Colored pencil, 12" x 18" (30.5 x 45.7 cm).

PROCESS

To begin, discuss with students the definition of the word *integration*. Focus on the ability to coordinate, or to blend; to unite with something else. Tell students that integration also means to take an idea and to incorporate it into a larger unit.

Encourage students to select two or three strips from different photographs and to think about possible compositions. They can do this by placing an individual strip on a sheet of newsprint or manila paper and sketching out various ideas. Options are to extend the original image or create a new one. Next, have students select one 2" strip of the photographic image that they feel will give them the best composition and visual possibilities. Recommend that each student use only one photograph from the magazine in their final composition.

Have students choose the media as well as the size in which they will work. Most will use a 12" x 18" sheet of white vellum. Use glue sticks to adhere the photo. Some students may need to use watered-down white glue especially if they add other kinds of paper or use media such as watercolor. Remind students to focus on the concepts of uniting, blending, and incorporating their image so that their results will reflect the concept of integration.

CHOICES

• media
• photo image
• size

EVALUATION

Have students respond with verbal critique. Ask: "What have you learned about the integration of visual media and images?" "How well do your artistic elements visually come together?" "How might the viewer discern the success of the integrated idea or media?" See also the rubric on page 34.

RESULTS/OBSERVATIONS

Students created varied solutions to the visual problem. Three students cut their photos into tiny pieces, using the pieces as pure color and texture to create a new image. Thus, they integrated the partial photo of the model into a completely unrelated subject. These miniature montages used only the 2" strip and presented a highly creative solution to this problem. Students' subjects included a raccoon, a flower, and an elephant. One student worked with photocopied images, burnt paper, and charcoal to create a powerful Holocaust collage. Another student developed a strong composition built around the concept of femininity, using black-and-white photos of women in the background and intensely colored tropical flowers in the foreground.

CONCLUSION

A great variety of results came from this challenging project. What began as a difficult concept, in the end fully engaged the students. Students learned how to blend media and use line, color, and texture to integrate the 2" section of photograph into a larger creative composition. The project could have been done without access to the European magazines; photographs with the words eliminated would have worked as well.

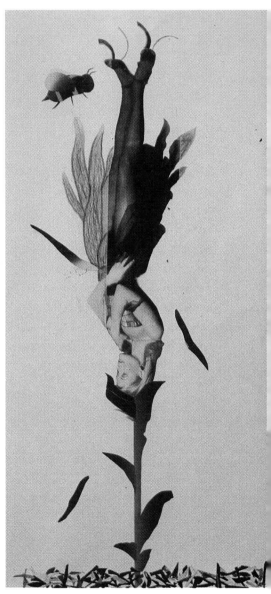

Jean deconstructed the original photo image and then reconstructed the parts into this delicate flower.

Jean Su, grade 11. Paper collage, 18" x 12" (45.7 x 30.5 cm).

Sculpture: A Visible Aspect of Our School

INSPIRATION

Making art an important part of the school environment takes commitment, time, and support. I chose to focus on making sculpture a visible and permanent part of the high school building. This is an ongoing process that motivates art students to work collaboratively.

In the beginning, this project grew out of my desire to increase students' knowledge of American artist George Segal. Segal became famous by casting the human form in white plaster. His sculptures place people in everyday situations and depict the rhythm of the human spirit and life. He is quoted as saying, "I wanted to deal with the expressiveness that's in the human body in a new way." His strategy was to depict everyday situations while adding a sense of mystery and emotion.

PROBLEM

Students will cast volunteers in plaster to create site-based sculptures of the human form. They will cooperatively produce and carefully select the placement of the sculpture in the school environment.

TIME FRAME

Two and one-half weeks.

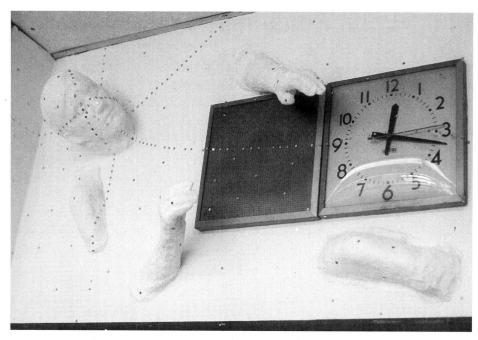

An unattractive wall space above the door in the artroom was transformed into an eye-catching sculpture of a human form emerging in white from a white surface. Individual plaster pieces were attached to 2" pieces of wire mesh and screwed to the wall surface; the screws and mesh were then concealed by plaster gauze. The 1/4" mirrors were placed to focus the viewer's attention.

Carl Lessing, grade 12. Plaster gauze, mirrors, 4' x 8' (122.4 x 244.8 cm).

MATERIALS
- plaster-covered gauze
- petroleum jelly (for covering face)
- surgical scissors

STARTUP

Share information about the work of George Segal. Gather student models for the casting process. Explain and demonstrate the casting method. Note: Being a model for this project is not recommended for anyone who is even slightly claustrophobic.

PROCESS

Create the work using plaster-covered gauze. This is a simple but messy process. Because class time is limited, plan the procedure carefully. Have students work cooperatively in small groups of three or four students. Divide the human form into sections to achieve success within classroom time constraints. Each body part will represent a forty-minute experience. It may take one class to complete the right arm, and another class period for the left, right leg, left, torso, and head.

Guide some students to begin cutting the plaster rolls into 2" squares while others get a container of room temperature water and cover the desktops with newspaper. Have models wear old clothes. Cover bare legs or arms with clear polyethylene wrap to avoid messy cleanup of the petroleum jelly. Do not use the clear polyethylene directly on the face; however, as this will result in a loss of detail. Dip plaster-covered gauze into water, apply, and smooth with each layer overlapping the previous one to make a strong bond. Cast hands with fingers held together rather than spread apart due to the difficulty of removing the cast from around individual fingers. Carefully pry apart the plaster gauze so that the hand can be removed from the casting. The castings can be removed in approximately twenty-five minutes, which will allow time for the model to clean up and for other students to clean up the work area.

Additional tips: Covering the human head can be complicated. Suggest that students use a swimmer's bathing cap and apply a generous amount of petroleum jelly to

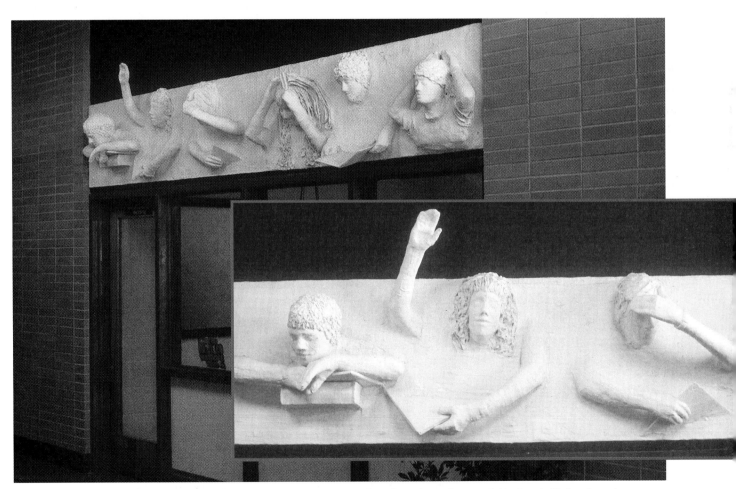

This sculpture comprising six figures is located over the entrance to the principal's office. The students who created this piece decided to show what they typically did in school. One is sleeping on her books, the next is raising her hand (this student felt she was always asking for help). Also shown are the serious test-taker, the person who is forever combing her hair, the constant reader, and the student who often leans back and contemplates the school experience. This piece is attached to plywood covered in a wire mesh for strength. It was permanently bolted to the wall.

Students, grades 10, 11, 12. Plaster gauze, 2' x 15' (61.2 x 459 cm).

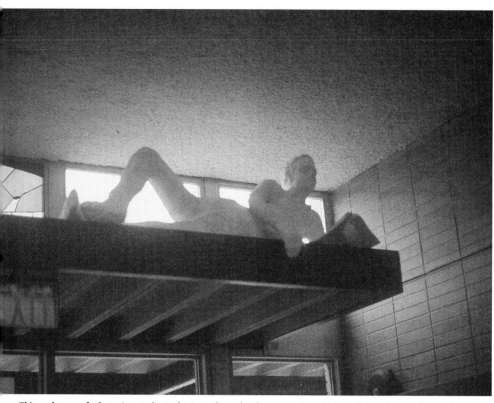

This sculpture of a lounging student who is reading a book seems to be asking students who pass by, "Did you remember your homework?" The sculpture is freestanding.

Students, grades 10, 11, 12. Plaster gauze, life-size.

RESULTS/OBSERVATIONS

Groups worked cooperatively to complete each piece. Together they problem solved and made decisions. Students experienced a high degree of satisfaction and felt their work had a positive and permanent effect on the school environment.

EVALUATION

Ask students to reflect on the challenges they faced and how they solved technical difficulties. Ask: "How did your group decide on the sculpture's placement in the school environment?" "Did you need to recast any specific parts of the sculpture?" "If so, why?" "What was the most difficult aspect of the casting or overall sculpture?" See also the rubric on page 34.

CONCLUSION

A permanent collection of art is a valuable addition to any school environment. The effects of such a collection have an impact on the entire school complex. Students, teachers, and visitors now see the permanent collections in classrooms, the media center, main hallways, and even above exits.

There are many ways to support advocacy of the visual arts. One way is to connect with other art teachers by joining professional organizations. Another is to solicit support from parents and community members. As advocates of the arts, we need to continually evalu-

exposed skin surfaces. Use extra petroleum jelly for the eyebrows and sideburns. Do not cover the eyes because the lime in plaster will irritate the eyes. Do not cover nostrils—this will block the model's air supply! These two areas can be easily covered from the inside of the created form once it is removed from the student's face. Have students cover the head with three layers, wait thirty minutes, and then using surgical scissors, cut along the side of the neck to the top of the head. Tell students to count the number of layers they apply in order to avoid applying

more than three layers, especially on the area to be cut. Cut along the side of the neck, in front of the ear to the middle of the top of the head. Then, with the help of the model, pry open.

After all body parts are cast, have students decide the kind of human sculpture they would like to create. As a group, students should decide the position of the figure and its ideal placement in the school.

ate our programs, be proactive, and educate people who are not particularly interested in art. Finally, we can contribute to arts publications and celebrate student successes by providing them with consistent recognition.

In addition to using the glass showcases available in many schools, you might also consider making a series of 4' x 8' x ¾" foam core panels. These can be hinged in pairs and provide lightweight portable exhibition units. Work can be hung in the artroom and easily moved into the library, entrance halls, or into the larger community for student exhibition.

The three-dimensional projects in this chapter: A Visually Inviting or Repelling Environment and Connecting with Dreams to Create an Artistic Expression made very engaging exhibitions. Viewers first saw a large stack of boxes or triangular forms. They were drawn to look closer to discover what the artist had created. Viewers responded in a similar manner to the miniature landscapes because of the uniform small size, which also invited the viewer into the focused world of the artist. A year-end exhibition can celebrate and share all the students' hard work with the larger educational community.

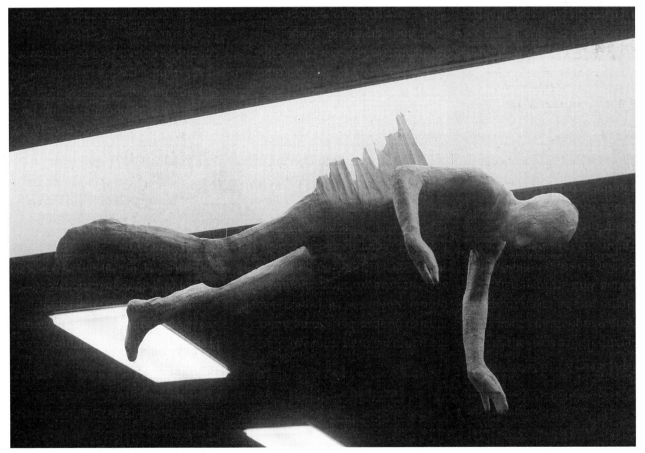

A group of students wanted to create a feeling of movement. They chose a large skylight as the location for their figure, which appears to be flying. This piece is dynamic—the light changes the sculpture's appearance during the day. It is suspended with heavy-duty fishing line.
Students, grades 10, 11, 12. Plaster gauze, life-size.

7 Conclusion

The artist/teacher in the process of growing and reflecting consistently brings new insights, projects, and guidance to the classroom. Embracing the artist/teacher identity means developing projects that go beyond enhancing skill levels in various media— structuring projects to open doors to new possibilities that engage students in problem-solving experiences. The goal is to present students with thought-provoking challenges that inspire them to create new visual images.

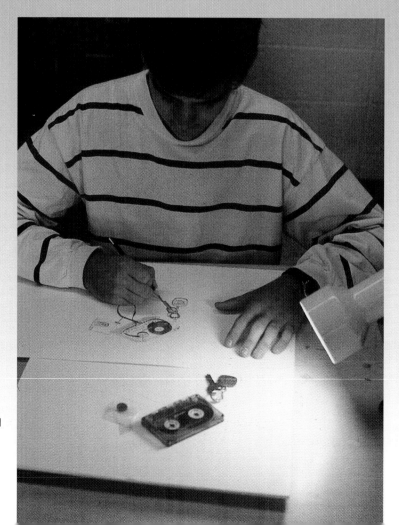

A project need not be dramatically unusual to be effective. Here, a simple still-life exercise enabled students to reach a deeper level of understanding and develop their drawing skills. What made the assignment compelling was the addition of a fun, engaging twist: trompe l'oeil. See page 52 for a complete description of the project.

Artist/Teacher: A Full Circle Involvement

As artist/teachers, we need to stay active as creative artists. In this way we keep our teaching authentic and meaningful. We can do this by staying artistically productive in our chosen media and by completing ourselves the challenging projects we assign to our students.

The demands of teaching often leave little time for personal creativity. But, paradoxically, we maintain freshness in our teaching only to the extent to which we hone or perfect our skills as artists. As we integrate our artist and teacher selves by personal involvement in the artistic process, we motivate our students to develop their own potential in their work.

Integrating the roles of artist and teacher creates a synergy that enhances the vital qualities of both roles. Thinking, problem solving, and presentation are themselves art forms. As we skillfully choose our words, invest in creative thinking, and share our vision, we engage students. Observing the relationship between the artist as teacher and the artist as maker will inspire our students to see the value of communicating expressively.

Rice paper with a scalloped pattern unifies this photomontage when used as an overlay.

Jessica Stanton, grade 12. Mixed media, 8 ½" x 11" (21.6 x 27.9 cm).

PROBLEM SOLVING

As we search for new ways to generate self-expression, we need to look closely at the structure of creative visual problems we give our students. Good problems should focus clearly on the concepts and skills students need to develop. Problems should be authentic, addressing real issues, interests, or concerns. Assignments need to engage students, spark their imaginations, and encourage self-expression.

One of the most exciting aspects of the projects described in this book was their emphasis on open-ended solutions. Preconceived ideas regarding solutions were purposely avoided; at the same time, problems included focused objectives that provided clear direction for students. Project outcomes proved fascinating and surprising as students consistently created unique and personal solutions. The element of surprise served as a constant reminder that learning can and should be an aesthetic experience, an adventure that keeps us alive.

"Andrew is a bright, intense eleventh-grade student whose family had recently changed its name. The significance of this experience for a teenager cannot be ignored, so I decided to integrate his name into the design of his portrait study."

Ken Vieth. Felt-tip marker and watercolor, 18" x 24" (45.7 x 61 cm).

"Chris is a colorful, rebellious student with a half-shaved head and an earring. One day, as he quietly sat and listened to his Walkman, I seized the moment to draw him. He had drawn on the back of his denim jacket and exuded an adolescent attitude worth capturing."

Ken Vieth. Pencil, watercolor, metallic marker, 18" x 24" (45.7 x 61 cm).

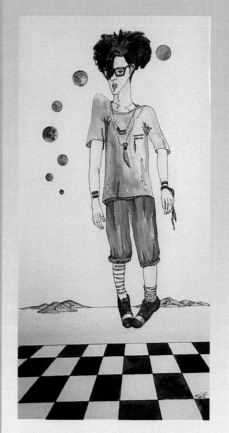

"Mike, an unusually tall student, wanted his body to be an artistic statement. His hair was cut at different lengths and assumed new form and colors on a weekly basis. He also dyed his socks different colors and wore them at different heights. Some of his self-made jewelry protested the eating of red meat. Most notably, Mike was not firmly grounded in reality. My artistic response was a reflection of his personality, and surprisingly, he appreciated it."

Ken Vieth. Watercolor and fine-line marker, 15" x 29" (38.2 x 74 cm).

The Artist/Teacher Sharing with Students

I shared my identity as artist/teacher with students during a project on expressive portraits. While students were in the initial stages of figure study, I chose a model for my own quick portrait. I made the initial drawings during class, then added color and developed the work during free moments and before or after school. I left my work in progress accessible for students to view. Their thoughtful observations led to suggestions and questions, such as "That color seems too strong" or "What do you plan for this area?"

The three individuals in the accompanying illustrations were from different classes and different years. The medium in each was a combination of pencil, watercolor, and pen or marker.

COMMUNICATION

To teach effectively, we need to continue to refine our communication skills. This means paying close attention to what we say and to what others say or write about art. Choose words that emphasize important details, open doors to new possibilities, and give students a new vision. Give students permission to take risks, to envision and explore many possible solutions.

Promote the habit of focusing and paying careful attention when the new project is first presented. Encourage students to ask questions as a way of freeing their thinking, clarifying possibilities, and developing a clear understanding of where they are headed. Open-ended questions with an emphasis on creativity and higher-order thinking skills—such as analysis, synthesis, and evaluation—motivate students to investigate further and to assume responsibility for their own learning. It is important also to listen closely to what students say about their artwork and the direction they want to pursue. Careful listening communicates respect and acceptance.

Communicate visual problems verbally, posting written and other visual information either on the chalkboard or on large sheets of paper. At times, I use a set of two hinged panels (4' x 8' x 3/4" foam core) placed behind me as I introduce the new concepts. These large surfaces can be used to share information such as rubrics for evaluation, time lines, or examples of artists' work. Refer frequently to handouts and posted information as this will reinforce what you expect from students. Sketchbooks can be used as journals for reflective writing and as a place to keep handouts for each assignment.

EMPOWERMENT

It is of utmost importance that each student feel fully involved in the creative process. Students should understand that their input leads to greater ownership of what they produce and to increased self-expression. One way to empower students is to involve them in the decision-making process from the very beginning. As new ideas for projects evolve throughout the semester, "tune in" to students and seize opportunities to allow them to direct assignments—even when you might prefer to retain complete control. You will be pleasantly surprised by the results.

Every project includes a couple of areas in which the student has total control. For each project presented in chapters 2–6, areas in which students make choices are highlighted. Another way to involve students in decision making occurs when projects take longer than anticipated. Encourage students to use time after school to think, plan, and work. Well-organized class periods will maximize students' time on task. Most of the projects in this book take from two to three weeks to complete, and students are encouraged to spend additional time working at home.

RISK TAKING

I've never seen myself as a great risk taker, but, rather, as an artist/teacher who gets bored with repetition. Much of the excitement in my program comes from creating new problems for the students and myself to work through. Interestingly, the more I have pursued this direction, the more of a risk taker I have become. The positive results I have experienced both in terms of cognition and creativity have been well worth the effort it took for me to overcome my fear of failure and of the unknown. This is not to say that things always go smoothly.

I have at times encountered great resistance from both students and from the school community. Examples of assignments which met resistance are psychologically based projects such as the mask project (Exploring the Landscape of Our Mind, page 75), the symbolic representation of family (Family Tree, page 83), and Family Structure Seen Through Shape and Form, (page 88). The school psychologist felt I was "opening Pandora's box" with these projects, and asked how I was going to handle the fallout from students. Because respect and confidentiality were built into the structure of these projects, none of the problems predicted by the psychologist material-

When students see that their hard work is acknowledged, they are more likely to experiment.

Brian Calhoun, grade 10. Pencil, 18" x 24" (45.7 x 61 cm).

ized. While the psychologist raised valid concerns, it is important to remember that the art teacher can significantly influence how such projects will affect students.

Students may initially resist exploring emotionally laden issues in their artwork. Some students, for example, hesitated to put their energy into the family structure project until they were reassured that no one had to identify the people represented. Another student who initially opposed the family tree project worked through her fears and in the end, found the artwork so meaningful that she shared it with her therapist.

Risk taking on the part of students is not something emphasized or held in high regard in most high school subject areas. For the grade-conscious student, taking risks can be scary. Yet as artists, we know that we are not here to make images that have already been created. Therefore, we encourage students to invent rather than imitate. Students need to see that "going

out on a limb" artistically leads to personal growth, that failure is not fatal, and that it is more important to push boundaries than to play it safe. The rewards can be great.

The nature of assessment will influence students' willingness to take risks. When students see that their hard work is acknowledged, they are more likely to experiment. The assessment scale I use, which consists of ten points, takes into account both effort and outcome. Up to five points are awarded for use of class time and creative effort, and up to five points are given for a successful solution to the given problem.

Resourcefulness is a quality connected to risk taking. Resourcefulness in relation to visual problem solving includes being open to and seeing the creative potential of whatever comes your way. For example, a box of 200 business envelopes inspired a project where students invented a new way to transport mail in a sculptural format. The envelope, part of the final piece, contained students' reflections on their creative process and their self-evaluation. Their evaluation addressed reasons for the invention, aesthetic concerns related to the media they chose, and quality of the overall presentation. Students were asked to solve this problem in a creative and resourceful manner. For the artist/teacher, resourcefulness means finding new ways to enhance students' higher-order thinking skills and creativity.

REFLECTION

The educational model presented in this book encourages reflection. Spending time identifying and reflecting on what was learned is a valuable addition to any art program. Ten years ago, if I were asked "What are the attributes of a successful art program?" my first response would have been "The quality of the visual results." My opinion in recent years has broadened. Visual results are not the only significant factor; the depth of student learning is equally important.

Written reflection reveals students' thinking and understanding and how these affect students' treatment and solution of problems. The reflective process also helps students crystallize their understanding of their working processes and the art they create. For me, this aspect of reflection has been a revelation. Students' insights concerning their own cognitive and artistic growth, openly shared through reflective writing, have affirmed the success of this program.

When we take the risk and make the commitment to go beyond a media-centered studio class, we empower and transform ourselves and our students. In my personal journey as an artist/teacher, this growth—this process of transforming ordinary teaching into extraordinary results—has taken years and continues today.

Closing Thoughts

- Art is an expansive process. The building blocks of knowledge, skill, insight, and expression combine to create wisdom about the human experience.

- Art feeds the human soul and yet speaks from the soul. It connects people to each other in new and unexpected ways.

- When artists think and reflect, they nurture their creativity. When they share what they know about creative thought and processes they are artist/teachers.

- To become visible as a creative thinker one needs to take risks, share ideas, and empower others. This metamorphosis will cause doors to open and spirits to fly.

Safety Considerations

Art programs utilize specialized equipment, materials and tools. Precautions must be taken to insure that working with art materials does not lead to student illness or injury. **Failure to take necessary precautions may result in litigation if students become ill or are injured in the artroom.** Nontoxic materials can usually be substituted for toxic ones with little or no extra cost, and good classroom management will prevent accidents.

Under the art material labeling law passed by Congress in October, 1988, every manufacturer, distributor, retailer and some purchasers (schools) have a legal responsibility to comply with this law. The law amended the Federal Hazardous Substances Act to require art and craft materials manufacturers to evaluate their products for their ability to cause chronic illness and to place labels on those that do.

The Art and Craft Materials Institute, Inc. has sponsored a certification program for art materials, certifying that CP, AP, and HL labeled products are nontoxic and meet standards of quality and performance.

CP (Certified Product) are nontoxic, even if ingested, inhaled or absorbed, and meet or exceed specific quality standards of material, workmanship, working qualities and color. AP (Approved Products) are nontoxic, even if ingested, inhaled or absorbed. Some nontoxic products bear the HL (Health Label) seal with the wording, "Nontoxic," "No Health Labeling Required." Products requiring cautions bear the HL label with appropriate cautionary and safe use instructions.

Teachers should check with their school administrators to determine if the state board of education has prepared a document concerning art and craft materials that cannot be used in the classroom.

The teacher also is responsible for instruction in how to use all tools and equipment safely.

Make sure that the artroom has accident preventing items such as the following:

- Signs on or near all work areas and equipment where injury might occur if students are careless, or should have instruction prior to use of the equipment.
- Protective equipment such as safety glasses, respiratory masks and gloves.
- A complete first aid kit.
- Adequate ventilation.
- Safety storage cabinets and safety cans for flammable liquids (outside the artroom if possible).
- Self-closing waste cans for saturated rags.
- Wash-up facilities.
- Locking cabinets for hazardous tools and equipment.

Precautions the teacher may take:

- Demonstrate the use of hand and power tools and machines.
- During demonstrations, caution students concerning any potential hazards.
- Give safety tests before permitting students to use tools and machines, and keep the tests on file.
- Establish a safety zone around all hazardous equipment.
- Establish a dress code for safety indicating rules about clothing, jewelry and hair.
- Establish a code of behavior conducive to safety, and enforce it.
- Keep aisles and exits clear.
- Be aware of any individual student health issues.

Some "Do Nots" for the Safety Conscious Art Teacher:

- Do not absent yourself from the studio when pupils are present.
- Do not ignore irresponsible behavior and immature actions in the artroom.
- Do not make the use of all tools and machines compulsory.
- Do not permit students to work without supervision.
- Do not permit pupils that you believe to be accident prone to use power equipment. Check on the eligibility of some mainstreamed students to use power tools.

For more specific information see *Safety in the Artroom* by Charles Qualley.